BRITISH JOURNAL OF PHOTOGRAPHY ANNUAL

1984

EDITOR
Geoffrey Crawley

PICTURE EDITOR
Anna Tait

ASSOCIATE EDITOR
Tim Hughes

BOOK DESIGN AND PRODUCTION
Anna Tait

©1983 Henry Greenwood & Co. Ltd
ISBN 0 900414 28 6
Published by Henry Greenwood & Co. Ltd
28 Great James Street, London WC1N 3HL
Distributed in the USA by Writer's Digest Books
9933 Alliance Road, Cincinatti, Ohio 45242

Printed and bound in Great Britain by
Billing and Sons, Worcester.

SUCCESSIVE EDITORS OF THE ANNUAL:

1861–62	Samuel Highley
1863	James Martin
1864	Emerson J. Reynolds
1865–79	J. Traill Taylor
1880–86	W. B. Bolton
1887–96	J. Traill Taylor
1897–1905	Thomas Bedding
1906–1934	George E. Brown
1935	H. W. Bennett
	P. C. Smethurst
1936	H. W. Bennett
	Arthur J. Dalladay
1937–67	Arthur J. Dalladay
1968–	Geoffrey Crawley

PICTURE EDITORS:

1964	Bryn Campbell
1965–67	Norman Hall
1968	Ainslie Ellis
1969	Anna Körner
	Geoffrey Crawley
1970–71	Anna Körner
1972–73	Mark Butler
1974–76	Anne Owen
1977–78	Judy Goldhill
1979	Geoffrey Crawley
1980	Jan Turvey
1981–82	Christine Cornick
1983–	Anna Tait

THE ANNUAL'S HISTORY

The British Journal of Photography Annual is the oldest photographic yearbook in the world. It appeared first in the form of a wall calendar for the year 1860 and was published as a supplement to *The British Journal of Photography* issue of 15 December 1859. In the following year the *British Journal Photographic Almanac*, 1861, as it was then titled, with the sub-title *Photographer's Daily Companion*, appeared as a pocket book, $4 \times 2\frac{1}{2}$in in size, issued free of charge to subscribers of the *Journal*. The 1886 issue was produced in the Crown 8vo format, $4\frac{1}{2} \times 7$in, and sold as a separate publication with 118 pages of text and 44 of advertising, priced 6d. This format remained unchanged for 97 years until the 1964 issue, when the book was enlarged to 8×11in, enabling photographs to be properly displayed, selected by a picture editor also responsible for the layout of the book. With the 1980 edition, the book adopted a new, 255×240mm, format.

CONTENTS

FOREWORD

Well, here we are–arrived at last at the dreaded 1984 and although the world cannot exactly be said to have sorted its problems out, those which confront it are very different from those foreshadowed in Orwell's book, and even Big Brother has been transposed to Big Sister. In fact the concern was always based on a misunderstanding since the book was originally entitled '1947', being a vision of immediately post-war Europe, but the publishers changed the title to give the work what we in photography would call a longer expiry date. One of the factors which has prevented the world breaking down into the predicted war-ravaged isolated communities has been the development of visual communications to an extent which could not have been envisaged a half century ago. Prominent in this global get-together has been the growth of camera usage to a position where it has fully borne out Steichen's description 'the folk art of the 20th century'. Whereas communication by language has national limitations, the now almost universally developed ability to read a picture means that almost anyone anywhere on the globe can appreciate or learn from a photograph. Although the printed word remains the most precise way of conveying fact or thought, the photograph, despite its capability of being interpreted in a number of ways, has now won an equal position and is preferred by many. Nevertheless it must be recognised that photography, in the conventional sense of using camera, film and paper to produce a picture, represents now only one of a number of techniques in visual communication. The year 1984 is scheduled to see the launching of at least one electronic still camera and probably a number of makes of movie and video systems under the general description of '8mm video'. Development has been slow and it is possible that new types of magnetic recording media will have to be taken from research and development through to mass production, before such products can compete with conventional means. It is surprising that electronics is still seen as a threat to photography whereas in practice the more convenient, higher-quality silver-based photography has all the advantages. For example, it has been estimated that to provide the electronic equivalent of the detail which can be recorded on a 35mm motion picture frame–half the size of that used in 35mm still cameras–a TV system with over 2000 lines would be required. The best current standard is 625 lines and even the best high definition system proposed for the late '80s has still only some 1100 lines.

Obviously silver-based film manufacturers want to limit as far as they can the inroads that electronic recording methods are likely to make and the photographic year now ending has produced what is really a major step up in colour film quality. Kodak began it by announcing an ASA/ISO1000 colour negative film which gained its remarkable fineness of grain for that speed by using what Kodak call 'T-grain' technology. It is an advance in emulsion chemistry which other manufacturers have subsequently been following. It consists of making the light sensitive crystals in an emulsion flatter, more tablet-like in shape and so presenting a larger surface area to the light falling on them. Without going too deeply into the scientific details, the result is an emulsion which is faster without showing as great an increase in granularity as can usually be expected. The ability to make more sensitive films with high image quality has helped re-establish confidence in silver photography in the face of possible electronic advances. The way in which Fuji and 3M have also contributed during the year to advances in colour film quality will be found in the Summary of Progress section. A product whose general availability is still eagerly awaited is Agfachrome-Speed which provides a simple, rapid way of making positive prints from colour transparencies which can be used in professional or amateur darkrooms.

Turning to the cameras which will use the new improved films, there has been a change of direction. Neglecting the low cost cartridge loading systems for mass market cameras, which have sold in many millions over the last 20 years and have culminated in the Kodak disc system, it is evident that the major boom for the enthusiast and the professional in the same period has been the remarkable one in the 35mm single lens reflex camera. For many years literally millions of these have been manufactured, and mainly in Japan–in fact so many it seems surprising that you do not see every other person in the street wearing one. Sales of this type have now at last evened out or in some countries declined. After all, a saturation point must be reached sooner or later if you are producing 8-9 million units each year. The type which has taken over the stage centre is the viewfinder camera, designed to be pocketable and equipped with interesting features which may include fully automatic or manual exposure, rangefinder, automatic focus and even a built in electronic flash. Such a camera represents a compact self-sufficient photographic unit with the ability to take most subjects without requiring accessory purchases. A main reason for their success, however, is that these cameras take pictures on the standard 35mm format, larger than 110 or disc, and therefore guaranteeing a reasonably high image quality. The popularity is also the result of a natural tendency for people to upgrade once they become interested in a leisure pursuit. There is always a fair percentage of people for example who, after buying a low cost, simple to use camera become more interested than they expected and want better results. For many the expense and involvement jump to a 35mm SLR is too much and the advent of these medium price range all-in camera packages has filled the need and also offered SLR users the possibility of a pocket notebook to have handy at all times. This type, using modern electronics, has become almost as simple to operate as a snapshotter camera. So many people today are quite accustomed to using electronic calculators, TV games, home computers, quite apart from video and audio equipment which 20 years ago would have been thought to require a degree education to understand, that they present no problem. Just how sophisticated the consumer of today has become, seems to have escaped the distributive and retail sides of the photographic industry. So much emphasis has been placed on the ease with which cameras can be used and excellent photographs produced, that there is a danger of the public believing that photography does not offer a worthwhile challenge or provide the satisfaction that comes from mastering a skill. Those have always been the very properties which have attracted generations of enthusiasts to using the camera and processing the materials over the last century and a half. There is clearly a need to give photography the appeal of something which is not difficult to approach but equally it should be promoted as a craft to acquire and which can lead to a satisfying creativity and in fact a whole way of life.

Although the 35mm SLR camera may have been levelling off in sales, with some 8 million a year still being built there seems no likelihood whatsoever of it being dethroned from its overwhelmingly dominant position. There have been no major recent developments in the design but most leading manufacturers have updated models showing some refinement of existing features or improved electronics. One such trend has been the automatic only model–with no manual control of aperture

or shutter speed–as in the Canon TR50. Another refinement is the building in of power wind using a hub motor in the take-up spool and so doing away with the increased body height which power winders previously required. The Konica FT-1 is a good example of this design improvement and the model has no lever wind. Changes in the top rank models in each make occur, thankfully, much less frequently and the stage is now held by the Canon, Contax, Leica, Nikon, Pentax etc models, which have been on the market for a year or two. There are always hints and whispers of future developments in the top 35mm SLR systems but it is unlikely that these will be other than modifications in the light of user feedback. Once you have a 35mm SLR camera, the way is open to a remarkably wide choice of interchangeable lenses and accessories, both in specifications and price. This is one of the most thriving sales sectors worldwide for, even if saturation point is reached with camera body sales, every owner remains a possible buyer of lenses and accessories. So strong has the market been that many dealers are content to make what would previously have been considered a ridiculously low margin on a camera sale, relying on picking up the subsequent sales of lenses and accessories. On the other hand, with disposable income being nowadays spread over so many possibilities of domestic purchases, there is a temptation to discount to the barest margin. This is a very shortsighted policy since it then takes only a small fall-off in sales volume to make a company insolvent. In the past year there have been notable examples of this happening.

Another sector which has been showing a plateau is sales of electronic flash units but this does not mean, paradoxically, that fewer units are being acquired. The advances in design brought about by small circuit boards and transistorised circuits mean that electronic flash units can easily be built into the quite small, compact cameras and even into the wafer thin Kodak disc camera range. The result is that a flash unit comes with the camera so that you do not need to buy one separately later on. That is why more flash is being used but fewer separate units being sold. But this is a far cry from the days when electronic flash meant a shoulder slung power pack and a separate flash head. The tiny but still adequately powerful units of today, working off perhaps two AA batteries, are a further example of how photographers have benefited from modern electronics. On the other hand, these developments have meant the virtual disappearance of the friendly flashbulb–friendly, because each flash was a separate expendable item whose firing had a definite cost, whilst repeatable electronic flash seems more impersonal, quite apart from giving a colder, softer illumination. Thinking of photography in the low light level for which flash is intended, it is worth bearing in mind that with ASA/ISO1000 films becoming commonly available, one wonders whether the aid of flash will be as necessary in the future.

Turning to the end product–the picture–there has been no sign of any decrease in the number of exhibitions held around the country. One or two of the more ambitious centres have gone out of business but they have been more than replaced by others. It looks therefore as if the showing of photography to the general public on a wide scale is one of the developments of the last ten years which will remain an important feature of the photographic landscape. It is a far cry now from the days when the only shows were those held by local camera clubs and topped with the annual RPS and London Salon exhibitions. This proliferation should not be taken to mean that the photographers exhibiting are necessarily earning a living by taking pictures, since sales of prints are understood not to be numerous unless the photographer is a national or preferably an international figure. In that case the selling price of a print can be £60-£150. The galleries show not only the self-expressive work of individual photographers but also hold retrospectives and exhibitions of photographs taken in the locality over a period of many years. Bear in mind that straightforward record shots of everyday, commonplace surroundings and people may be more eagerly sought after in a century's time than some of the over-indulgences of the self-expressive school. It is a type of work in which the amateur may not realise there is a contribution to be made and it is always worth contacting the local historical society to see if they need help. For the amateur enthusiast it is worth mentioning that regular visits to photographic exhibitions, even if the subject matter does not always appeal, are very useful in showing what is possible in the way of black and white and colour print quality. Without such awareness, it is difficult to progress.

In the professional sector the amount of work available, apart from High Street businesses which have a stable base of weddings, christenings, functions and other social gatherings to work from, must always fluctuate in its prosperity with the nation's economy. Photography nowadays is used in so many ways–applications–and these are all linked in with the industries, businesses and agencies photographers serve, that their fortunes automatically follow those of their main employers and customers. There have been some long established names which have gone out of business and others have emerged, but there is no sign that the profession as a whole is anything but optimistic. Like everyone else, pro's are looking forward to the promised economic turn-up but it is clear that this will occur slowly. Consequently, since the working climate will by then have changed, any future buoyancy in professional photography will not constitute a return to a previous normality but will occur in quite changed conditions. It cannot too often be repeated that professionals will, in the last decade or so of this century, have to cope with quite new opportunities coupled with new means of image making and it is those who with the mental outlook to look forward and prepare for those changed conditions and means who will be the winners. During the year the Institute of Incorporated Photographers changed its name to the more easily understood 'British Institute of Professional Photography', which is in itself a symbol of the new face for the profession which will be required, and it is making every effort to plot a new course. Turning from the professional to the 'learned' body, it is particularly gratifying to report that the Royal Photographic Society, after a period of severe financial problems arising from the founding of the National Centre for Photography in Bath just as inflation and the recession were biting hard, now appears to have achieved stability. With more members visiting the RPS in Bath and tourists beginning to click the turnstiles of the NPC, there is every reason to believe that the world's premier photographic society is beginning to assert its position once again.

The word 'photography' embraces an astonishing number of people from the happy-go-lucky snapshotter through to the most advanced scientist. In whatever way individuals use the camera and process, there remains a bond between them: the satisfaction of making a permanent image from a transient event or an interesting person or place. We hope that this *Annual* which represents such a very wide spectrum of interest will be found useful, instructive, entertaining and above all enjoyable by all photographers, however they use the camera. *September 1983.*

IN THE TWINKLING OF AN EYE

Ainslie Ellis

JACQUES-HENRI (Charles Auguste) Lartigue was born under the sign of Gemini in Courbevoie, Seine on 13 June 1894. His family was inventive and exuberant, and unusually wealthy in the matter of cousins, uncles and, rather later, splendidly fast motor cars.

On 13 June, too, this year a small boy will be celebrating his birthday. Nothing unusual about that? On the contrary, there is something exceptional about it. For it is the same little boy who was born in Courbevoie but who learned the secret of secrets: how to stay youthful all through his life. This same small person, so large in genius and now ninety years young, has given to photography, preserved in thousands of his exposures, a sense of fun, of happy mischief and, that rarest of all gifts, the spirit of delight.

Photography, before the arrival of Monseieur Lartigue, was bent on being taken far too seriously for its own good. It was, in short, a most earnest and glum thing. Whereas the joy of Lartigue's photography, and it is full of joy, lies in his appetite for the amusing, the beautiful, and the zestful elements in life. But one can still be born into fortunate circumstances, as was the case with Lartigue, and yet make no use of them.

On the contrary, as Roger Therond has well pointed out, 'Some drunks drink sad alcohol; some rich people

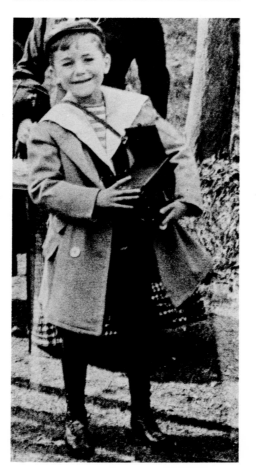

The ever-youthful genius of Jacques-Henri Lartigue

possess dismal money. Not Lartigue's parents. With them, money was, as it were, merry money. The first bit of good luck in his favour was that he learned about money not as the stuff of vanity and deadly pomp but of joyous handouts. For his family, avant-garde for their time, everything was greatly loved; they were intoxicated by their Golden Age, with its arts of living, its discoveries and its naivetés: the automobile, the airplane, the phonograph, the cinema, photography (which his father, a financier, had already discovered), sports of every kind, travel, the sea, the snow – and the array of gadgets, like the inflatable suit which (in theory at least) allowed the wearer to drift in a gentle current without getting wet. There were, in short, a profusion of subjects for Lartigue, a child of that time and class, to capture.'

There are of course those, a dismal sort, who really believe that they, given an identical background and armed with the gift of a camera on their seventh birthday, would have done just as well. An identical miracle is far from likely. Instead I believe Richard Avedon when he says:

'. . . it would be a great mistake to credit his artistry merely to the fact that he was not corrupted by professionalism. Or to say that his work is the product of accident . . . that his photographs are extraordinary because the people around him were. Or the time

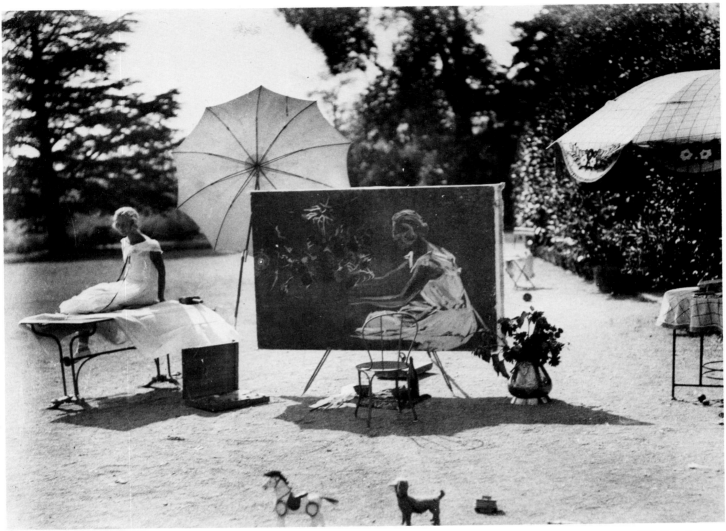

1923 – Portrait of Rose

in which he lived. Hundreds of children with similar backgrounds were given cameras in those days – but they never became Lartigues. And accidents are capricious. They just don't happen that often. They can't produce a single body of work so consistently brilliant.'

Of his own attitude towards photography, towards time, the fervour for preserving the fleeting moment or capturing for an instant the delicate bluebird of utter joy, he speaks with a disarming directness.

'As a little boy I already had a passion for preserving the fleeting images of life so I took photographs. I want to catch time, I have an obsession with catching time as it passes. But the subject always finds me. I am only the spectator. I used to be a tennis player so I have a very quick eye, I react very quickly.'

Did he find everything worth photographing?

'Everything which pleases me, fills me with enthusiasm, delight and wonder. The rest I pass by.'

So is it really an act of love?

'Absolutely! . . . Of passion! Everything is passion – writing, painting, photography. An invitation to rejoice, to love. Everything is fascinating: nature, the talent of others, music above all!'

When he was asked, in a television interview by Peter Adam, whether his legendary enthusiasm was something he was born with, or whether it was instead something that he had acquired, his answer was simple.

'There was a fairy at my cradle. I have looked after her gifts. I have

9

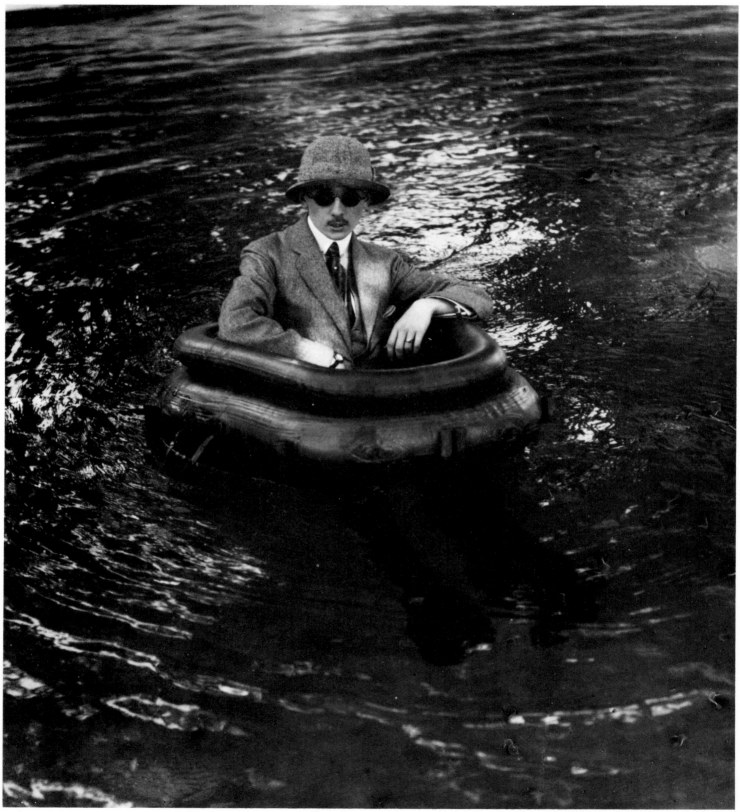

1911–Zisson in his tyre boat

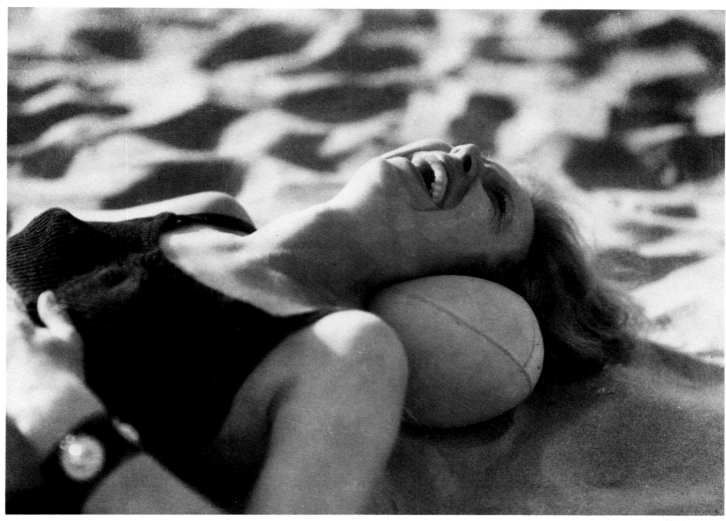

1938 – Biarritz

tended them well like a gardener.'

On 26 June 1979 in the presence of the Minister for Culture and Communications, and surrounded by his friends, Jacques-Henri Lartigue signed the public declaration donating all of his photographic work to the French State. There is now, in consequence, a permanent exhibition of Lartigue's work as a photographer at the Grand Palais in the Champs-Elysées. Housed under ideal conditions, and as beautifully displayed, the collection is in the care of Isabella James, and the Association of Friends of Jacques-Henri Lartigue which was formed specifically to manage the collection of some 200 000 documents in the Grand Palais. Included in this total are some tens of thousands of negatives of every type and format which he has taken since 1902, and, of exceptional interest, about a hundred albums. Of these Isabella James says.

'In addition to their importance to us as reference albums which provide us with a clear insight into his preferences and settings, they also have undeniable interest as a result of their actual presentation, as the pictures are placed in sequences as well as having handwritten notes around them. These albums are equally precious because they contain numerous prints which represent particular eras: the Belle Epoque, Art Deco, the Pre-War Movement and the contemporary period.

'In the exhibition we try to recreate the relevant expression of the atmosphere which comes over to one from the albums. We have tried to achieve

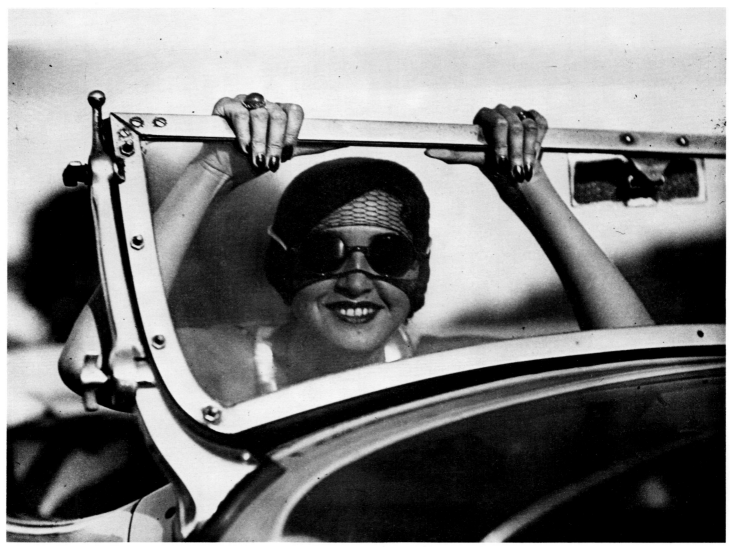

1931 – The road to Paris

this either by respecting the autonomy of the "masterpieces" or by telling a story through a sequence of pictures, or alternatively by placing a dialogue between the photographs and their captions.'

If anyone deserves the untranslatable accolade of the word *'Maître'* it is Lartigue. For here is a man who has fully developed an amazing talent for distilling time. In his daily Journal, kept assiduously and lovingly for more than eighty years, he writes with a sparkling eye and a warm heart.

Everything that he observes, everything that matters to him, everything to which he responds, is preserved in these vividly illustrated pages. So that today, in speaking of his first photographic encounters, he recalls them with an inimitable freshness.

'Yes . . . The Bois de Boulogne . . . well, every day pretty women displayed their dresses. And every day at lunch-time, after school, I rushed to see them. I was fascinated by fashion, by their hats. I just liked seeing pretty women. Sitting on a chair I saw them

coming . . . I thought this one is pretty . . . I got up . . . and "click!". My camera was very noisy. When they were alone they smiled. Their gentlemen were usually furious. I didn't care. I was young. What counted was I had my photo. Every time you met somebody you raised your hat. This went on every morning of the week as they went to meet each other. To show their dresses . . . and their hats. They needed high carriages. They didn't fit into ordinary cars. One lady asked me to bring her one of my photos but I

12

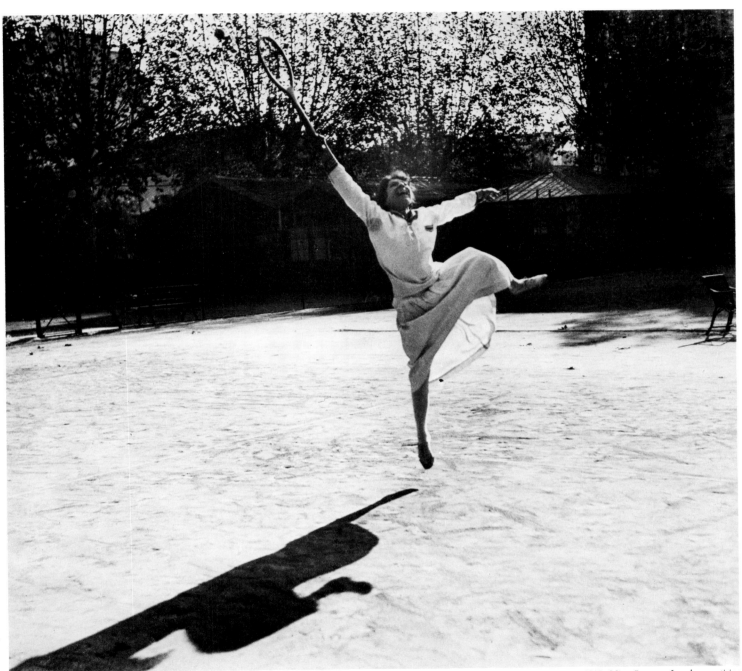

1915 – Nice, Suzanne Lenglen practising

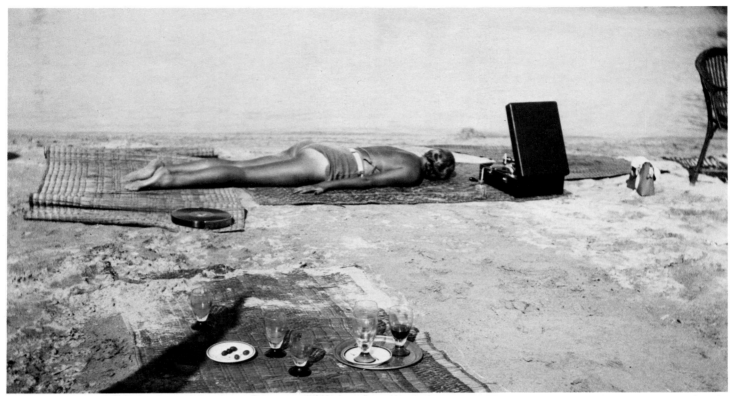

1932 – Cap d'Antibes

was shy and panicked. She was a famous dancer, Regina Badet from the Opéra Comique. I sent my brother Zissou instead.'

Last summer, invited to take lunch under a great olive tree at his home in Opio, in the hills near Grasse, I asked him whether he could choose between his two passions: painting and photography. What would you do if you *had* to choose one or the other? His eyes twinkle. 'Oh then I should write!' he replies merrily.

Here is a man who has fully developed many talents and each has its own flavour, contains its own unique possibilities. So when he was asked recently whether painting, writing and photography are able to express the same things, his answer was:

'No. They complement each other in order to express something. Paint-ing is an accumulation of time . . . photography is the frozen moment. Painting comes from inside, photography from outside. Photography happens very quickly, painting can catch the elusive. Photography is a lighter game. Painting is a profound one.'

Speaking personally, and not attempting to wear the hat of an art critic (and they are very suspect hats) I can only say that Lartigue's canvases give me a different, but as great, an enjoyment as his photographic prints. And it is the same thing too when I read extracts from his Journals or relish his *Diary of a Century*. Yet this is not in the least surprising. For these are the fruits and flowers of the same man. When Peter Adam, showing him one of his early photographs of some little accident which had amused him, said 'You are a little boy who laughs when someone slips on a banana skin,' Lartigue replied 'Worse! I am an incorrigible little boy.' In so doing he revealed in a sentence something of the mischievous twinkle that always animates his expression. But the secret lies deeper. There are those, like Proust, who have spent their lives preserving memories, laying them down in some medium like wine in a cellar. But, partly as a result of such preoccupations, their own living stopped. There was no naked edge of awareness open to the shimmering touch of each day and all it brings. That is the vital difference. Lartigue is profoundly open to that touch. He has put it marvellously.

'There are cooks who pick cherries to preserve them and make jam. I am a cook who makes jam but prefers to eat fresh fruit.'

Why take photographs? You could

14

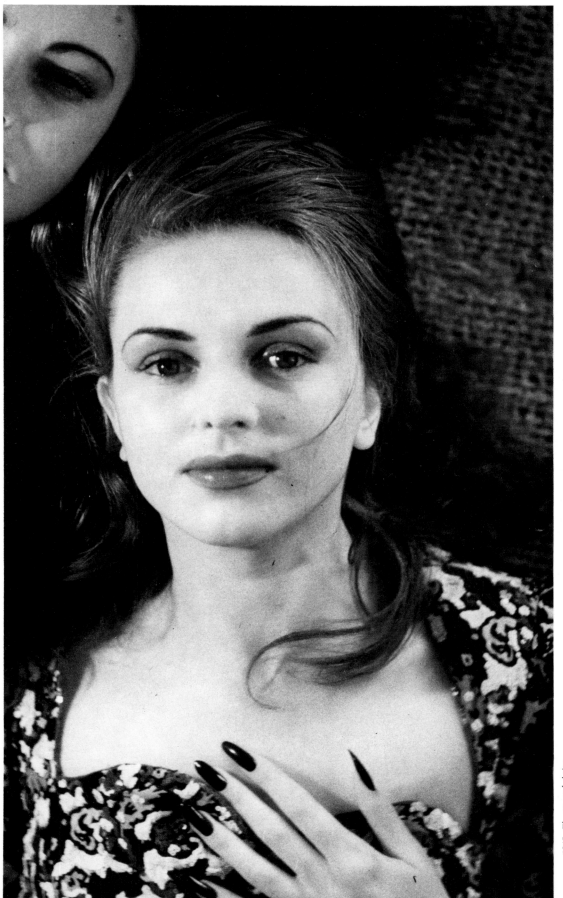

1945 – Florette and Anita

carry the memories inside you.

'That is how I started. I just blinked and pretended that I had taken a photograph.'

Why weren't you content to keep those pictures in your head?

'Because I am also a cook who hates any cherries to be wasted.'

How valuable, one might ask, has been the preservation of these particular cherries, individually gathered and so carefully cherished? To Lartigue himself, to us who are now able to share them, and to photography as a whole? The answer is both complex and straightforward: they are invaluable. And the reasons for this are perfectly stated by John Szarkowski in the brilliant text that accompanies 100 Pictures from the Collection of Modern Art, *Looking at Photographs*. This is not surprising since it was at the Museum of Modern Art, New York, that Lartigue had his first one-man show of photographs as late as 1963. Since their first astonishing appearance in the early 1960s (they reached The Photographers' Gallery in 1971) his photographs have been exhibited widely. His work was first seen in France at the Festival d'Avignon as late as 1969 and was not exhibited in Paris until 1975. This is not as surprising as at first it seems to be. For this was a photography done entirely for personal satisfaction, and never for either gain or acclaim. That is why it is so natural and so enjoyable. But why is it also so very good? John Szarkowski answers this question.

'From the subjects of his pictures one would assume that the life of his family was dedicated wholly to the pursuit of amusement: the beach, the racetrack, beautiful women in elegant costumes, heroic motor cars and daredevil drivers, flying machines, and all manner of splendid games—including photography itself. Even if Lartigue had been an ordinary photographer, his document of these things would be precious, but he was in fact a photographer of marvellous talent. He caught memorable images out of the flux of life with the skill and style of a great natural athlete—a visual athlete to whom the best game of all was seeing clearly.'

As for his direct effect or influence on photography, this has been slight. It did not surface for more than half a century so it could scarcely have been otherwise. But when it did, Szarkowski again, 'it seemed to confirm the inevitability of what had happened in photography much later, when more mature and sophisticated photographers came to understand what the child had found by intuition.'

When Paul Hill and Thomas Cooper went to talk to Lartigue, and there is a brief interview in their book *Dialogue with Photography*, he told them,

'For forty years I was known as a painter. Since the war I have been known as a photographer—each one in its turn.'

But when he was asked whether he still saw the world with a child's eyes he said,

'Fortunately, I am still a child. It seems to me that human beings tend to get more and more "down" as they get older. One must try always to remain childlike, gay, happy.'

A meeting with that irrepressible smile, with the twinkle in his eye, and you know for certain that he has really learned, and lives out, the magic secret of being a child who has known ninety years of passing time. He has captured moments, thousands upon thousands, in images and in words, but he always releases them. He is unbound by time, and time's effect, simply because he does not try to hold on to the past. He always lives in the present moment, loves it passionately, and *lets it go*.

There are photographers who dwell on early photographs that they have taken, look at them and so live in the past. But when he was asked whether he liked looking at them, Lartigue replied, 'I never do.'

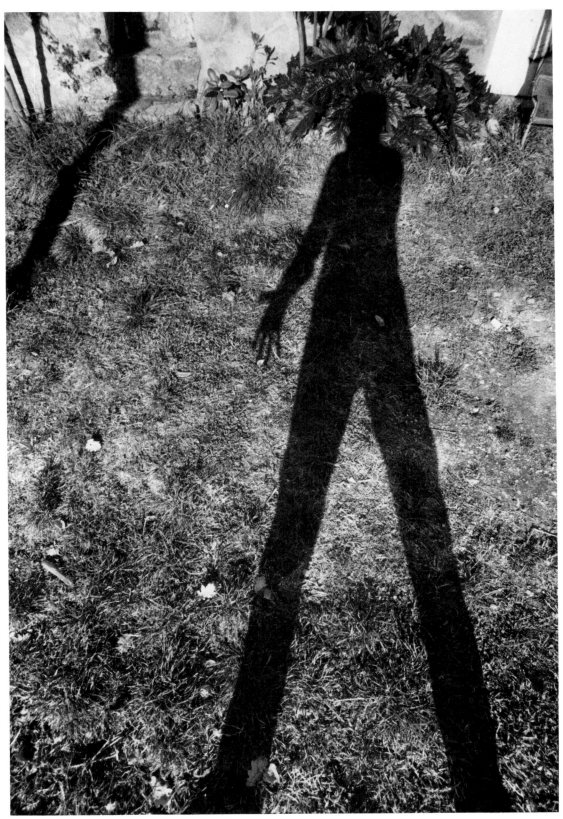

1980—Meanwhile, I still have a shadow . . .

ROUND TRIP

Bryn Campbell

I SAW A killer whale once in Vancouver Aquarium. It was like a cross between a panda and a Polaris missile. As we sailed for the Antarctic, I kept remembering it and the fright that eight of them had given Herbert Ponting, the photographer who had accompanied Captain Scott. He was convinced they had tried, and almost succeeded, to gobble him up. Scott called the incident '. . . about the nearest squeak I ever saw!'

Over a year later, I stood in Ponting's darkroom at Cape Evans. It was the end of my second Antarctic visit and I could afford to laugh at my earlier fears. We were heading north, eventually far into the Arctic Ocean itself. I began to think of a huge polar bear I saw once in Stockholm Zoo.

Photographic problems ranked quite low in the pecking order of my worries, after frostbite and crevasses but before seasickness and getting dirty. Nevertheless, it had taken me hours to decide on the cameras and equipment I would take with me on this unique assignment. *The Observer Magazine* had offered me the chance to photograph the Transglobe Expedition, led by Sir Ranulph Fiennes, which hoped to complete the first-ever circumnavigation of the world via both Poles. The journey was expected to take about three years and I would cover some of the more interesting

The Transglobe Expedition 1979-1982

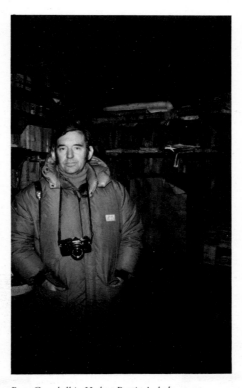

Bryn Campbell in Herbert Ponting's darkroom at Cape Evans.

stages, beginning with the voyage from Cape Town to the Antarctic and the setting-up of two winter bases.

At that time, I worked with either SLR cameras or Leicas, depending on the job. The Leicas picked themselves for this project, because of their proven robustness and reliability, and so I sent one M3, two M4s, 28mm, 35mm, 50mm and 90mm lenses to be winterised by Leitz. Their service department at Luton knew exactly what needed to be done.

The importers of the SLR equipment were far less knowledgeable and helpful, so I talked over my choice of camera with other photographers. Weight was an important consideration, since I did not know how far I would be physically stretched and a too-heavy camera bag could prove a serious handicap.

It seemed wise to choose a fully mechanical camera, since batteries lose their power very quickly or even fail completely in extreme cold. Eventually I decided on the Olympus OM-1n, after friends reassured me that it was sturdy enough to trust. I bought three bodies and 18mm, 28mm, 85mm and 180mm Zuiko lenses, all of which Olympus checked over for me. An ƒ/5.6 400mm Vivitar lens and a x2 teleconverter completed the outfit. In the field I usually worked with two OM-1n bodies and a small range of

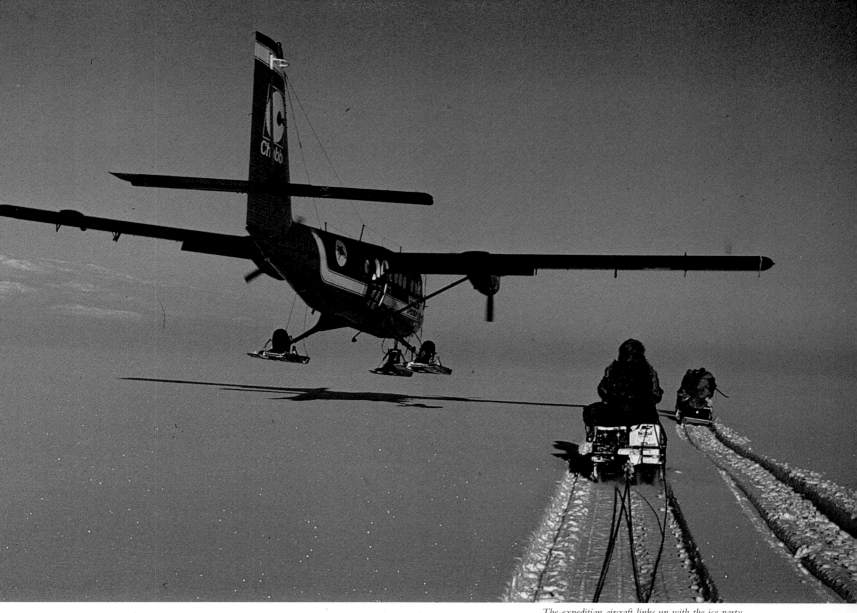

The expedition aircraft links up with the ice party.

lenses, plus a Leica M3 with 50mm Summicron. The other equipment was kept safely in reserve. Later, this caution was to pay off.

Choice of film was simpler. I always use Kodachrome 64 whenever possible and Ektachrome 400 when its speed is essential. With some experience of shooting in snowy conditions, I measured exposures by taking incident light readings with a Weston Master meter and Invercone attachment. The film was advanced and rewound slowly to avoid static electricity marks.

Condensation proved to be a real problem. If the cameras were taken from the cold outside air into a warm hut, they dripped with moisture. The answer was to slip them first into a plastic bag, squeeze it tightly to get rid of as much air as possible and then tie a knot in the top to seal it.

Both my trips to the Antarctic were in the summer and so the coldest temperature I had to work in was just below −30°C and usually it was a good ten or even twenty degrees warmer. The chill factor brought on by the wind speed or travelling on our exposed snowmobiles, sometimes increased the cold considerably. Carrying the cameras under my duvet coat gave them added protection and warmth. The film had to be handled very carefully when it was really cold or it just cracked apart.

My first visit to the Antarctic was by far the happiest and most productive period of the expedition for me. The feeling of comradeship and common purpose was at its greatest and the range of activity and general subject matter at its widest. One had to be careful, especially on bright days, to wear protective sun goggles whenever

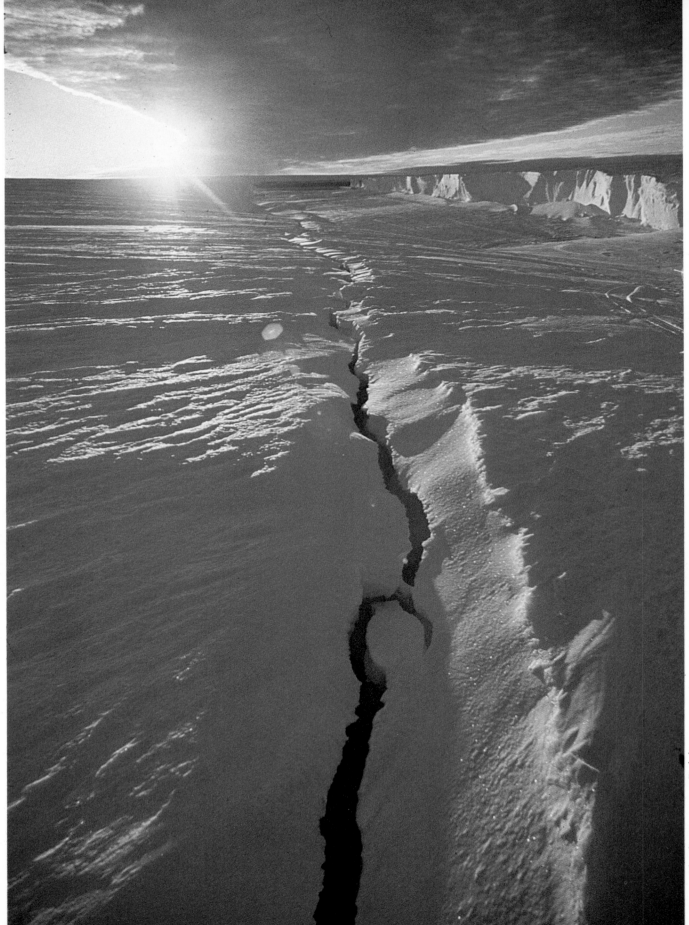

A lengthening crevasse at Fimbulisen.

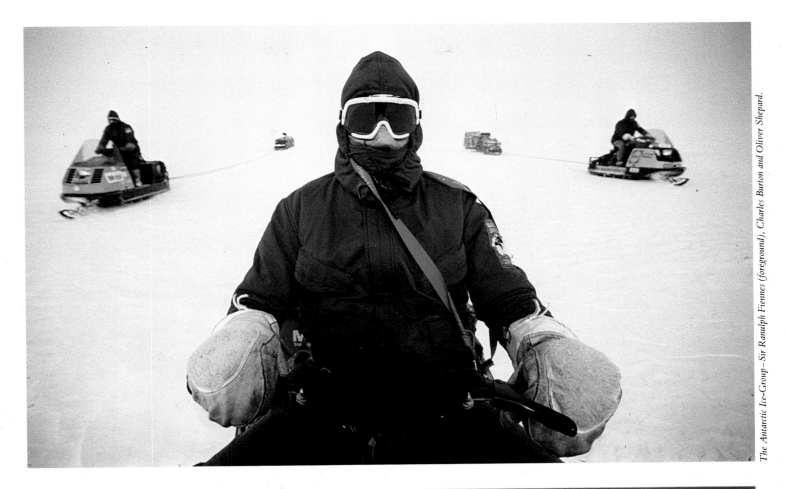

possible: the glare from the ice was incredible. There was so much more colour than I had expected, the ice-cliffs reflecting the varying shades of the sky through the 24 hours of daylight, the bright turquoise of open crevasses, the orange throats of the emperor penguins, and the conspicuous hues of our own clothing and machines.

Throughout the expedition, I found myself using very wide-angle lenses most of the time, sometimes through choice – to suggest a sense of space, and sometimes out of simple necessity – cramped interiors, such as a tent or a cabin, views from the crow's-nest showing the ship set in the ice, or relating foreground and background interest. Half of these published photo-

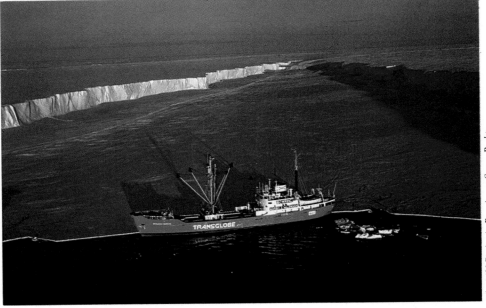

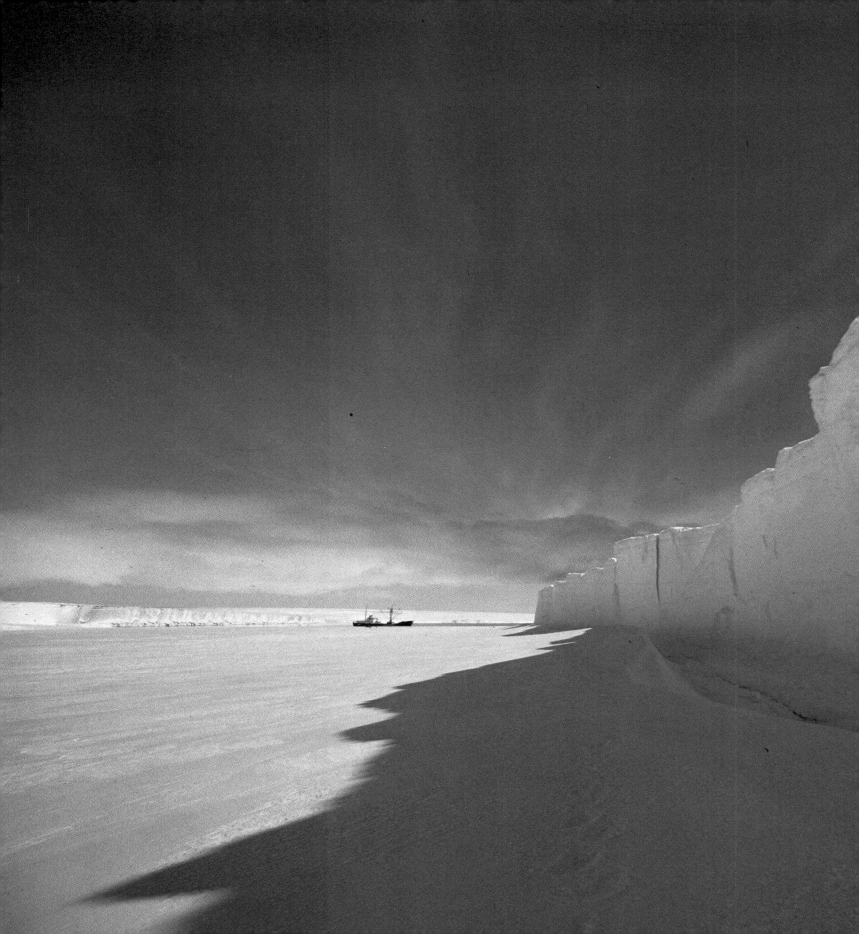

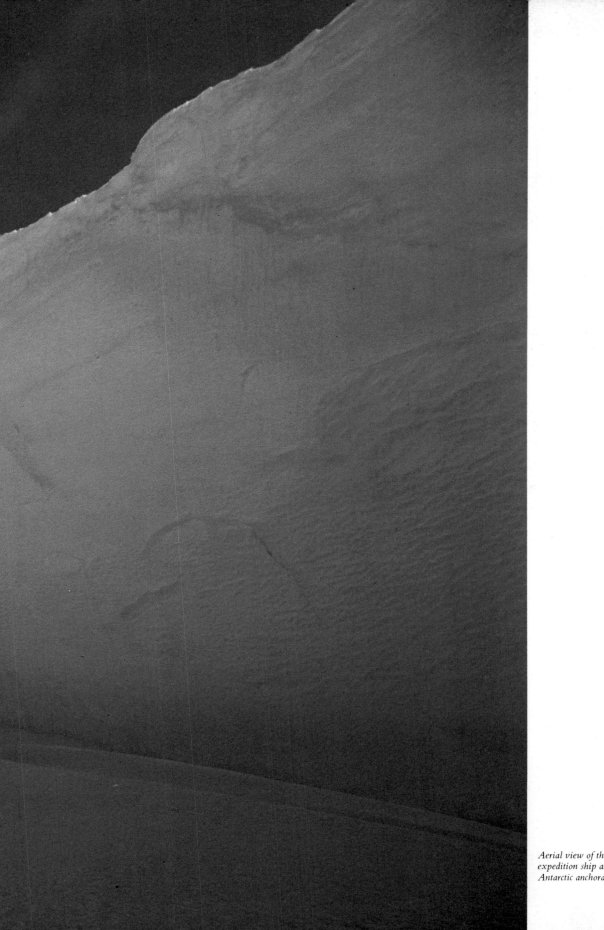

*Aerial view of the
expedition ship at its
Antarctic anchorage.*

Oliver Shepard (right) and Sir Ranulph Fiennes rescue equipment on the breaking-up bay ice.

Adélie penguin.

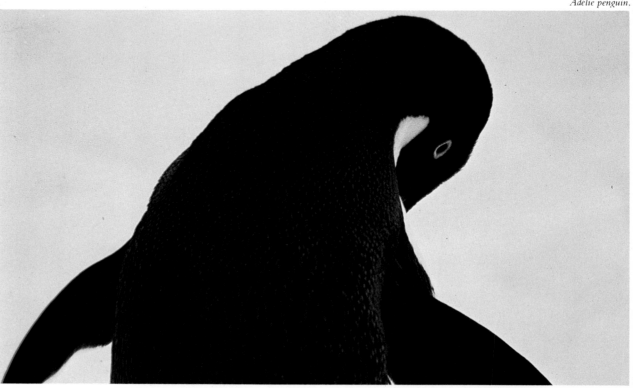

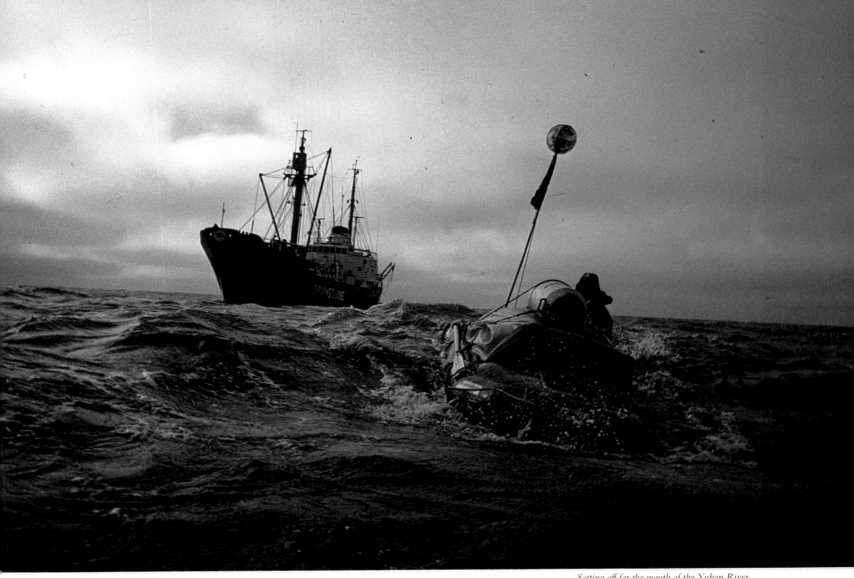

Setting off for the mouth of the Yukon River.

graphs were taken with the 18mm lens.

My experiences in the Antarctic taught me an added respect for Herbert Ponting and Frank Hurley, the photographer with Shackleton. Now I own an original print by Ponting, showing a view across the bay near Scott's hut. It thrills me to know that I have stood at that same point and enjoyed that same sight.

After the Antarctic, the expedition moved on to New Zealand, Australia, across the Pacific to Los Angeles, then up to Vancouver, where I rejoined them. A couple of weeks later, Charlie Burton and I were thrown into the water when our rubber boat capsized in heavy seas as we headed for the mouth of the Yukon River. There had obviously been a risk of this happening and so I was carrying a Nikonos underwater camera. This unfortunately was damaged during this incident. I was also carrying an Olympus OM-2 with motor-drive and 18mm lens in a supposedly waterproof pouch and this was ruined. One had to take such a chance in order to get the best possible pictures of a key moment in the journey. The rest of my equipment was safely packed in genuinely waterproof and buoyant cases.

During later Arctic stages I was unable to work so close to the action and had to rely on over-flying the ice team or photographing from the ship itself. I am greatly indebted to both of the expedition pilots for the patience, skill and courage with which they placed me in the best possible position to take photographs. I am equally obliged to many other members of the team for their kindness and help. I owe them the best of my pictures.

Expedition photographs by courtesy of *The Observer.*

25

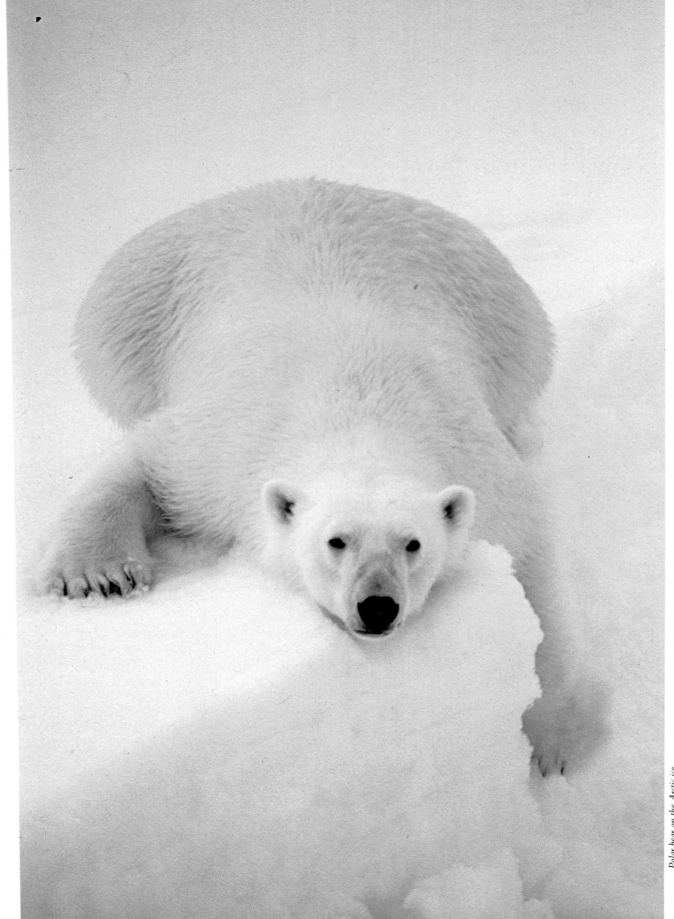

Polar bear on the Arctic ice.

DOUBLE PAGE DREAM

Tim Imrie

'Each of the recent decades has turned out to be very different indeed from what watchers a. its birth expected.'

Leader in *The Economist* at the beginning of 1950

British Photography 1955-1965

YES INDEED. At the beginning of that particular decade, the bright hopes of postwar socialism had all but drowned in a morass of strikes, blackouts and shortages. Despite victory in the most desperate and most justifiable war in its history, the people of the (then) third most powerful nation on earth were still subjected to rationing almost as severe as during the war itself, and the freezing winter of 49-50 was made grimmer still by a prolonged miners' strike. Life in general was dreary, unjust and under-nourished; joy was the most strictly rationed commodity of all.

Seven years later, his party in the middle of thirteen years of continuous office, the Conservative prime minister Harold Macmillan was able to say, with as much justification as a politician has for ever saying anything: 'Some of our people have never had it so good'. Britain really was embarking on an economic boom, and a social and psychological revolution. Much of that revolution may have been shallow, shoddy and idiotic, but that has not stopped the shape of British society from being moulded by the changes it underwent in the late fifties and early sixties, and many of the facets of life that we take for granted had their origins in those years.

The decade covered by 'British Photography 1955-1965' at The Photographers' Gallery exactly co-incided with Britain's postwar social revolution and, intentionally or not, was a reflection of it. A decade that began with Britain's first taste of rock 'n' roll (Bill Haley and the Comets in *Blackboard Jungle*), James Dean's semi-suicide in a car crash, the fanfared launch of commercial television and the more modest but equally sig-nificant opening of Mary Quant's first boutique, Bazaar in the Kings Road, and closed with the death of Winston Churchill, the birth and almost im-mediate demise of the magazine *London Life* and the zenith of the swinging sixties. A decade in which photography along with the rest of the country finally threw away its demob suit and went stepping out in a neat set of threads from Cecil Gee.

In the introduction to the excellent and indispensable guide to the exhi-bition, Sue Davies writes: 'The original idea for the exhibition was to explore my assumption that the crafts-men photographers of the fifties had metamorphosed into the specialised heroes of the late sixties'. She con-tinues: 'As well as a new generation of photographers, the late fifties pro-duced a new generation of art directors and editors who had the means and the enthusiasm to use photography to good effect.' And with the courage of its convictions, the exhibition boldly went where most are too snobbish to tread, devoting about half its wall space to magazine covers and spreads; in fact, although it was divided into five sections, it could just as well have been split into two—framed prints, and magazine and newspaper pages, the yellow, curly-edged sheets being more revealing, more appropriate and more fun than the prints in their sober Sunday best of heavy wood frames. And since most of the photographers shown made their names, if not their money, through magazine work, the exhibition did concentrate on fashion and editorial photography, hard news and documentary, although the omis-sion of advertising photography, except for some of Bert Hardy's campaigns for Lucozade and Strand

THE MODELMAKERS

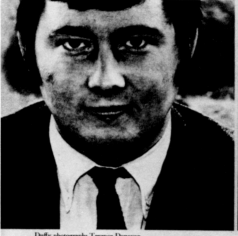

Duffy photographs Terence Donovan Terence Donovan photographs David Bailey David Bailey photographs Duffy

THE LONDON idea of style in the 1960s has been adjusted to a certain way of looking, which is to some extent the creation of three young men, all from the East End. These are the fashion photographers Brian Duffy, Terence Donovan, David Bailey. Between them, they make more than £100,000 a year, and they are usually accompanied by some of the most beautiful models in the world: they appear to lead enviable lives. They have little in common with the pre-1960 conception of fashion photographers; it is their straightforwardly sexual interest in women, combined with an unbroken attachment to their East End origins, which has enabled them to interpret the mixture of toughness and *chic* peculiar to their time. "We try and make the model look like a bird we'd go out with." Very often, the model and the bird are the same girl.

All three are deeply involved with each other, although they reject the idea of a group: "We're very much lone wolves." They are unusual in being at the same time rivals and conspirators. They get their money from advertising and their power from fashion magazines: in both spheres, they are fierce competitors. Yet their solidarity can be illustrated by many anecdotes. Duffy, for instance, has hired both Terry Donovan and David Bailey to take pictures for him, which have later appeared under Duffy's name while the clients have remained ignorant of the deception. They view each other with affection, suspicion, respect and an almost morbid interest.

Duffy is one of the star photographers for *Elle*, the magazine with which a fashion photographer today is most proud to be associated. He is 30, with a quick-nervous intelligence. Both the others said in front of him that he could be "vicious": he seemed surprised. When he finds himself in competition with Terry Donovan over an important advertising job, Duffy will tell Donovan exactly what he is going to do— "I like to show all my cards first, and then play the hand. Power is more appealing to me than fame. If I was a film director I'd want to be like Huston—put a whole lot of people together like scorpions in a tin kettle, and watch them work on each other." Duffy is the only one of the three who had an art school training. The others say of him that if he decided to take up fashion design, he'd be better than anyone.

Terry Donovan is 27, and has been a photographer for 12 years. He started as a lithographer: "I was involved in blockmaking. Every Friday afternoon I used to sneak up and start making these magic things. And for several years I used to have a dark room in a cupboard. And I got obsessed with the disease photography . . ." He is large, affable, giggly. A consummate technician, he works on most of the big advertising accounts and spends much of his money on equipment. He is less interested in women's fashion than Duffy and David Bailey (though equally interested in women) and was influential on the changing attitude towards men's clothes in this country. "It's not so long ago that the only way you photographed a man was on a shooting stick in Regent's Park, sitting there. So I thought, right, we'll get on to this, we'll go to the gasworks. You know, the obvious reaction to it."

David Bailey is 26. For more than two years he has been associated with Jean Shrimpton, his favourite model. With thick black hair and large bright eyes, he is handsome, reserved, slightly sulky. He does less advertising and more editorial work than the others, and therefore makes less money: but, according to them, "he puts more in his pocket because he has fewer people to keep." They have a rhyme about him: "David Bailey makes love daily." He is reluctant to talk about his work—"I just take photographs" —but revealed: "I think Fred Astaire has influenced me more than anybody. His sort of attitude, and his camp chic. And films like *Jules and Jim* and Fellini's 8½." A great pet of the fashion editors, he looks so young that often, at glossy magazines, he has been taken for his own assistant. David Bailey works mainly for British and American *Vogue*. He owns three cars: an E-type Jaguar, a Land-Rover and a Mini Countryman.

The following conversation took place against a changing background: an empty bar at the Ritz; a crowded Chelsea restaurant; a party given by Mary Quant and Alexander Plunket Greene, proprietors of Bazaar shops; Terry Donovan's small Hampstead flat, which contains a collection of Victoriana, a pile of books on Judo and an organ. There was a regular (if occasionally somnolent) audience of extremely beautiful girls.

"Before 1960, a fashion photographer was somebody tall, thin and camp," said Duffy. "But we three are different: short, fat and heterosexual!"

"You mean, we're in it for the birds," said Terry Donovan.

"No, I don't agree," said David Bailey.

"You get up in the morning, you've got a terrible hangover," said Terry Donovan. "There's the camera. You look through it. There's this woman. You've got to make it so when she sees the picture she's going to think: 'I wish I looked like that'. It can happen, you know, for the model to look at a picture of herself and say, 'I wish that was me.' You take a roll. But you never know if you've got a good snap. Just a fraction of a second—you can't be aware of it at the time. You only know later, when you look at them. It all boils down to a chemical thing between you and the girl."

"And sometimes /continued on page 19

Double page spread from 'Sunday Times' Colour magazine, 1964.

cigarettes, was not a deliberate slight. It was just impossible to get hold of the material.

There were pictures from forty-nine photographers on show and it would be tedious to list them all here. Just think of any British photographer whose work was widely used by magazines at that time and he or she was probably there somewhere. Many of pictures shown are already classics of British photography: David Hurn's coverage of the Hungarian uprising of '56 (*Observer*), and of Soho strip clubs in '65 (*Sunday Times*), Don McCullin's first published photographs, 'Guv'nors of Seven Sisters Road' (*Observer* '59) and his pictures of the civil war in Cyprus (*Observer* '64). There was Robert Freeman's '63 cover for the Beatles' LP 'With the Beatles', and Brian Brake's colour photo-essay on the Indian monsoon that took up almost the whole of *Queen* magazine in October '61. There are four prints from Bill Brandt's *Perspectives of Nudes*, also from '61, and three from David Bailey's *Box of Pin Ups* of '65.

The show was a massive visual assault, an attempt to overwhelm the audience with evidence that the late fifties and early sixties were both a high point and a turning point for British photography in print, a period in which photography and photographers were young, energetic, professional and dynamic.

Those at any rate were the adjectives people liked to have used of them at the time, and by 1965 they had become virtually the only form of praise in use. By 1965 the metamorphosis of craftsman to hero was complete; everyone who was young, energetic, professional and dynamic was, potentially, a hero. The very concept of hero had changed. No longer was it Douglas Bader or Scott of the Antarctic, no longer was it concerned with deeds but with image. So it was only to be expected that the image-makers themselves should become heroes. If the photographer in Antonioni's *Blow Up* (1967) seems laughable now, in 1955 the character was inconceivable.

At the beginning of the exhibition there was a picture by Terry Fincher of Jayne Mansfield arriving at Heathrow Airport in 1957. She is surrounded by slightly suspect men in ill-fitting rain-

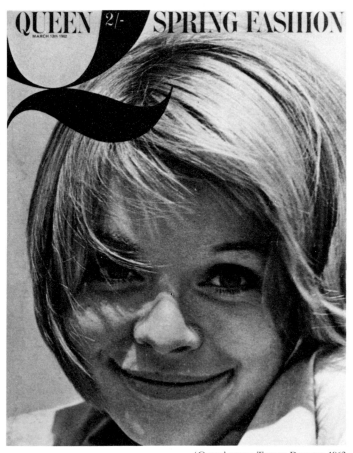

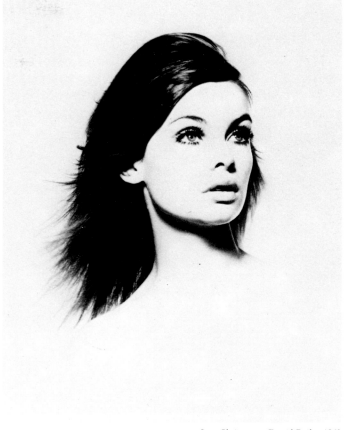

'Queen' cover; Terence Donovan 1962.

Jean Shrimpton; David Bailey 1963.

coats, carrying vast Speed Graphics and saucepan-shaped flash guns. And that was the public image of the photographer. In the cinema in particular, with few exceptions photographers appeared only as walk-on parts, frequently grubby or disreputable or both, and never as people of either skill or consequence. Ten years later, things had changed so much that, whatever the reality, the idea of a photographer as a young fashionable male, rolling in money, success and women was not only conceivable, it was inevitable.

By that time a job in music, in fashion or in communications—television, journalism and photography—had acquired an aura of glamour previously reserved for film stars. As youth gained economic force for the first time, it turned away from the values of steadfast mediocrity enshrined in *This Happy Breed* and *Meet the Huggetts* to new ones concerned with style and ephemerality, exactly the atmosphere in which the photographer in *Blow Up* lives.

In between the two ends of that decade, there had also been a fair increase in the number of jobs available in those areas. For editorial and fashion photographers, although *Picture Post* went, rather overdue, to its final resting place in 1957, over the following years many more picture magazines were launched, re-launched or made more photographic, including the *Daily Express* with its Photonews page ('56), *Queen* ('57), *Man About* Town ('60), *Sunday Times Colour Supplement* ('62), *Observer* and *Weekend Telegraph Supplement* ('64) and *Nova* ('65).

As the nation slid into the fantasy world of the Swinging Sixties, the editors, writers and photographers who had helped to create this febrile, neophiliac dream increasingly became the subject of each other's adoring profiles and hard-edged pictures. In 1964, the *Sunday Times* magazine published an article by Francis Wyndham on the trio who more than anyone else had made photography a cult profession. The article was called 'The Model Makers' and it began like this: 'The London idea of style in the 1960s has been adjusted to a certain way of looking which is to some

29

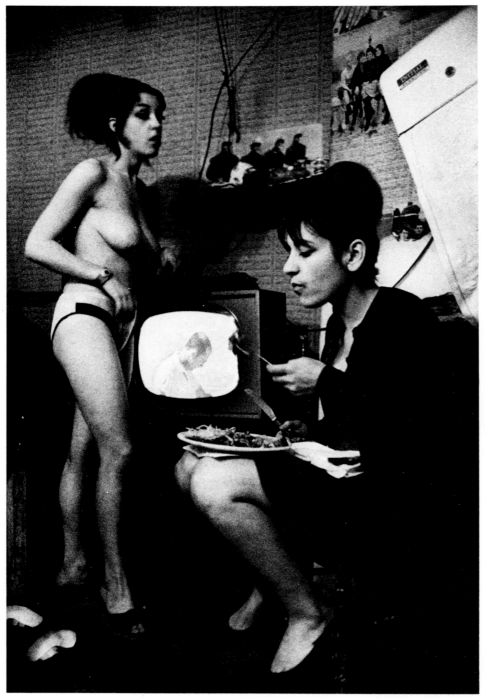

Soho Strip Clubs – 'The Sunday Times'; David Hurn 1965.

world: they appear to lead enviable lives.'

The article says rather more about both photography and society in 1964 than the author probably intended.

The following year, David Bailey, on whom Antonioni is believed to have based the lead character in *Blow Up*, produced another piece of revealing evidence on the sixties mentality – his *Box of Pin Ups*, a collection of 36 photographs, again with text by Francis Wyndham, of the 'people who in England today seem glamorous to him'. With the outstanding exception of the Kray brothers, the pictures are mostly of people who were what could loosely be described as 'creative': designers, actors, pop stars and their managers, models – and photographers.

It would be unjust and untrue to play the nostalgia game and claim that British photography went into a decline after 1965, but it is true that magazine photography was never as strong again. Or rather, that magazines were never as strong. *Town* quickly followed *London Life* into oblivion, and then *Topic*. Even the specialist magazines had their scary moments, when the pulse fluttered and a bad cold threatened to develop into terminal pneumonia, but their loyal and well-defined markets generally pulled them through. The colour supplements survived because they had managed to establish themselves as an integral part of the national press and as much a part of Sunday as washing the Cortina.

But they have changed. They use photography less and they use it less well. The *Sunday Times Colour Supplement* for 2 August 1964, for instance, was a fairly slim magazine, but the balance of editorial material to advertising was 70% to 30%, and on the editorial pages, the ratio of photography to text was about two to one

extent the creation of three young men, all from the East End. These are the fashion photographers Brian Duffy, Terence Donovan, David Bailey. Between them they make more than £100000 a year and they are usually accompanied by some of the most beautiful models in the

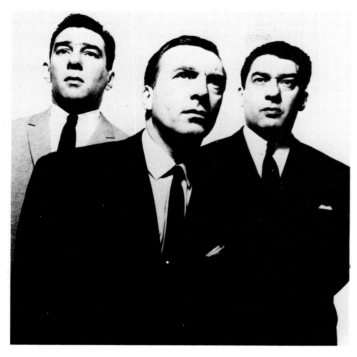

The Kray Brothers;
David Bailey 1963.

with nearly half the available space for pictures given to single shots filling an entire page. And colour photography outdid black and white, also by about two to one.

The issue of the same magazine on sale at the time of writing, 1 May 1983, is far thicker, but while editorial space has increased by only 50%, advertising has leapt up 650%, upending the previous balance to 37% editorial, 63% advertising. At the same time the ratio between pictures and text has fallen to about one to one, with black-and-white photography predominating. There was only one double-page spread.

Advertising has always been important to the colour supplements—they were actually created to give advertisers opportunities denied them by newsprint—but now it is almost out of control. Not only is the best photography often in the advertisements, the ads get the best space too. When it is possible to interrupt a four-page picture story

with twenty-three pages of advertising, something is wrong. As a good old sixties Dylan song says: 'Money doesn't talk: it swears'.

Ah yes, money. There have been a few changes in that direction too. In the early sixties, it was apparently possible to make quite a respectable living off magazine photography. It is possible now, too, but only just and only with the patronage of at least one art director. And it is not simply that there are more good photographers stampeding after a somewhat shrivelled market; it is as much because rates of pay for magazine photography in this country are a joke. While the rate for journalists has risen by about 300% in the past fifteen years, for photographers it has risen a mere 40%.

A few months previously, photographers had also featured prominently in a feature in the *Weekend Telegraph* by an American journalist on 'London–The Most Exciting City'. The journalist, John Crosby, had caught the bubble only

just in time though, for by the autumn of '65, the excitement was found to have evaporated when a vacuously glossy new magazine, *London Life*, was born with enormous pre-launch publicity paid for by the Thompson Corporation, only to keel over at once, stone dead from lack of solid nourishment. The exhibition at The Photographers' Gallery bypassed *London Life* although the names linked to it frequently crop up elsewhere in the show–Mark Boxer, of *Queen* and the *Sunday Times* magazine, Francis Wyndham, also of *Queen* and the *Sunday Times*, Brian Duffy who had freelanced regularly for *Queen*, *Town* and the *Sunday Times*, and the model Jean Shrimpton. Perhaps the oversight was fortunate since it must be an episode they would prefer to forget. Its failure was the failure of the sixties' dream.

The mood was changing. The world was turning serious again, serious, uncertain and introspective. In February 1965 America grew impatient with its problems in Vietnam and began bombing the north; in April Larry Burrows' photo-story on a disastrous helicopter mission, Yankee Papa 13, appeared in *Life*; Peter Watkin's TV documentary 'The War Game' was banned from the small screen but still managed to terrify cinema audiences all over the country. In Chicago the hot summer became hotter still as the negro suburbs of Watts was gutted in a series of riots that almost turned into a civil war between black militants and the National Guard. In Britain everyone said it could never happen here, but many kept their fingers crossed as they did so.

And at the very beginning of that year, on 24 January, Winston Churchill had died. The event was mourned as the end of an era; in fact the era in which men like him were

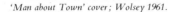

'Man about Town' cover; Wolsey 1961.

'The Sunday Times Colour Magazine' cover; Robert Freeman 1964.

allowed to be great had been over for years, but the funeral brought on a mood of self-examination the British had not experienced for some time.

And of course the international news coverage of the funeral was massive. Newspapers printed special editions and *Life* magazine chartered a DC-8 to carry its huge editing team, forty journalists, designers and editors, complete with typewriters, telex and a colour processing suite, across the Atlantic at top speed so that the whole story would be ready to go to press the moment the plane touched down in New York. It cost a fortune and was a complete waste. Even though *Life* increased their usual run of 7 million copies to 65 million for that issue, the

numbers were still paltry compared to the estimated television audience of 350 million. If Churchill's death marked a change in the mood of the British people, his funeral was a turning point in the coverage of major news events. From then on television would always take precedence.

It is easy to be fooled by the myth of the sixties; the New Aristocracy, as the characters that spilled out of Bailey's *Box of Pin Ups* came to be called, did a fine job of convincing themselves and us of their world of 'quick fame, quick money, quick sex' and it is too late for them to start denying it all now. But even if the photograhpers of the early sixties did change the image of their profession from a rather anonymous

calling to do with unwieldly wooden boxes, murky chemicals and brown overcoats to one of impulsive creativity, light, fun and sports shirts and sneakers, it didn't happen easily or even particularly quickly. The ones who made it did so because they worked long and hard at anything and everything, every job treated with the same professionalism, and if they did lead conspicuously glamorous lives, they also invested an inordinate amount of time, energy and money in their work.

And they could justifiably believe that the mass circulation magazine was the best place for the best photography.

So was it all a dream? Was that era

no more than a burst of adolescent enthusiasm before society (and photography) settled back into cautious conventionalism? Well, you only have to look at the *Hunter Penrose Annual* for 1950 or watch a film like *Passport to Pimlico* (1949) to realise that in both cases we are practically a different species from the pre-55 British. But even so, less has changed than might have been expected; the Establishment has an extraordinary capacity to absorb its critics, to applaud them into collaboration. Angry young men have tended to complacency in their affluent middle age, and the New Aristocracy turned out to be not so unlike the old one. The obscene difference of wealth and power still trails behind democracy like a taunting spectre. If the talents and high profiles of photographers in the early sixties have created a public myth of photography as an effortlessly exciting, endlessly innovative career, the reality has fallen embarrassingly short in the seventies and eighties. The letter pages of the *BJP* are still dotted with sad reports on the bad pay, poor status and wretched treatment accorded to photographers; the professional associations remain huddled against the new technology and unionisation; the profession as a whole is scarred by pathetic jealousies and snobberies.

Against all that is the fact that photography has a prominence in all levels of culture that was unthinkable thirty years ago, that the sheer volume of available talent is staggering, that there are whole shops full of photographic books where previously there were none, that there are now 35 fulltime photographic courses where in 1955 there were seven. The fact also that all of this is turning a large number of photographers away from editorial work into an introverted but not always very profound fine art is as much the fault of magazine publishers

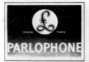

Beatles record cover; Bob Freeman.

as of anyone. After all, The Photographers' Gallery started up in 1971 precisely because so many photographers were dissatisfied with the way their work was being used.

We are now a generation away from the photographers and editors and art directors who made the medium so special and so powerful in the late fifties and early sixties and who have determined the style of fashion and editorial photography every since. Today there is a new generation of photographers and designers in training or working as assistants who were being born as the sixties boom was dying. Boom times may never come

again but if this exhibition can convince the future that a mass circulation magazine does not have to look like it has been designed by the Finance Director and that a photographer with something to say is better off saying it to a million people on a printed page than to a few hundred via a glass-fronted 11 × 14in bromide, then 'British Photography 1955-1965' has succeeded.

AFAEP ON THE WALL

Kim Saunders

THIS showcasing of nineteen contemporary photographers, currently operating professionally, largely within the fields of advertising and editorial work, arose from a joint venture organised between the Association of Fashion, Advertising and Editorial Photographers (AFAEP) and Kodak, which in turn resulted in an exhibition in Spring 1983 at the latter's former High Holborn gallery. Equivocally, the show was named 'Infocus'.

Kodak assumed responsibility for the organisation and reproduction of the display—complete with thoroughly tasteless piped 'elevator' music, as I think it would be described in the States. On the other hand, the reproduction from a submission of—almost exclusively—transparencies was executed to a very high standard.

Three reproduction methods were used, first the conventional interneg method with subsequent printing in the normal way, second by printing transparencies directly onto Ektachrome 14 reversal paper, or finally by using large sheets of duplicating film so that the end result took the form of transilluminated transparencies.

Before delving into AFAEP's role in the organisation and adjudication of the show, a brief resumé of their origin and basic function would be in order.

The Association of Fashion, Advertising and Editorial Photographers on show in London

Unlike the modelling profession, photographers have been, and probably always will be, fairly insular and independent, which makes agreement on any widespread or significant issue fairly difficult. This is typified by the recent wranglings concerning copyright.

It was in the late 60s that the discontent between photographers and model agencies came to a head regarding, primarily, fees and their payment. To buffer the situation, a group of photographers involved directly with the agencies got together to form The Association of Fashion Photographers. Later, but separately, Advertising and Editorial were added to the title as the scope of the association, together with the specialities of its members, expanded.

Besides acting as a stabilising force the association provides a means of communication between members, both via formal and informal gatherings. Nevertheless, AFAEP is primarily a non-profit-making, working body acting not only on behalf of photographers but assistants and other associated professions such as styling and model making.

Subscriptions are not cheap, especially if you're interested in the letters after your name, because, when all is said and done, you don't get any.

A formal request for entries for the exhibition was made through the *Image*, AFAEP's house journal, and combined with a bit of surreptitious needling of specific members, 55 sets of four prints were made available for judging. Although the brief was open, there had to be a common denominator between the four prints from each entry. In most cases, the subject matter itself was used as the common point either as a campaign series, or simply by its photographic treatment. The brief did allow for the submission of both commissioned and non-commissioned work, although as things turned out the latter was in the minority.

While the exhibition undoubtedly proved a forum and showcase for the photographers concerned, it is really the professional commissions to which the public can best relate—and appreciate having seen and reacted to earlier in the media. This is particularly the case where personal work deviates considerably in style from that for which the photographer is generally known.

The competition was judged by creative directors from two large London advertising agencies, together with an art director from *Good Housekeeping* magazine and two practising AFAEP members.

The exhibition will of course have been and gone by the date of publication, but nevertheless gave a means of getting a foot in the door and having a chat with some of the finest photographers in the world. All the photographs accompanying this article were taken by winning entrants of the competition. Where possible all the pictures have been reproduced in the same proportions as the actual adverts complete with copyline.

Unfortunately, I was unable to get around to visiting more than a handful of the final nineteen photographers–night shoots, location work–you name it. However, top marks must go to the lady I spoke to at Adrian Flowers studio, though I'm not quite sure, or possibly too polite to say, what for. 'Which magazine did you say? No, I don't think he'd be interested in doing an interview, thank you.' And that was after consultation from the couch. Thank you Adrian.

Maybe word was out on how bad I was at interviews; no, must be positive. A phone call to John Claridge was fruitful and a meeting was set up–avoiding a weekend location shoot.

Just in case you've ever listened to Ronnie Scott introducing golden greats between games of chess at midnight, spare a thought for John upstairs who may well be packing gear for a location shot the following day. It brings new dimensions to 'Upstairs at Ronnies'.

The first thing I noticed in the studio–besides John's agent Janet with welcoming glass of wine–was the bristling Cleos, *D & AD* and *Campaign* awards which covered just about every

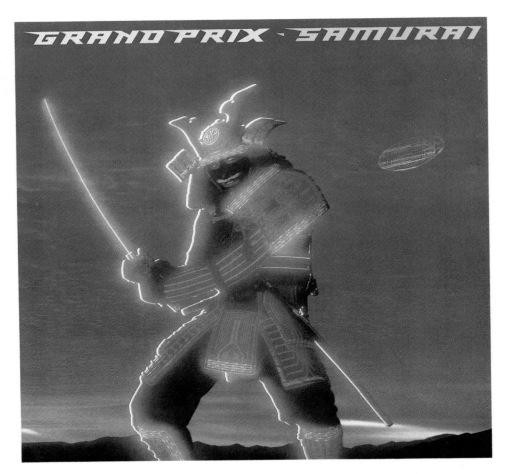

available space. Everything was incredibly neat, which I suppose can in part be explained by the fact that about 95% of John's work is carried out on location. A backup in the form of two producers–one in New York, the other in Los Angeles–usually ensures between four and six months' work in the United States each year, notably the British Airways adverts currently running as 48 sheet posters.

Like several other photographers in the AFAEP competition, John has a Benson and Hedges advert to his credit–the desert scene with the 'Freehold land for sale' sign.

Along with the Shell valley, Citroën forms part of the work photographed on location in Britain–Scotland to be precise. Actually, Citroën is rather an

extreme example of John's idea of working with a concept rather than a brief, whereby the eventual result may not adhere exactly to the brief after a series of co-ordinated changes. In this case one shot was actually taken when searching for a location for another. As he says, open briefs don't worry him.

In answer to the question whether he ever used large format cameras, John replied 'Yes, occasionally I use 6×7, but it's generally 35mm.' When Polaroid became available for 35mm it was quite a boon especially with John's individual lighting styles. And before that? 'Well, I just prayed a little' he said; modest, too.

John has also worked on the Perrier account, like John Turner whose work we will be looking at later. In fact

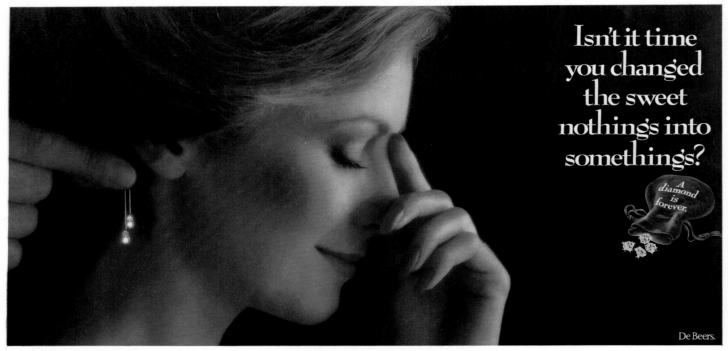

Isn't it time you changed the sweet nothings into somethings?

A diamond is forever.

De Beers.

Photographer: **Sanders Nicholson**; *Client: De Beers; Agency: Doyle Dane Bernbach Ltd; Art Director: Max Henry.*

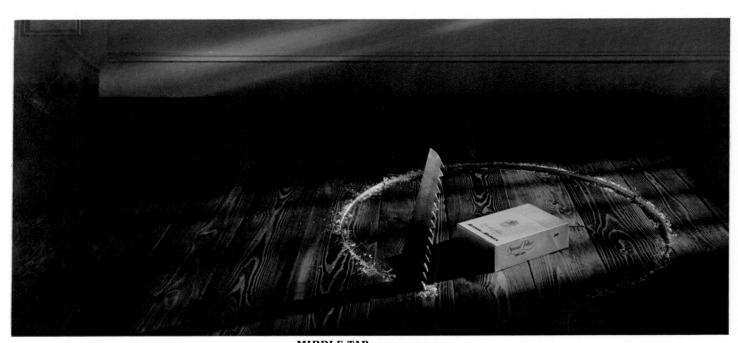

MIDDLE TAR As defined by H.M. Government
DANGER: H. M. Government Health Departments' WARNING: THINK ABOUT THE HEALTH RISKS BEFORE SMOKING

Photographer: **Mick Dean**; *Client: Benson and Hedges; Agency: Collett Dickenson Pearce; Art Director: Nigel Rose.*

A little present to bring back the past.

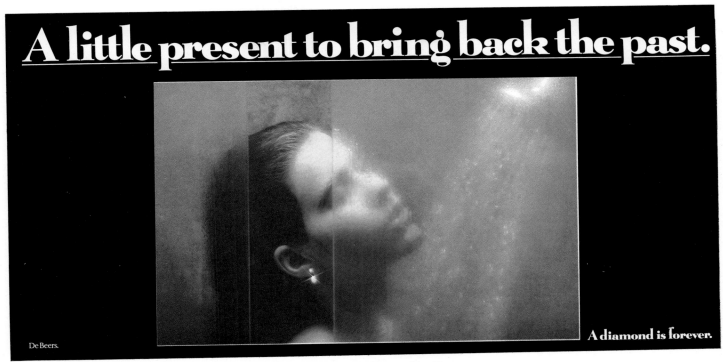

De Beers.

A diamond is forever.

Photographer: **John Turner**; Client: De Beers; Agency: Doyle Dane Bernbach Ltd; Art Director: Max Henry.

Legs as soft and smooth as the day you were born.

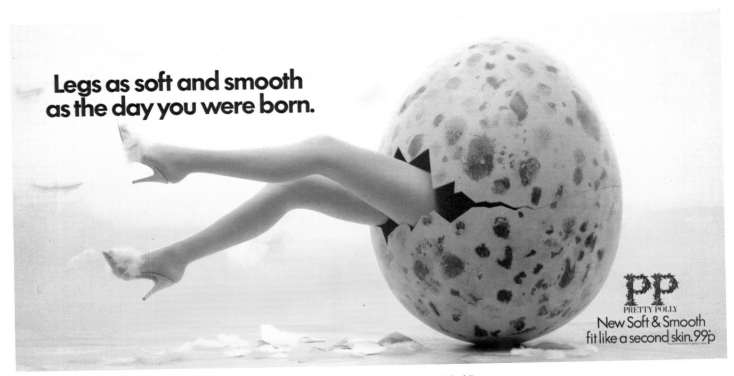

PP
PRETTY POLLY
New Soft & Smooth
fit like a second skin. 99p

Photographer: **Barney Edwards**; Client: Pretty Polly; Agency: Collett Dickenson Pearce; Art Director: Nigel Rose.

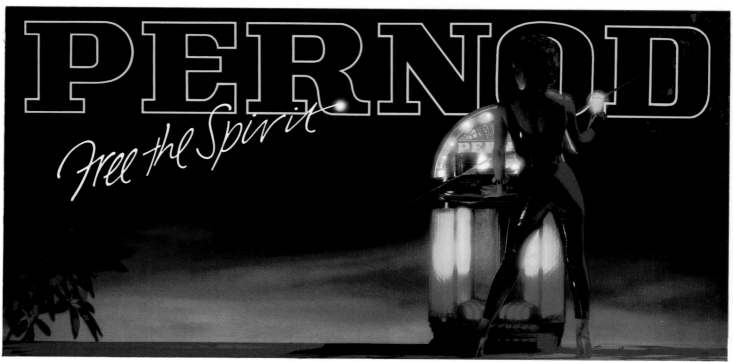

Photographer: **Phil Jude**; *Client: Pernod; Agency: D'Arcy McManus Masius; Art Director: Stuart Horrod.*

Photographer: **John Claridge**; *Client: British Airways; Agency: Saatchi and Saatchi;*
Art Director: Graham Cornthwaite.

Photographer: **Graham Ford**; *Client: Wharfedale Loudspeakers; Agency: Saatchi and Saatchi;*
Art Director: Digby Atkinson.

I attributed Turner's 'Picasseau' to John Claridge which went down like a lead balloon with John Turner—although his correction was polite, as ever.

Claridge's submission for the AFAEP exhibition consisted of four location shots for Rolls Royce lit to produce some quite amazing colours. In fact, it was the prominent use of colour in his commercial folio which prompted the question as to how much black and white he used. It turned out that he does a substantial amount of black-and-white printing of his own work, but generally the end product is used in exhibitions rather than commercially, although a degree of cross fertilisation is inevitable.

The one Helmut Newton-style black-and-white shot in his folio for T. Richard Johnson turned out to have been taken on a £7.95 plastic camera using two rolls of film, indicating that you don't need expensive equipment to take good pictures. John said it sounded like a challenge; well, art director John Timney certainly wasn't taking any chances with the photographer.

My meeting with Barney Edwards put me in the privileged position of seeing part of his vast personal folio and briefly discussing some of his work.

Combining a daylight studio with his home just off the New Kings Road, the business area is anything but workroom-like, with the floor polished to a mirror finish and all the homely comforts an art director could expect.

As with most photographers in advertising, the majority of Barney's commissioned work is in colour although he does spend a considerable amount of time in the darkroom producing work for his personal folio—a huge stack of drawers full of a variety of work more than justifying

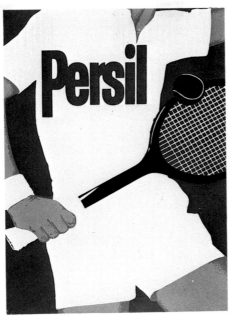

Photographer: **David Fairman**; *Client: Persil; Agency: J. Walter Thompson; Art Director: Anne Carlton.*

his ten years in the business. I should add that Barney has recently appeared in the *Campaign* awards with mentions for both colour and black-and-white work, and that throughout his career he has had over fifty mentions in *D & AD*.

His colour commissions tend to be completely different from the majority of his personal work, and though it sounds corny, frequently emulate a painted image. Examples of his 48-sheet posters currently running are the eggs and legs for Pretty Polly, and the Benson and Hedges hour-glass.

I had seen part of Mick Dean's folio before our meeting at his studio, since about a year earlier I had attended one of the lectures which he gives on a part-time basis at his old college, the London College of Printing.

It was while studying at college that he met Stak (Guinness toucan, Nat West goose with golden egg) with

whom he later went into partnership, before they each went their own independent ways.

Anyway, I led with an ace by knocking on the wrong door and had to phone up to see why he wasn't at No 1 Duncan Terrace. The reply was because he didn't live there. I was on the doorstep of the correct house making my apologies before my red face had died down.

I was expecting to find table-tops everywhere, but in fact he denied any responsibility for the Table Props Hire side of the business, which he said was exclusively his wife's problem—I hope she charges him the going rate.

Approximately 90% of Mick's work is done in the studio, with—as usual—most being in colour, and despite his academic photographic background he showed no desperate pangs to rush into the darkroom and reel out a few prints as frequently seems to be the case.

Probably his most famous account is Gordon's gin, closely followed by what he describes as 'the fag packet'—the Benson and Hedges box and saw. Food is also his speciality with notable accounts including Danish Bacon and Tesco—the latter being in the throes of preparation in the well-equipped studio kitchen when I arrived.

I visited John Turner at his Lancaster Gate studio where he has been based for quite a number of years now, and recently negotiated a further nine-year lease. It was the welcome extension which prompted him to have the whole studio redesigned, so I was rather lucky to get hold of him at all as he was going to be 'on location' for at least six weeks during the building. Unfortunately it never seems to work that way.

John only became seriously involved with AFAEP on a chance meeting with Tina Stapley, the general

secretary, at a social meeting. He had commented on the lack of heavyweight professionals involved in the association at committee level – the sort of comment often voiced at a safe distance. Well, Tina wasn't going to miss the opportunity, and so John was signed up virtually immediately.

'Politics will always be a tricky business in this and any other organisation,' he commented, 'but the only way to change people to other methods of operating is by active involvement, and that is what I am trying to do.' He did, however, confess that on one occasion he totally forgot about one meeting and went to the Derby instead. He did promise to send his winnings towards AFAEP's proposed new freehold offices.

His submission for the Infocus exhibition was rather novel in that the link between the four pictures was that each involved model making. The other interesting aspect was that the quality of both the photography and model making was such that unless you were aware of the fact, you would assume that the shots were authentic.

One shot for Pioneer of a haystack with a thirty-foot needle piercing it has been something of a bone of contention for John; everyone thinks it was stripped in. As explained by John, the same degree of smoothness on the needle wouldn't have been possible, and so the build was essential. At the time of the shoot, having specially built the haystack and positioned the two ends of the model needle, he was rather put out when a local walked through the field, nonchanantly strolling past the monstrosity as if he had seen three others that morning.

While John accepts retouching as an essential part of the photographic process, wherever possible he does try to shoot in situ. The needle problem was decided upon after a rather heavy drinking session, whereupon John put the idea to the art director. 'Oh yeah, wow a 30ft needle, great,' but the next day a phone call came just to confirm: 'I suppose you were serious about the needle?'

One instance where he did have to submit to 'retouching was for a series of adverts for Honda cars, where each shot was created as a composite of three separate transparencies, and as a series represent what I would consider to be some of the best examples of car photography around.

It would seem that these multiple image techniques are all taken in his stride both with cars on location and with multiple exposures in the studio. Nevertheless, he said that he had often spent hours calculating perspectives for shots to be stripped together, and more often than not ended up doing it by eye.

With a wife and two children, John tries to keep weekends to himself, although he invariably ends up working late nights. Apparently, on a number of occasions he has become so involved with shots that he actually forgets what stage he's got to and has to wait for the tests to come back from the laboratory. That should make the art directors nervous!

Phil Jude was a photographer I was particularly keen to see, having produced a very stylised and eye-catching series of photographs for the exhibition. Unfortunately, it was impossible by a matter of hours due to a

week's location work.

Unlike many products of 'high tech' effects under the duplicating enlarger, Phil controls the entire process with the use of multiple exposure techniques in the camera. He works mainly with tungsten light for the control and a 10 × 8 Deardorf camera – or one of those funny old wooden things as John Turner refers to them.

One of my personal favourite pictures of 1983 is Phil's Pernod advert ('Free the spirit') featuring a girl standing in front of an old style juke box. He has also produced a number of adverts for the Löwenbrau Pils campaign, which would have provided an interesting contrast with Graham Ford's submission of work from the Holsten Pils campaign.

The latter is a tremendously well respected photographer in advertising circles, with a list of prestigious accounts as long as your arm, many of which in my opinion would have done him more justice than the series exhibited.

I can only offer my sincere apologies to Bryce Attwell, Nic Barlow, Tim Brown, Dale Durfee, David Fairman, Sanders Nicolson, Bob Porter, Dave Sherwin, Malcolm Warrington, James Wedge, Reg Wilkins and Chris Alan Wilton for short-changing them on coverage, and hope that in future the advertising media will provide a suitable medium for displaying their talents.

It would also be nice to see a more realistic sponsorship from companies actively involved in the fields of professional photography on a practical day-to-day basis.

PICTURE SECTION

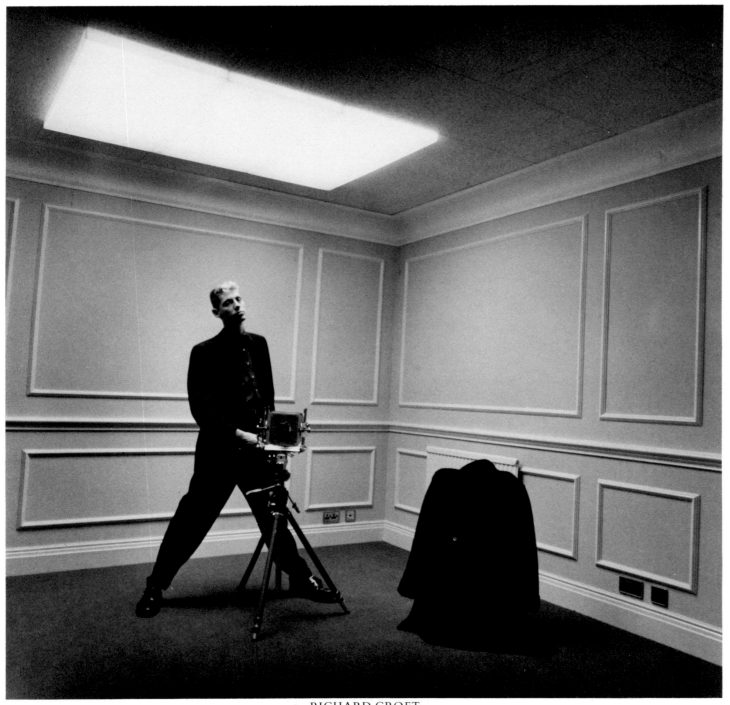

RICHARD CROFT
Nick with camera

THE PHOTOGRAPHERS

ROGER ARGUILE
Having done Fine Art at Exeter College of Art and Reading University, Roger Arguile started teaching whilst continuing his photographic skills and exhibiting still and film work in the UK, North America and Scandinavia. At present, he is the Artist and Residential Social Worker at a special school in Bexhill-on-Sea, East Sussex.

DAVID BANKS
David Banks studied at West Surrey College of Art and is now working as a freelance photographer. The photograph here is one of a series of commissioned portraits of architects.

ED BARBER
Ed Barber is a freelance photojournalist and writer, and is extensively covering the peace movement in Britain. He is also involved in the editing, writing and production of *Ten-8* photographic magazine.

ROBIN BATH
While publishing his freelance travel photography widely, Robin Bath teaches photography at the Central School of Art. He himself was a student to the USA and Mexico where he settled for five years before returning to England in 1975.

ROBYN BEECHE
Born in Australia, Robyn Beeche originally trained as a secretary and worked as such for eight years. After a European tour in 1967 and on her return to Sydney in 1971, she trained and worked as an assistant with Grant Mudford. She came back to England in 1973 assisting Harri Peccinotti for 3 years. Since then, she has freelanced in Fashion and Beauty, Advertising and Travel photography. Clients include Zandra Rhodes, Vidal Sassoon, Caroline Charles and Harrods.

MICHAEL BEDDINGTON
The work of Michael Beddington has been exhibited and published in England, France and America. His main influences have been the visual arts–in particular the impressionist painters and the way in which they saw and used light–music, and through Taoism to Zen. Beddington uses the zone system to give the degree of control that his work requires.

STEVE BENBOW
Steve Benbow originally trained as a lecturer in Physical Education, but became interested in photography and completed the Documentary course at Newport, Gwent. He has been a member of Network Agency from its beginning up to this year. He now works mainly as a freelance magazine photographer through Colorific Agency.

DOMINIQUE BONNET
French born Dominique Bonnet became interested in photography whilst very young, and later attended the Ecole des Beaux Arts in Poitiers. Currently in London completing his National Service, Bonnet hopes to make a photographic world tour next year selling his work from Rome on his return to Europe.

MARILYN BRIDGES
Born in New Jersey, Marilyn Bridges studied at the Rochester Institute of Technology in Rochester, New York. She specialises in aerial photography and looks at the landscape as a canvas for the arts, namely ancient and contemporary earth art consciously or unconsciously drawn on the earth, and architecture as a medium of design. Her work has been published and exhibited widely in America and is in several public collections.

TINA CARR
Tina Carr is an established freelance photographer whose main concerns are landscape and people. These photographs are from a landscape project which won a 1981 Kodak Bursary. Tina is currently working on the book of the project and was awarded a GLAA grant in 1983.

JONATHAN CLARK
Jonathan Clark has done a wide range of freelance commercial design and photographic work since leaving Middlesex Polytechnic with a degree in Graphic Design in 1981.

DOUGLAS CORRANCE
Born in Falkirk, Scotland, Douglas Corrance started as a junior photographer on a local newspaper in the Scottish Highlands. He has worked in commercial and advertising photography in London and Sydney. He is at present staff photographer with the Scottish Tourist Board.

GERRY CRANHAM
Gerry Cranham has been a professional sports photographer for the last 26 years. He is a Fellow of the Royal Photographic Society.

DAVID CRISP
David Crisp started working as an assistant and later as a photographer at the Fire Research Station in 1972. A part-time student at Harrow, David Crisp went on to employment as a photographic technician at Watford College until 1978 and returned as a Technical Assistant at Harrow from 1978-82. He is now a freelancer.

RICHARD CROFT
Currently a London freelancer, Richard Croft studied photography at Bournemouth and Poole College of Art.

MICHELE DEARBORN-GOLDBERG
The Backstage series began in 1979 with a local San Francisco-based dance company, which Michele Dearborn-Goldberg expanded to theatre and opera in an ever widening circle of cities, until it became a world-wide project. Can-Can legs was the only opportunity she has had to use natural daylight backstage: 'Someone opened a back door while dancer Loren Dearborn was adjusting her tights and there were those glowing hands . . .'

MELCHIOR DIGIACOMO
A photographer for ABC-TV, *Newsweek*, various sports journals and advertising agencies, Melchior Digiacomo describes himself as a Documentarian. He lives in New Jersey.

DIANA EAST
Diana East lives in the Forest of Dean, emerging from its isolation and trees to undertake photographic expeditions abroad.

ORDE ELIASON
Born in South Africa, Orde Eliason is now settled in England. He studied photography at Birmingham Polytechnic completing a Diploma in 1980, and a Master's Degree in 1981. He is a self-employed freelance photographer concentrating mainly on photojournalism and documentary work. His photographs are published regularly in British and European newspapers and journals.

BARRY FRYDLENDER
A self-taught photographer living and working in Tel Aviv, Barry Frydlender is an established commercial photographer. However, in his personal work his subjects are the unusual personalities and characters of the city. His work has been on show recently in London and is in a number of private and public collections.

MALCOLM GLOVER
Having qualified from Newport College of Art, Malcolm Glover won a Welsh Arts Council Grant to photograph slate miners in 1981. In 1982 he was Rochdale's Photographer in Residence, an appointment which culminated in a one-man show, 'Face to the East in the North' from which this photograph comes. He is at present back photographing in North Wales.

JUDY GOLDHILL
Judy Goldhill is a freelance photographer.

DAVID GOWERS
A senior photographer at the British Museum, David Gowers trained at Gloucester College of Art. This photograph is from a personal project on the English Coastline.

TOM GRACE
Presently working as a part-time lecturer in Photography at Dublin's College of Marketing and Design, Tom Grace has also freelanced as a photographer since graduating in 1977 from the National College of Art and Design, Dublin. He has exhibited regularly in group shows throughout Ireland, Great Britain and the USA.

ADRIAN FORD
With a Fine Art degree from the Central School of Art, Adrian Ford went on to an MA at the Royal College of Art. In 1980 he received a bursary from Southern Arts and

commenced a photographic study of craftsmen and women in Hampshire. Not interested in the 'arty-crafty' side, nor in making a step-by-step guide to Macrame or corn dolly making, Ford concentrated on people who were totally engrossed in their work and making a living at it.

ANDREW GRAY
Aged 22, Andrew Gray left school at 16 and started training as a commercial artist. After a year he left to join John Hatley & Partners, working three years in their photographic department. He is presently with BAF Graphics, but hopes to work more in theatre photography.

PHILIP GREY
Philip Grey is a young student studying 'Photographic Arts' at the Polytechnic of Central London.

VAUGHAN GRYLLS
Vaughan Grylls, born in Nottinghamshire, studied at Nottingham and Wolverhampton Colleges of Art in the mid-'60s and at the Slade School of Fine Art, University College of London from 1968-70. This work is from a large exhibition currently touring Britain entitled 'Views of our Time'. Grylls' photographs are included in British and American Public Collections.

SUNIL GUPTA
Born in New Delhi, Sunil Gupta migrated to Montreal in 1969. He has recently graduated with an MA from the Royal College of Art, after studying in New York and at West Surrey College of Art and Design. For his MA, Gupta returned for the first time to India and made a photographic study entitled Tilonia, focusing on the people and their impoverished life-style.

IVAN HAGGAR
With financial assistance from West Midlands Arts, Ivan Haggar is undertaking a landscape project this summer. He studied photography at Bournemouth and Poole College of Art, and exhibits his work regularly in Britain.

BRIAN HARRIS
Born in London in 1952, Brian Harris worked for local newspapers and press agencies before moving to The Times where he has worked for the past six years. He argues for honesty and not contrivance in newspaper photography.

FRANK HERRMANN
After three years' Photography at Art Achool, Frank Herrmann spent two years as a photographer with the RAF on National Service. In 1982 he became a staff photographer with the Sunday Times.

STEVE HICKEY
After studying photography at Birmingham Polytechnic, Steve Hickey moved to London in 1975 where he worked in various studios before becoming a freelancer.

ALAN HILLYER
Alan Hillyer is presently working in Saudi Arabia where he teaches maths and physics. Recent projects include commercial photography for companies in the Kingdom, and a special portfolio of people, scientists, poets and authors, whom the photographer admires.

MIKE HOLLIST
Mike Hollist has been a staff photographer on the Daily Mail for twenty years. He started out with the Lincolnshire Echo (8 years), three years with an agency in Doncaster and a period on the Mail in Manchester.

BOB IRONS
Born 1949, Bob Irons studied photography at the Polytechnic of Central London in the early '70s. He is now a freelancer, teaching part-time at Barnfield College, Luton and Watford College.

DAFYDD JONES
A prizewinner in the Nikon/Sunday Times photographic competition in 1981, Dafydd Jones works for The Tatler and freelances for a variety of magazines and newspapers.

NICK KNIGHT
Nick Knight studied photography at Bournemouth and Poole College of Art and is now freelancing in London.

LINTON LOWE
Working mostly with film and theatre companies in South Wales, Linton Lowe is a freelance photographer. He studied Documentary Photography at Newport College of Art, finishing in 1981.

DAVID LUCKHURST
Currently studying at Bournemouth, David Luckhurst is at present producing a folio on the Salvation Army and other religious sects and denominations. The photograph included here is from a series 'Young People in Organisations'.

ANNA LYSTRUP
Born in 1953, Anna Lystrup took Honours and Masters Degrees in visual communication. Her press work is published regularly in London.

MATT MEHRA
Having originally studied Art and taken up photography as a hobby, Matt Mehra is largely self-taught. He is mainly a fashion and beauty photographer but also covers travel and the photo-essay.

SUSAN MEISELAS
Susan Meiselas is a member of Magnum Photographic Agency and winner of the Capa award for her work in Nicaragua. She started as a documentary photographer and teacher in America and came almost by accident to be one of the world's foremost photojournalists.

NEIL MENNEER
Neil Menneer gained a distinction from West Surrey College of Art and Design in 1976,

and went on to a joint Honours Degree in English and Art History at Nottingham University. Since 1979 he has been freelancing for The Observer, The Sunday Express, Sunday Telegraph and other publications and companies.

DODIK MILLER
Dodik Miller is the son of a foreign correspondent. He became interested in photography at school which led to his first job as a photographer on a local newspaper in Hastings. On his own initiative at the age of 19, he travelled to the Moscow Olympics as a fully accredited British Press Photographer. This photograph is from his 'Olympics' series.

ALISTAIR MORRISON
Freelancing for the Sunday colour supplements, editorial magazines and in fashion work, Alistair Morrison trained in Photography, Film and Television at Harrow College of Art.

PETER MYERS
An established food photographer, Peter Myers works from a large studio in the City with a fully equipped kitchen. Myers works for Editorial and Advertising clients including Conde Nast, Marshall Cavendish, Octopus, McCann Erickson, and Wasey Cambell Ewert.

HANS NELEMAN
Living in London, but born in Holland in 1960, Hans Neleman has only recently finished his degree at the Polytechnic of Central London. However, he has already been offered many assignments in fashion advertising, food and editorial photography. This shot won him first prize in the Kodak Young Photographers Award 1982.

LAWRENCE NICOLLS
Lawrence Nicolls is a stills/cine cameraman for the MoD. He is also a freelance sports photographer, and until last year worked for an Advertising Agency in Covent Garden, undertaking additional freelance editorial work. He trained at North Essex School of Art.

CERI NORMAN
Ceri Norman is a freelance Editorial photographer with a Degree in Visual Communication from the London College of Printing.

RICHARD OLIVIER
Richard Olivier was born in South Africa and became a member of Xenon Photos, London in 1979. He is a Documentary photographer and prefers black and white for this work, but occasionally works in Public Relations and Commercial fields which may demand colour.

GWENDOLINE PATMORE
Since Gwendoline Patmore finished at Hornsey and Winchester Art Colleges in 1972 she has continued to take photographs. Part of a large collection taken on a two year journey through Africa and the Middle East, this

photograph was taken while passing through Afghanistan.

CAROLINE PENN
After taking a Geography Degree at Exeter University, Caroline Penn spent some time travelling through Europe and Africa and returned to attend a one week workshop with Paul Hill in Derbyshire helped by a Granada TV bursary. The following year Caroline Penn's concern for the problems of developing countries took her to the Sudan as a teacher where she used the opportunity to photograph people and their way of life.

SIMON POTTER
Born in 1955, Simon Potter assisted for three years before attending West Sussex College of Design, completing his degree in Photography in 1979. He is now a London freelancer, concentrating on portraiture.

ANDREW RANSHAW
Having become interested in photography as a camera shop assistant and photographic printer for three years, Andrew Ranshaw is at present studying Documentary Photography at Newport, Wales.

GLYN SATTERLEY
Born in Kent and with a Fine Art Degree from Ravensbourne College of Art, Glyn Satterley is now based in Edinburgh. He works as a freelance for several national magazines, newspapers and agencies including the British Tourist Authority. He is also busy with commissioned work for several books including *A Celtic Guide to Scotland*. These photographs are for a book documenting *Highland Sporting Estates*. His work has been exhibited throughout the UK.

MICHAEL SEABORNE
Michael Seaborne is the Curator of the Photographic Collection at the Museum of London. Since his appointment in 1979, he has been recording London's disappearing industrial environment in a project supported by Ilford Ltd since 1982.

PHIL SHELDON
Phil Sheldon is a freelance sports photographer. In 1981 he was the winner of the colour section of the Sports Photographer of the Year Competition for his portfolio, and received a Highly Commended for his entry to the Sports Picture of the Year. He specialises in golf pictures.

NICHOLAS SINCLAIR
Nicholas Sinclair is BBC Radio Brighton's Visual Arts and Film critic, and regularly exhibits his own photographic work. These pictures are from a touring exhibition entitled 'Circus'. Sinclair took a job as a circus musician, and travelled with them for some months to produce a series with unique qualities.

JOHN STATHATOS
Born in Athens in 1947, John Stathatos is a freelance now based in London. He has

recently exhibited in England, Greece and Belgium and had work published in various photographic magazines including the *BJP*. He has other exhibitions scheduled in London during 1984.

GEOFFREY STERN
A young self-taught photographer, Geoffrey Stern works for local London newspapers on a freelance basis. His involvement in skateboarding led to his earliest series of serious pictures, and his passion for soccer made him sneak on to pitches joining the ranks of professional photographers. This body of work gave him his first newspaper assignments. This photograph is from a series he took for a GLC competition with the theme 'Metropolis – Life in the City'.

DICK SCOTT STEWART
Dick Scott Stewart is a London based reportage photographer, specialising in industrial landscapes mostly for oil companies. He also takes what he calls the 'darker side' of society portraits.

HOLGER STUMPF
Holger Stumpf was born in Hamburg, Germany, where he still lives and works.

BERNHARD J. SUESS
Bernhard J. Suess is an American photographer living in Bethlehem, Pennsylvania.

BRIAN SUTTON
Brian Sutton is a self-taught, London based part-time freelancer. He has work published regularly in British books, magazines and newspapers.

JOHN R. J. TAYLOR
After studying illustration and photography at Dundee, John R. J. Taylor completed a Masters Degree in Photography at the RCA. He is a part-time lecturer at Watford College, Hertfordshire, and a freelancer.

DENIS THORPE
Denis Thorpe has been a staff photographer for the *Guardian* since 1974. In March this year 15 journalists were sent to Moscow for a week, with Thorpe providing photographs on a wide range of subjects for the reports which were to be published over a week in the *Guardian*. This picture is from a set of hundreds of prints on all aspects of Russian life.

JOHN TOMLINSON
A graduate of Glasgow School of Art, John Tomlinson now teaches there 24 years later. He freelances in Documentary work, and is concerned with the preservation of the countryside around the ever-growing city in his personal work. He likes to use infrared film, avoiding its more obvious effects.

YVONNE VAAR
Yvonne Vaar is a painter and cinematographer as well as a stills photographer. She lives in Toronto, Canada,

but travels extensively in Europe, and has exhibited her work in many countries round the world.

AL VANDENBERG
Al Vandenberg studied photography in New York with Brodavitch, Avedon and Bruce Davidson. His early work was done on the streets of depressing local neighbourhoods passing Diane Arbus and Garry Winogrand on the way. He exhibited at the Smithsonian Institute for the President's 'War on Poverty'. A later career in commercial, fashion, advertising, editorial and rock music photography, eventually brought Al Vandenberg to the Streets of London photographing those who enjoy being photographed.

RICHARD WAITE
Currently working on editorial and location photography, Richard Waite studied at Bournemouth and Poole College of Art from 1973-1976.

HOWARD WALKER
A staff photographer on *The Sunday Mirror* since 1974, Howard Walker spent his apprenticeship with press agencies and local newspapers in the North West, such as *The Bury Times*, and the *Bolton Evening News*. His work has been exhibited widely in this country and at the World Press Photo Exhibition in Holland.

JOHN S. WEBB
English born John S. Webb moved to Sweden in 1974. Freelancing at first, Webb became staff photographer of the Swedish photographic magazine *Aktuell Fotografi* in 1976. He now works two weeks of each month for 'Aktuell', which enables him to continue with freelance and personal work. In this, the Swedish Arts Council 'Konstnarsnamden' have helped with economic support.

JOHN ROBERT YOUNG
An established photojournalist, John Robert Young's work is mostly published in British editorial magazines. This photograph was from a photo-essay published in *She* magazine, on the rehabilitation of Falklands war wounded.

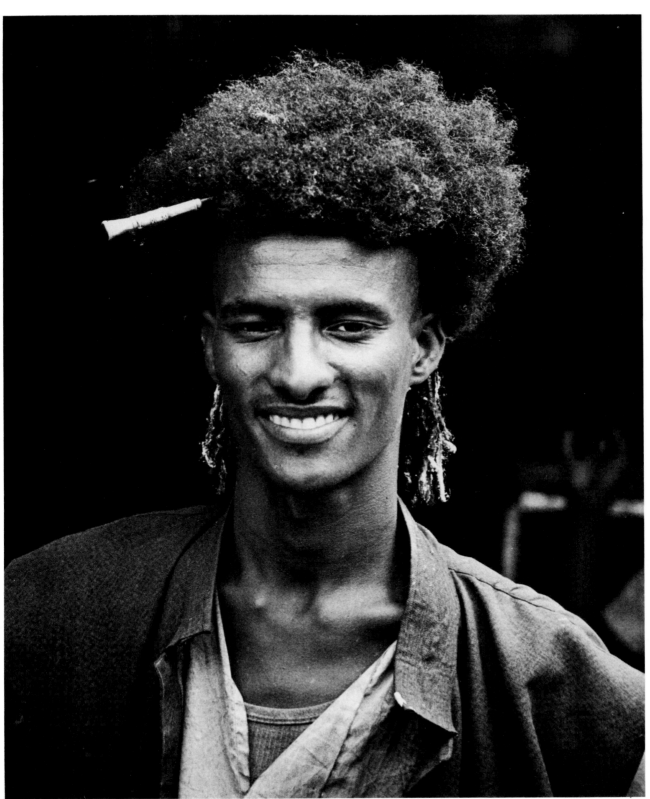

CAROLINE PENN
Hadendowa Man, Sudan

NARESH CHAUHAN
Untitled

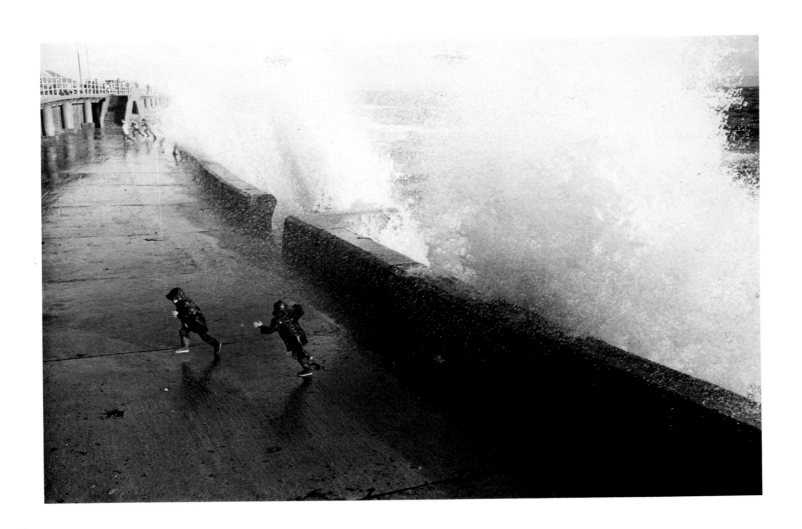

LINTON LOWE
High Tide at Porthcawl

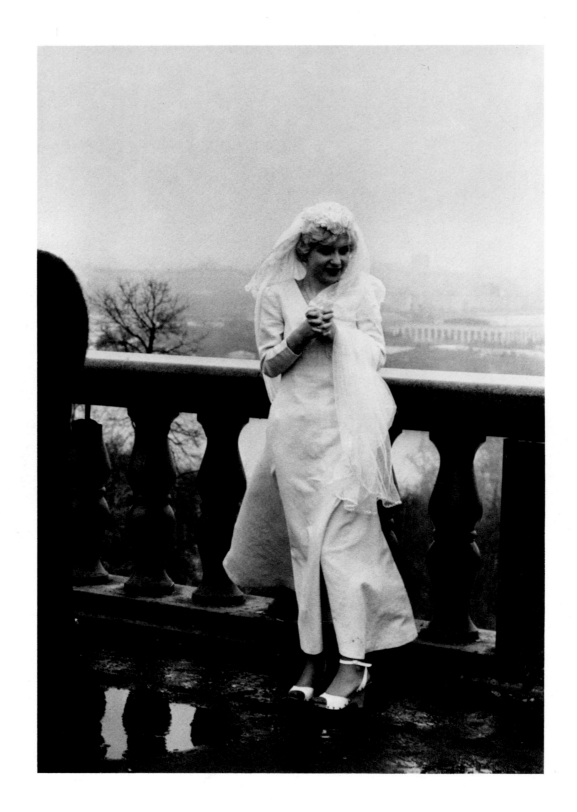

DENIS THORPE
Moscow Bride

JOHN TOMLINSON
Campsie Hill, Glasgow

TOM GRACE
Croagh Patrick (Holy Mountain, Co Mayo)

MALCOLM GLOVER
Praying, Blackburn

MICHAEL SEABORNE
Anchor Brewery, Tower Bridge, London

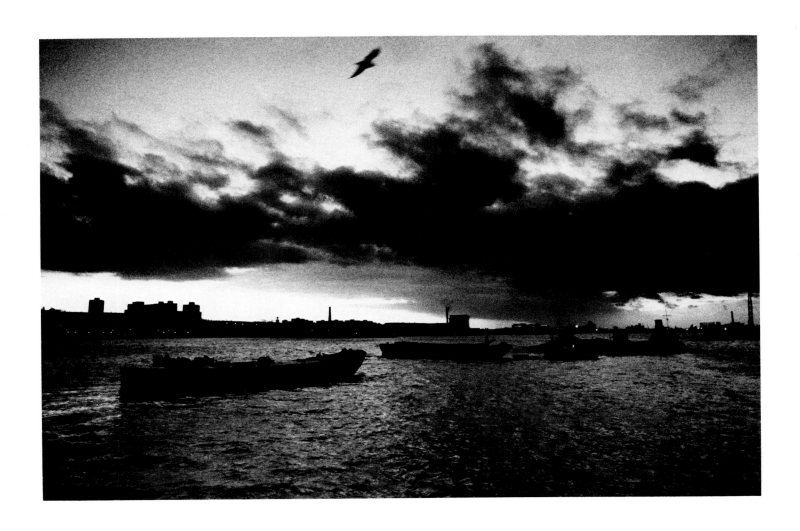

MICHAEL SEABORNE
Thames at Woolwich, London

AL VANDENBERG
The Kings Road, 1983
Covent Garden, 1983

ROBYN BEECHE
Painting by Numbers (Make-up by Phyllis Cohen)

ROBIN BATH
Formentara, Spain

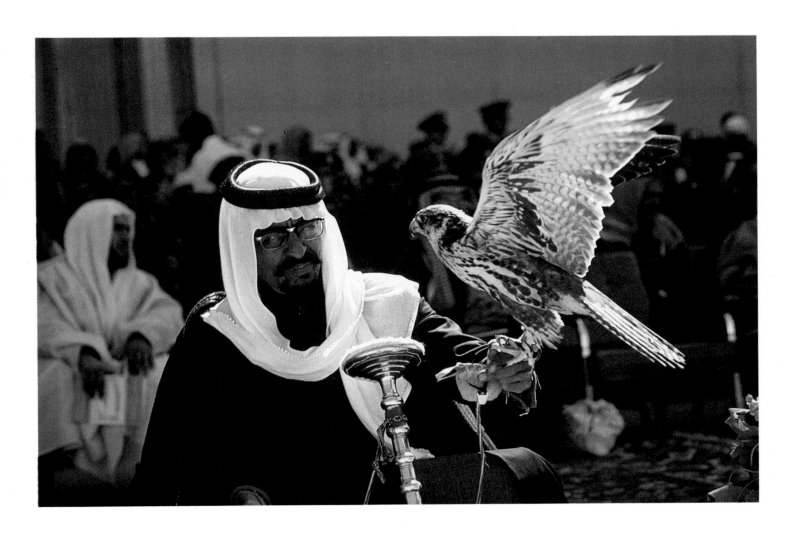

ALAN HILLYER
King's Hawk Master

KEVIN RYLAND
Cesena, Italy

JONATHAN CLARK
The Bowler

ANDREW RANSHAW
Harlequin Amateur Boxing Club, Newport, Gwent

CAROLINE PENN
Ingessana Feet, Sudan

CERI NORMAN
Polar Bear, London Zoo

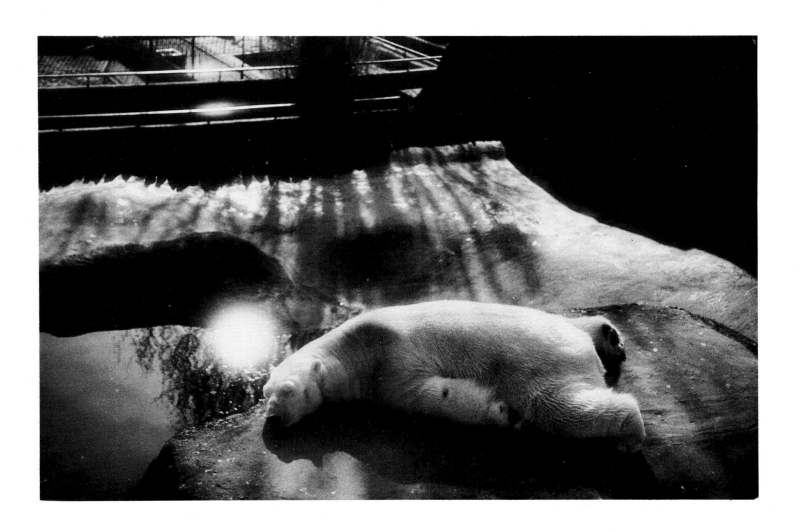

CERI NORMAN
Polar Bear, London Zoo

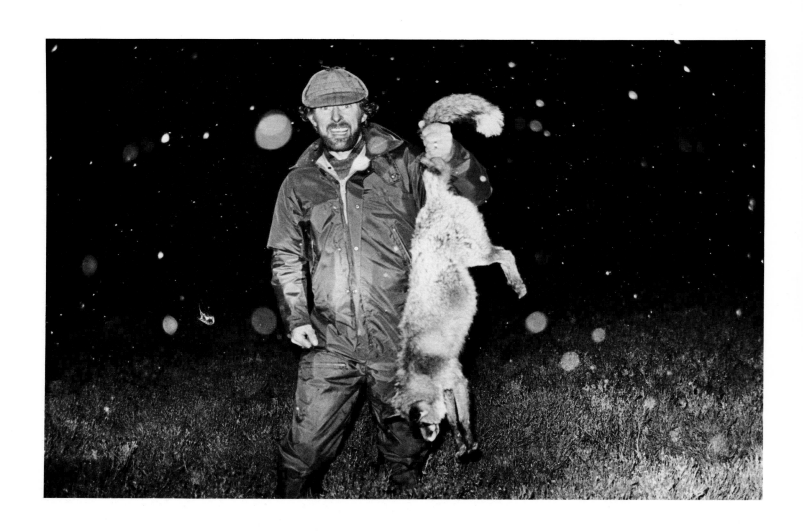

GLYN SATTERLEY
Midnight spring time foxing, Borrobol Estate, Sutherland

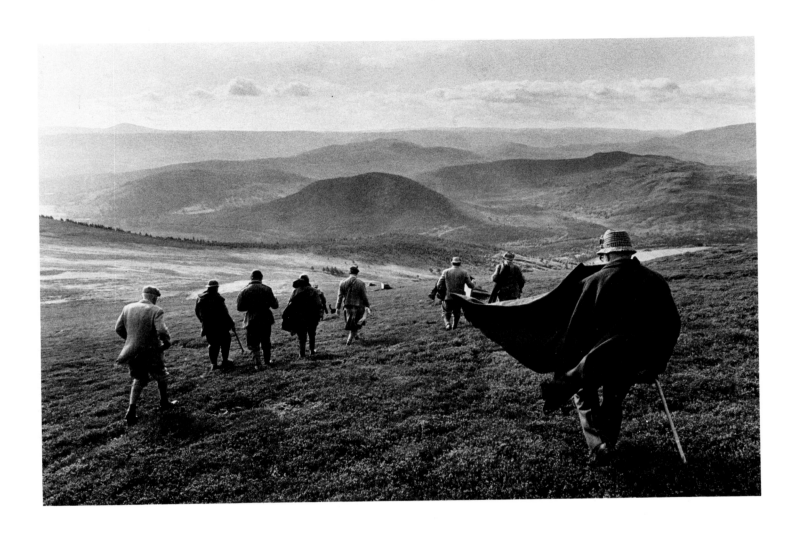

GLYN SATTERLEY
Going to the Hill, Invercauld Estate, Royal Deeside

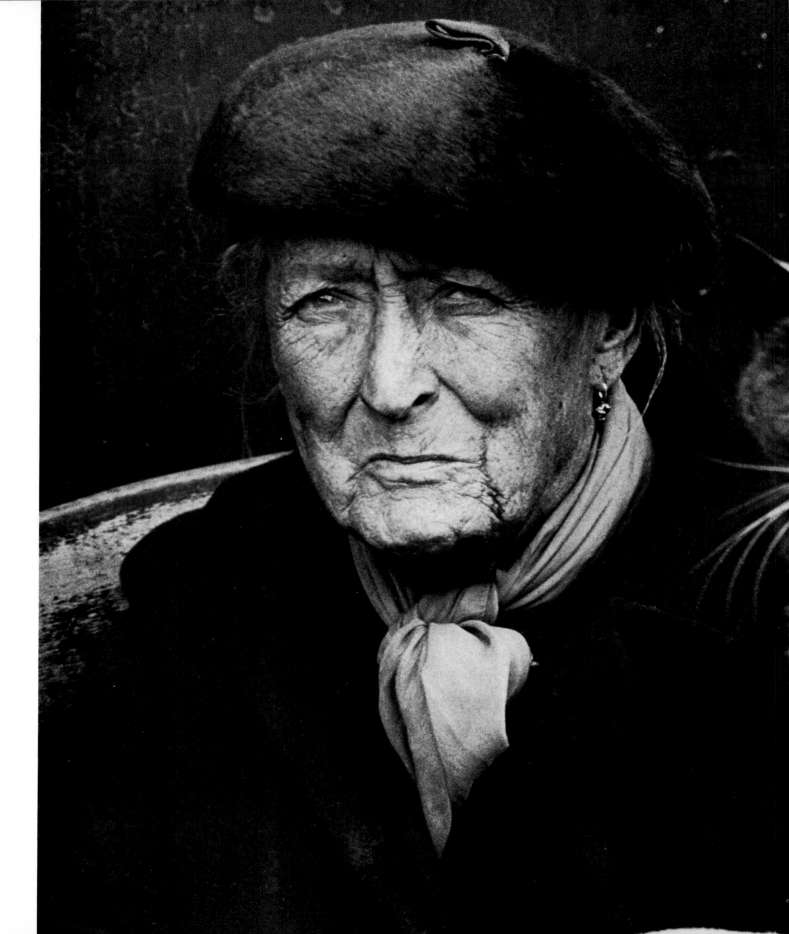

DOUGLAS CORRANCE
Madame Doubtfire
and one of her 20 cats,
Edinburgh

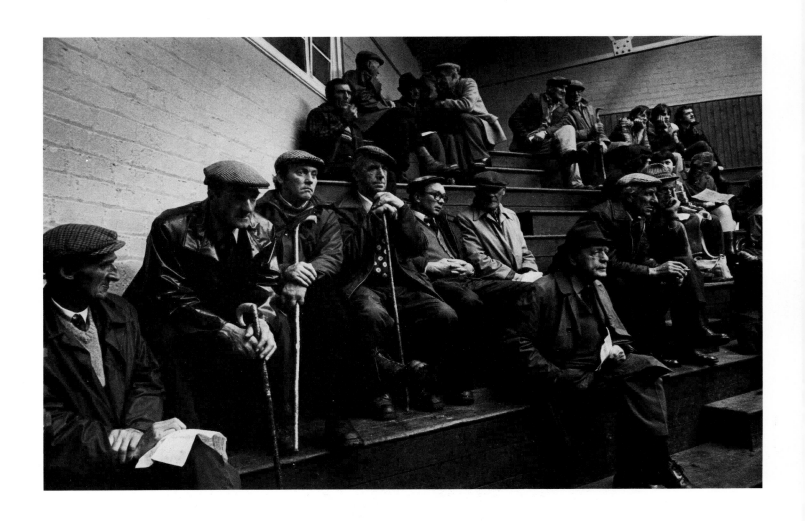

DAVID CRISP
Sheep auction, Oban

DAVID LUCKHURST
The Choir Boy

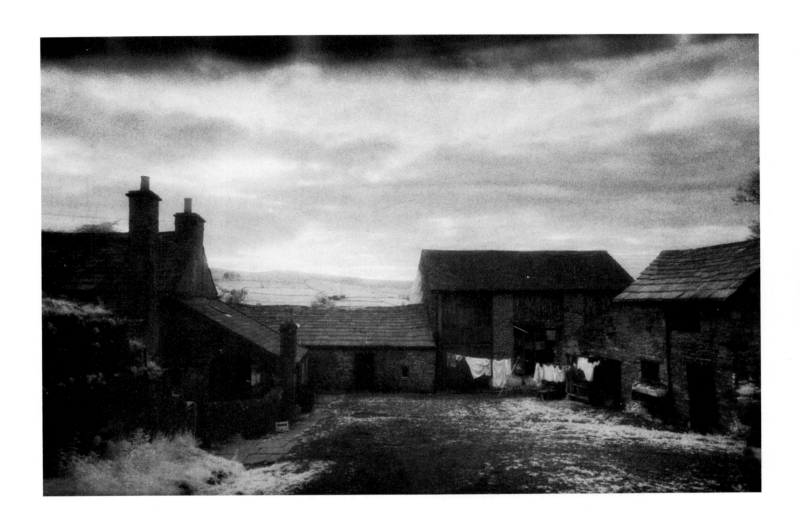

TINA CARR
The Butts, Alston, Cumbria

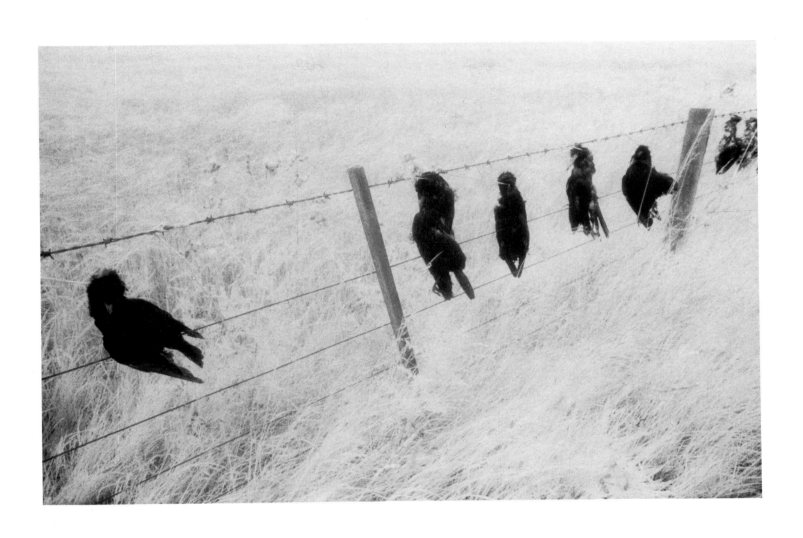

TINA CARR
Crows

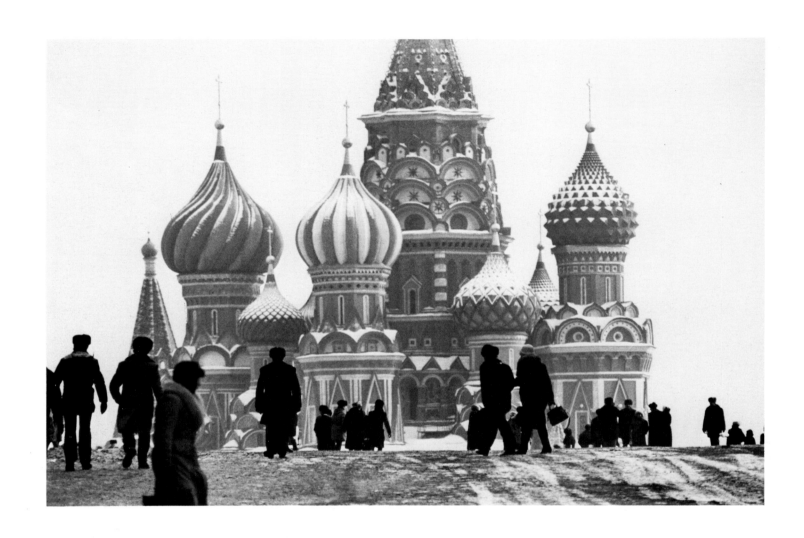

FRANK HERRMANN
St Basil's, Moscow

DOMINIQUE BONNET
Venice, December

IVAN HAGGAR
Untitled

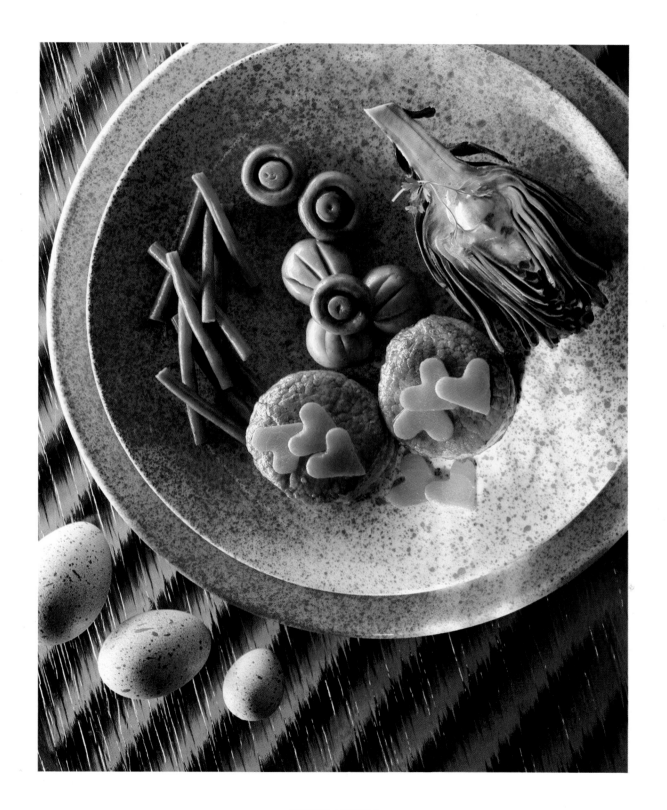

PETER MYERS
Portfolio shot

BARRY FRYDLENDER
Cafe Kasset, Tel Aviv

BARRY FRYDLENDER
Dizengoff Square, Tel Aviv

NEILL MENNEER
Tower Bridge, London

LEN JOHNSTON
Cadiz, Spain

MELCHIOR DIGIACOMO
Antigua

MELCHIOR DIGIACOMO
Antigua

DODIK MILLER
Opening of the Moscow Olympics 1980

PHIL SHELDON
Women's Powerlifting, World Championships 1982

ROGER HUTCHINGS
Michael Foot MP, Leader of the Opposition

GEOFFREY STERN
London Underground

JUDY GOLDHILL
Barmitzvah 1981, South London

DAFYDD JONES
A party in the country

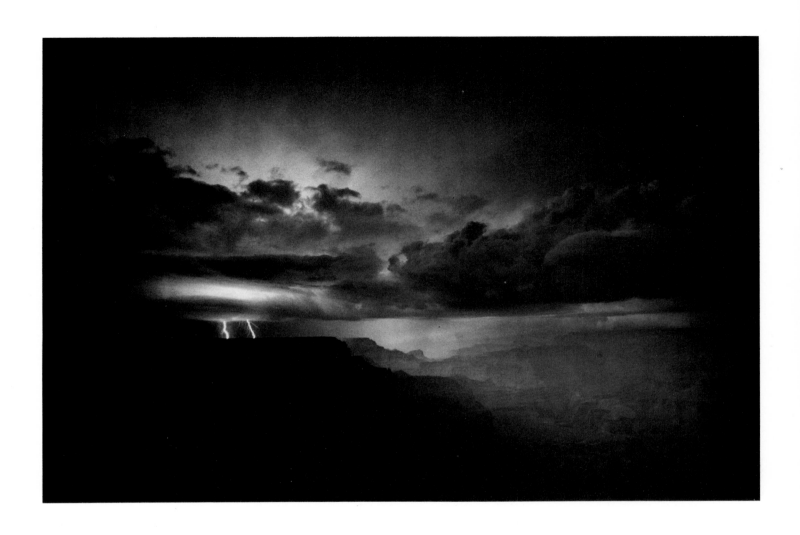

BERNHARD J. SUESS
Grand Canyon

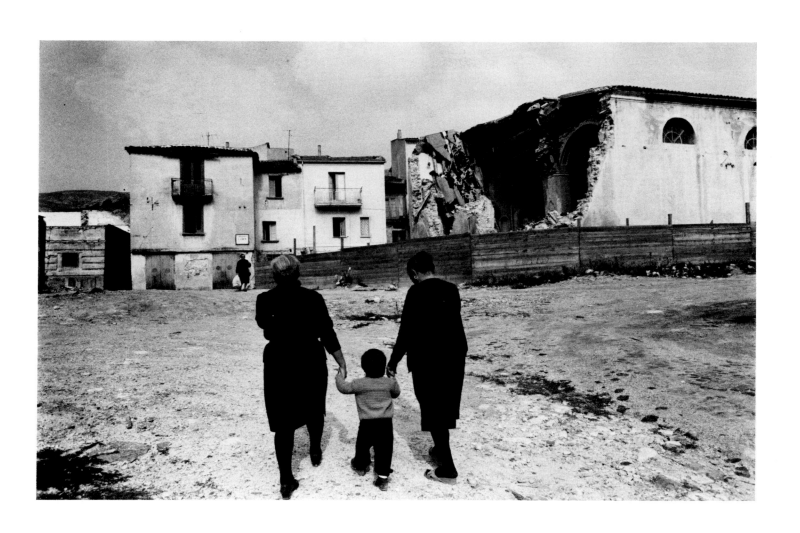

RICHARD OLIVIER
Balvano, Italy. Two years after the earthquake

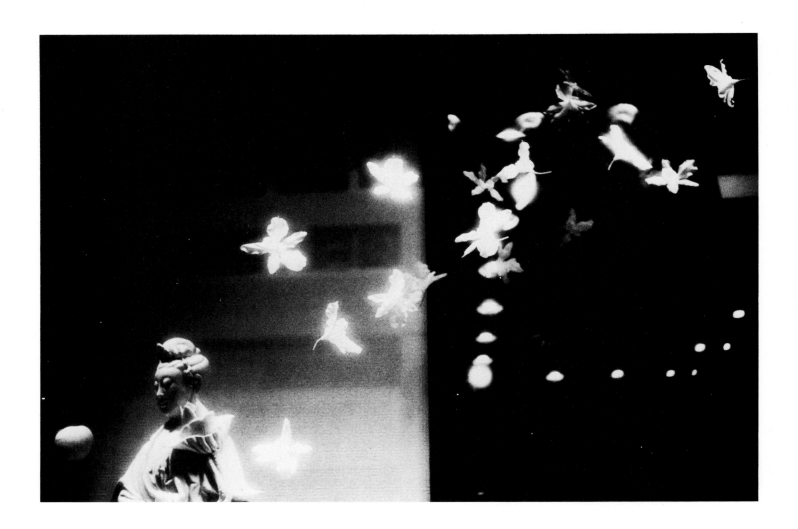

YVONNE VAAR
'8' from the Reflections series

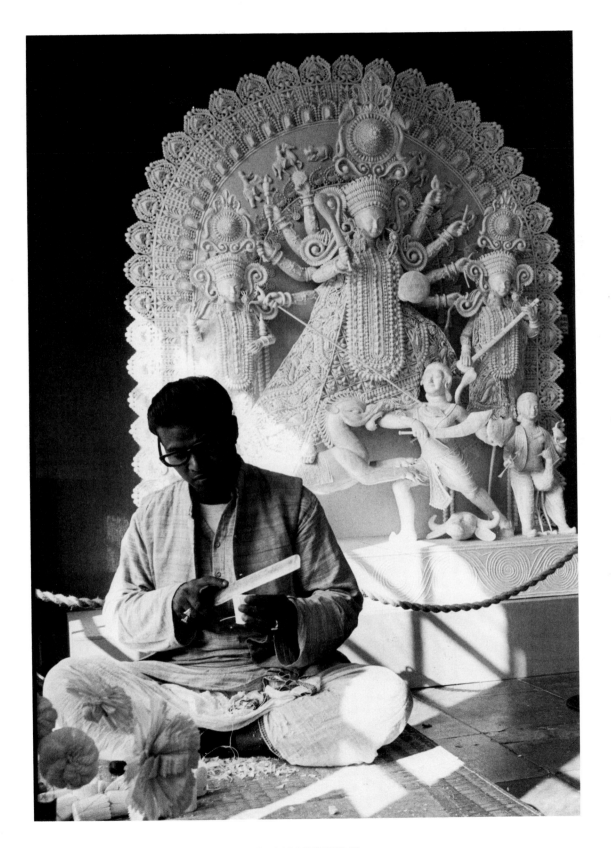

BRIAN SUTTON
Pith Worker, Crafts Exhibition, London

HANSJOCHEN HEINECKE
Untitled

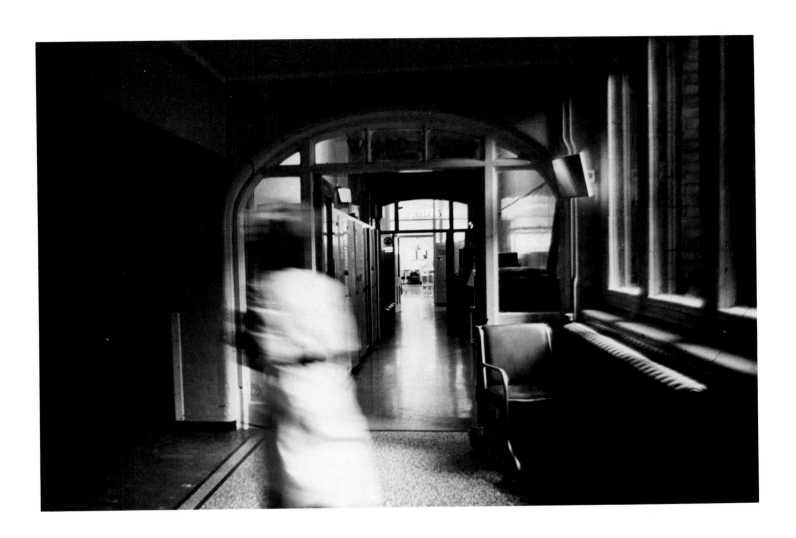

ANNA LYSTRUP
Women's Ward, General Hospital, Birmingham

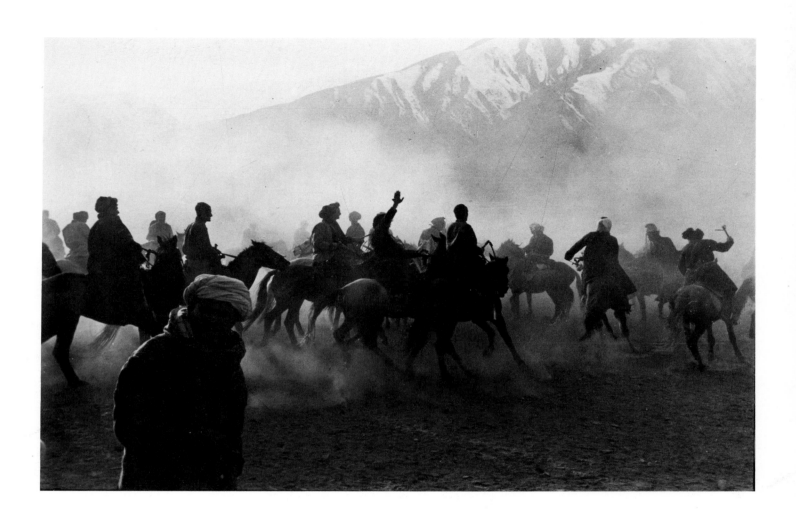

GWENDOLINE PATMORE
Afghan Horsemen playing 'Buskashi' in Northern Afghanistan

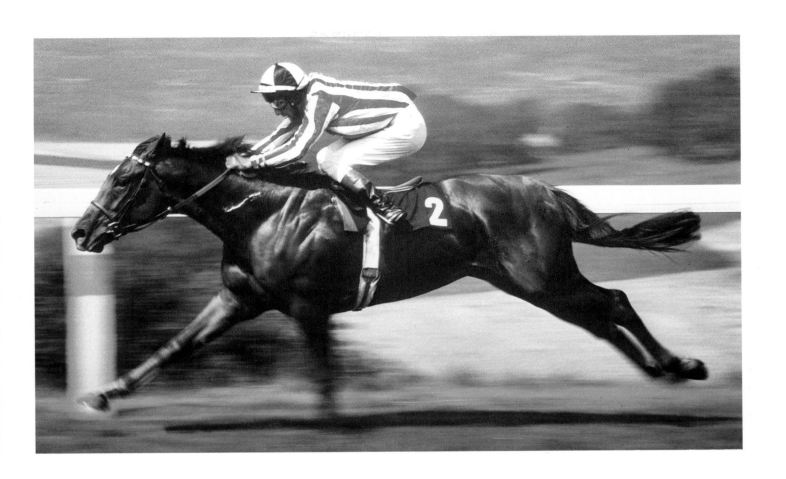

GERRY CRANHAM
Lester Piggot wins at Goodwood

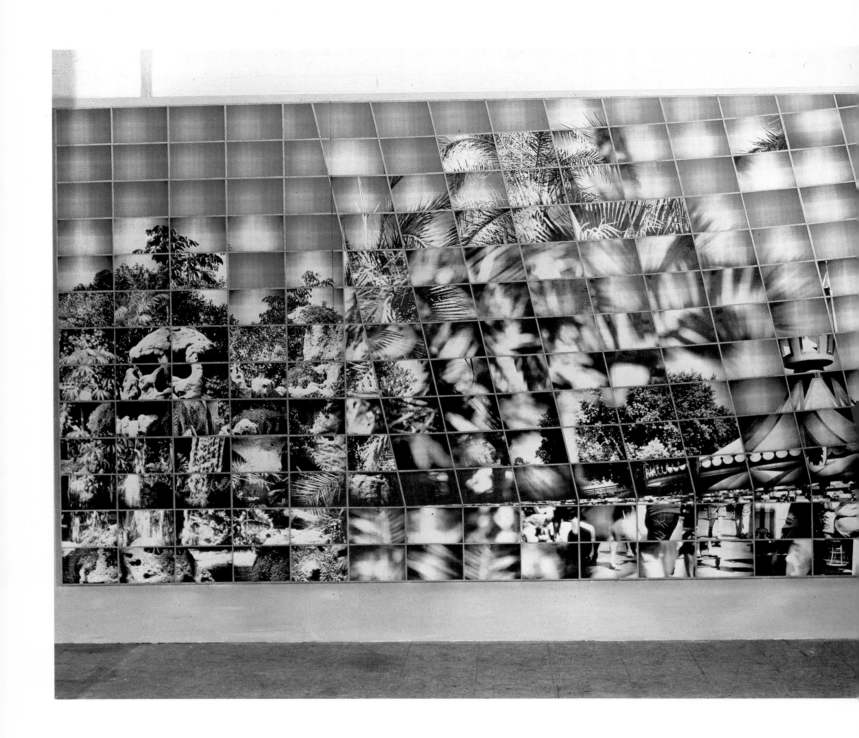

VAUGHAN GRYLLS
Nuclear War in the USA

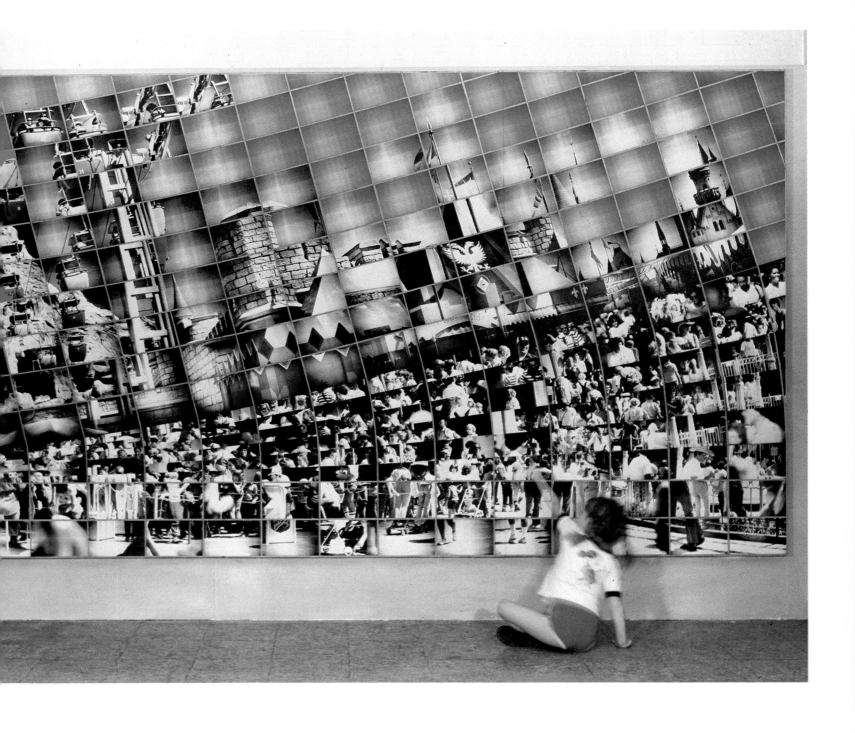

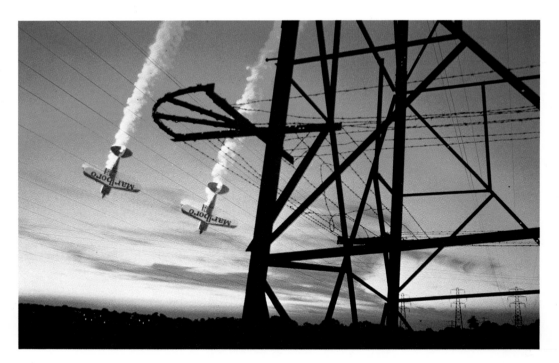

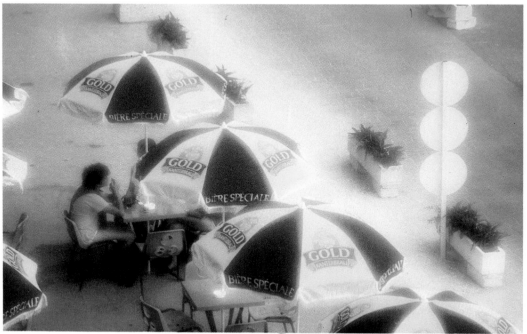

LAWRENCE NICOLLS
Marlboro' Bi-Planes.
Street Cafe, West Coast of France

DAVID GOWERS
Blackgang, Isle of Wight

JOHN S. WEBB
Aleklinta, Öland, Sweden

BOB IRONS
Milton Keynes

NICHOLAS SINCLAIR
Clown, Trumpet and Stars

NICHOLAS SINCLAIR
Spanish Trapeze Artist

JOHN R. J. TAYLOR
Ingliston Market, Edinburgh 1980

STEVE BENBOW
San Sebastian, Northern Spain

DAVID BANKS
Portrait of Richard McCormack, Architect

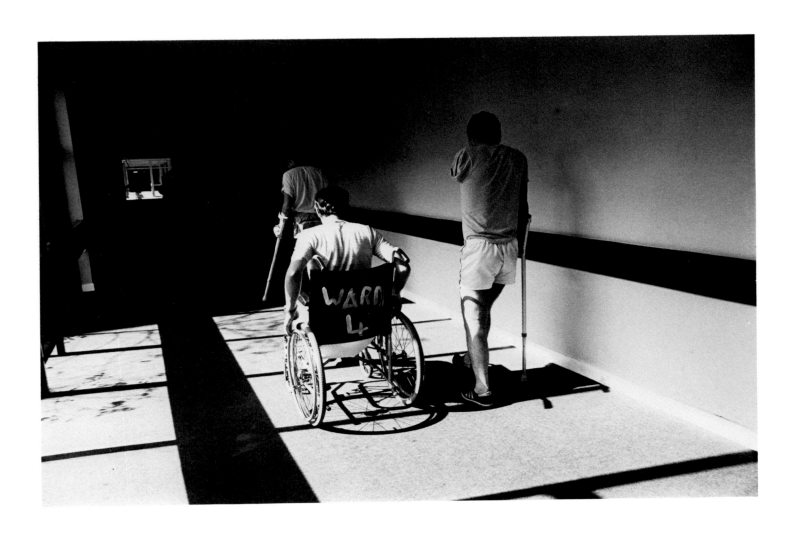

JOHN ROBERT YOUNG
'Courage to Live' – Rehabilitation of Falklands War Wounded

BRIAN HARRIS
Prince Charles and
Welsh Guardsman Simon Weston,
a victim of the Falklands War
at Buckingham Palace

ROGER ARGUILE
'A' – Tanya completes her name in sign language
(sequence of five)

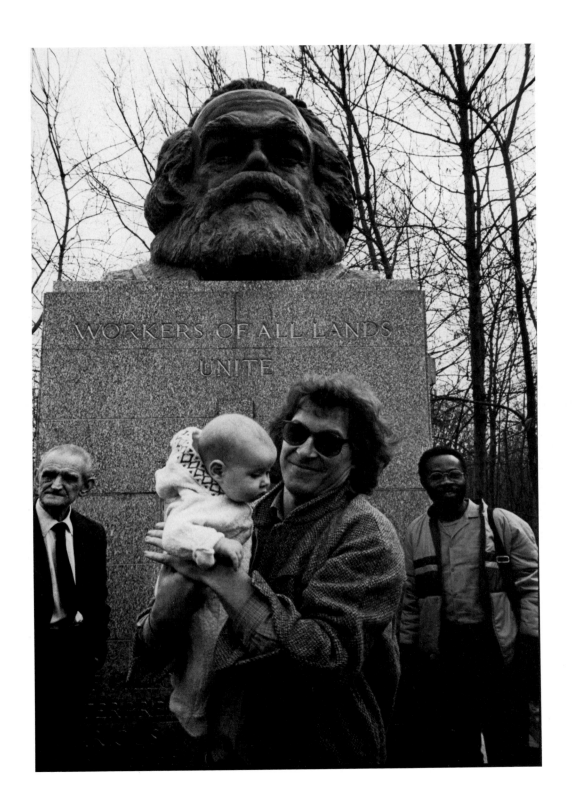

BRIAN SUTTON
Anniversary of the death of Karl Marx, Highgate Cemetery, London

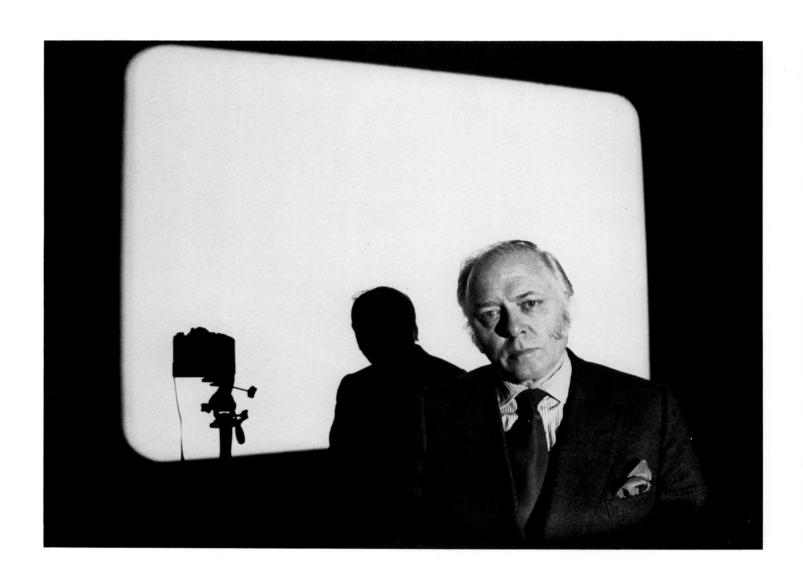

BRIAN HARRIS
Richard Attenborough

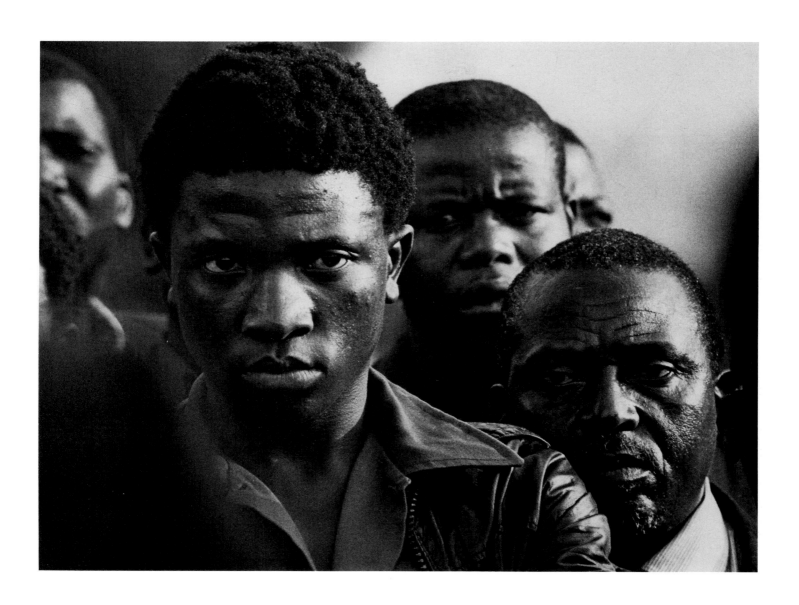

ORDE ELIASON
Bereaved workers, Johannesburg, 1982

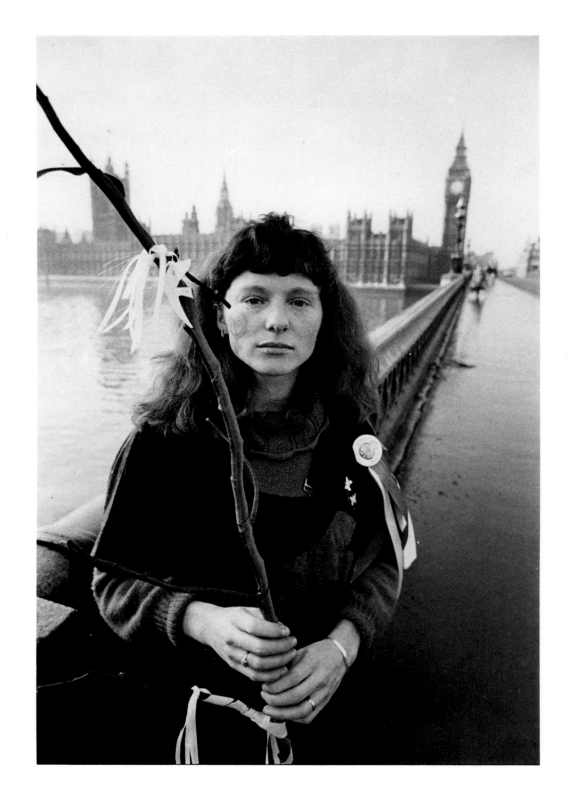

ED BARBER
Woman from Greenham Common peace camp after keening outside the
Houses of Parliament, January 1982

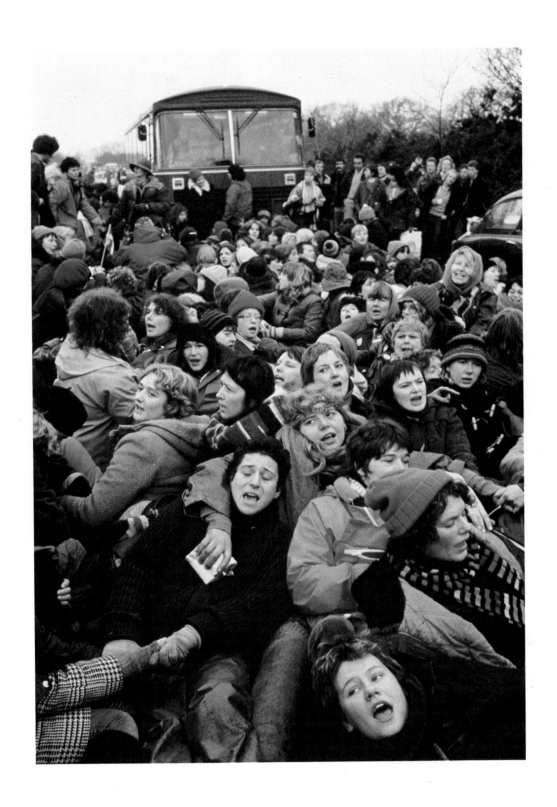

ED BARBER
After 30 000 women 'embraced' the Greenham Common Air Base in
December 1982, several thousand blockaded the base the next day.

VAUGHAN FLEMING
Cuzco Cemetery, Peru

SUSAN MEISELAS
'Nicaragua'. Funeral procession in Jinotepe carries portrait of
FSLN guerrilla killed three years earlier.

LIBA TAYLOR
Transvestite waits for clients – Saõ Paulo, Brazil

SUNIL GUPTA
Tilonia, Jat Farmer

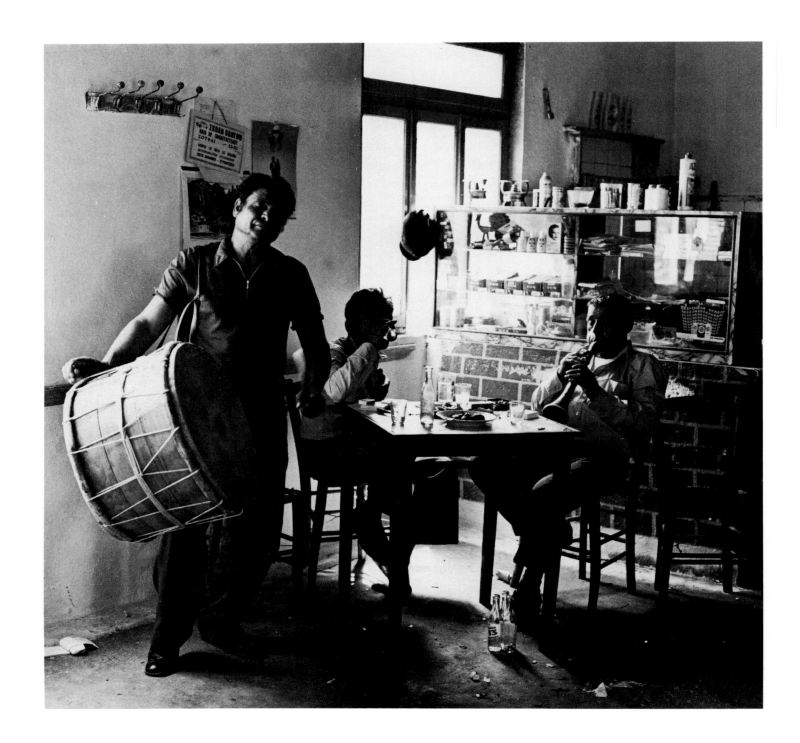

JOHN STATHATOS
Mega Devion, Thrace

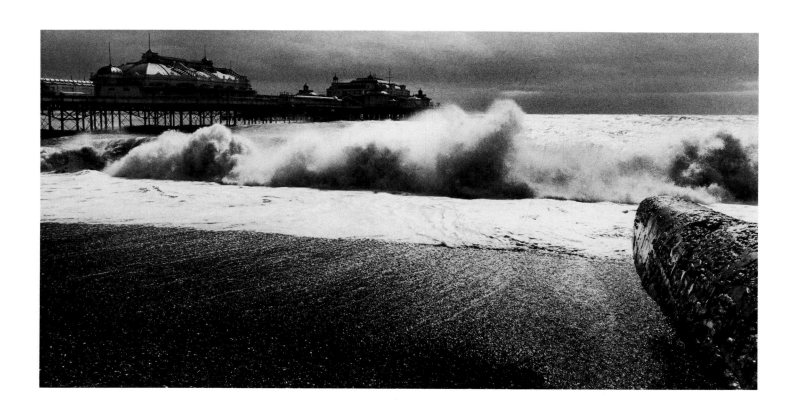

PHILIP GREY
Untitled

MIKE HOLLIST
'On top of their work'
–David and Ian Dawson, steeplejacks,
Lincoln Cathedral

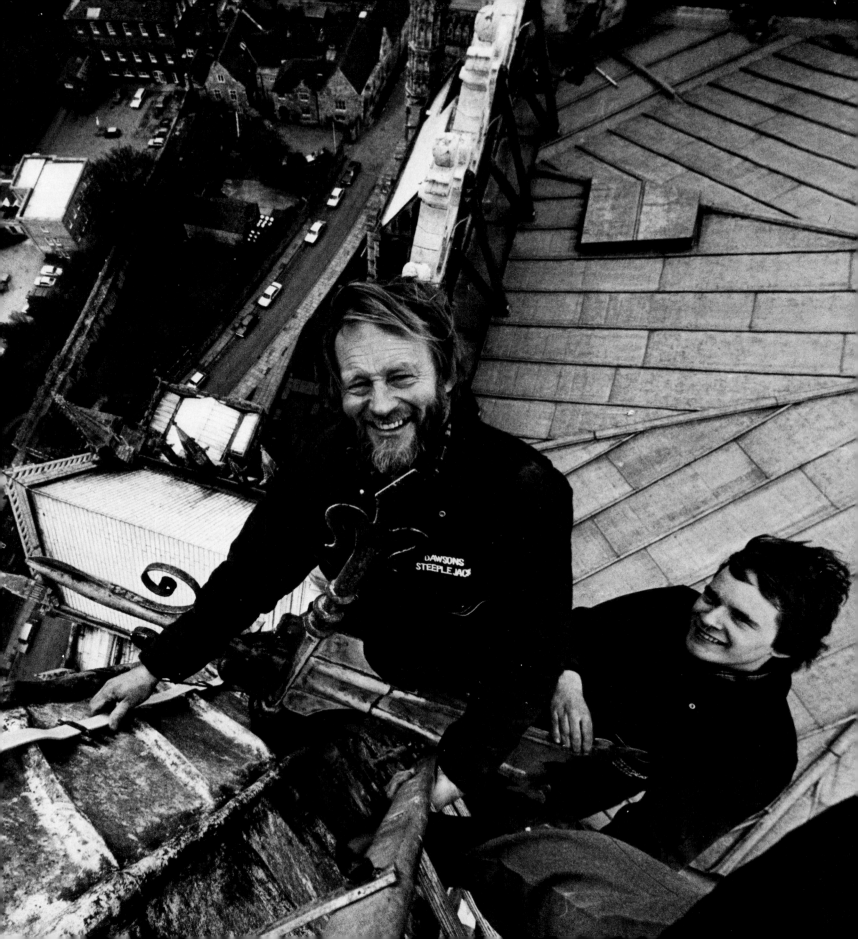

MARILYN BRIDGES
Farmhouse, LeRoy, New York 1981

MARILYN BRIDGES
Great Triangle, Nazca, Peru 1979

RICHARD WAITE
Stranded whale

MICHAEL BEDDINGTON
Breakwater, Rye

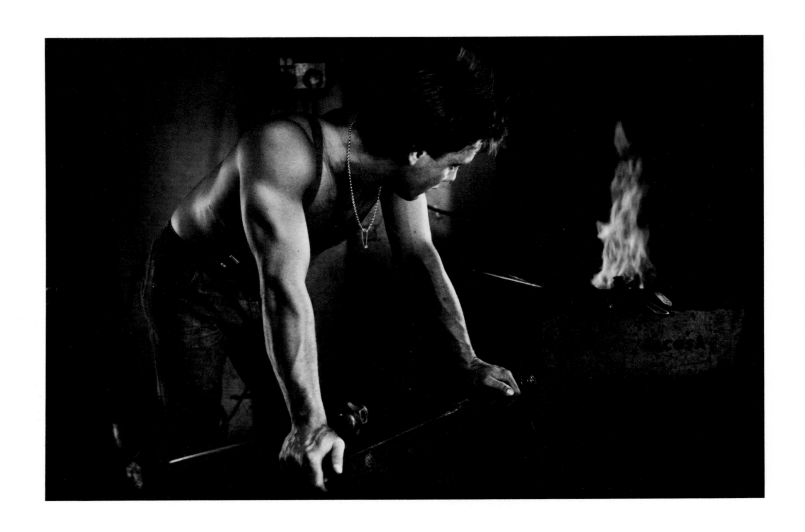

ADRIAN FORD
Blacksmith Carl Hood, Hedge End Forge, Hants

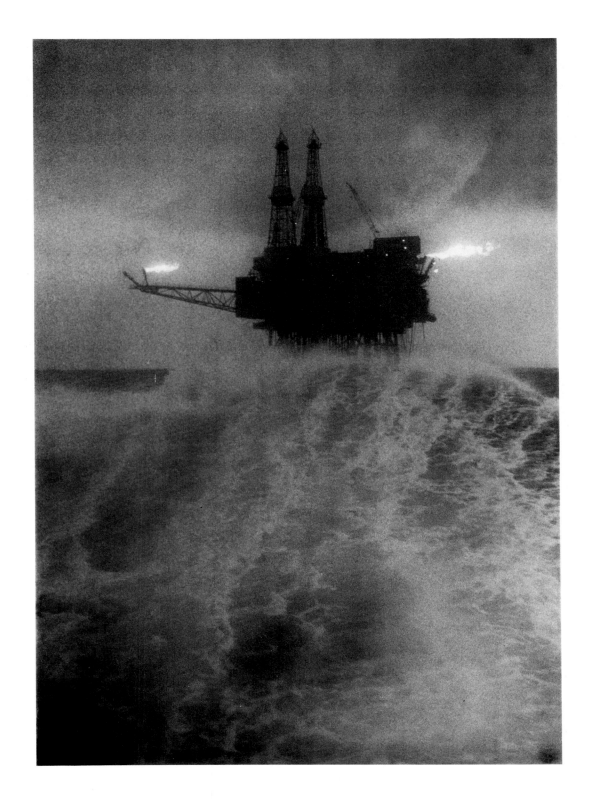

DICK SCOTT STEWART
Force 10, North Sea

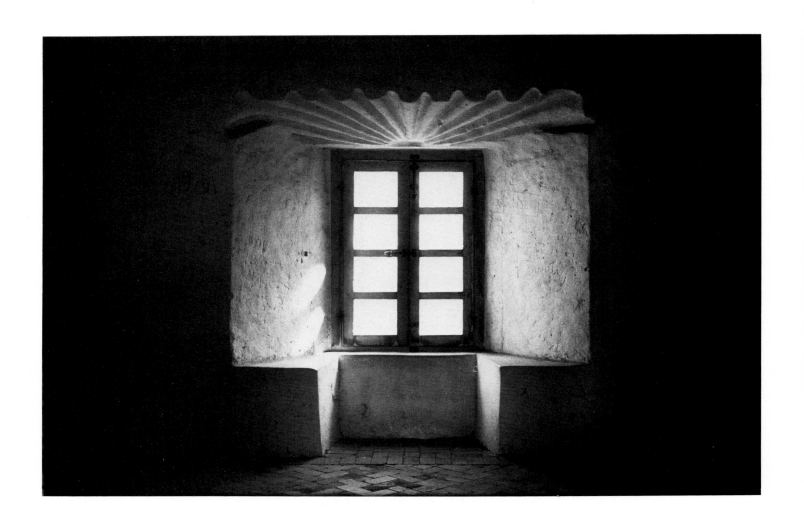

BERNHARD J. SUESS
Spanish Mission, San Antonio

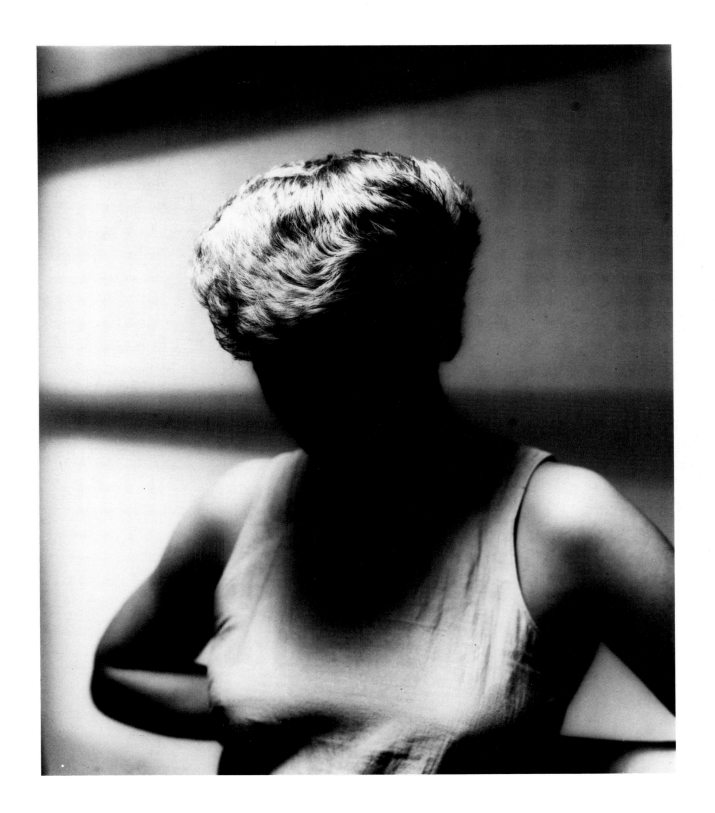

SIMON POTTER
Untitled

STEVE HICKEY
Publicity portraits for the band 'Sad Among Strangers'

MATT MEHRA
Untitled

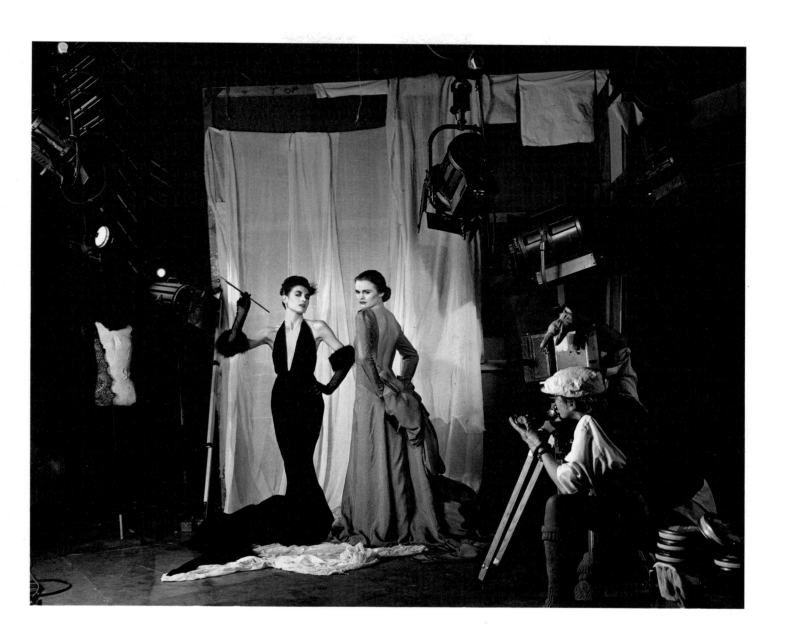

HANS NELEMAN
Untitled

ALISTAIR MORRISON
Ballet Class

MICHELE DEARBORN-GOLDBERG
Gigi: Can-Can legs from 'Backstage Around the World'

NICK KNIGHT
The Employee from 'Family Portraits'

ANDREW GRAY
Facing Face

JOHN R. J. TAYLOR
Turnpike Lane, London 1983

HOWARD WALKER
Vocal Support

HOLGER STUMPF
Paris, 1982

HOLGER STUMPF
Lisbon, 1982

HOWARD WALKER
Head in Hands

GLYNN BARNEY
Patrick Moore

BRIAN HARRIS
Mick Jagger and the
London Press Corps

MELCHIOR DIGIACOMO
Untitled

SUMMARY OF PROGRESS

EDUCATION

For photography, film and television the education motif of the year has been one of a strong sense of subterranean continuity rather than irreversible, possibly destabilising, change. Both the Council for National Academic Awards and DATEC are actively considering new course proposals, the former at undergraduate and postgraduate level and the latter at sub-degree level. The British Institute of Professional Photography sees its role as a professional validating body continuing and will be announcing new proposals later in the year. However, the thrust in education has been more of a general nature due to continuing financial constraints, projected 10% cuts by the National Advisory Board as well as rapid social and technological change.

For more than five years, since the publication in 1978 of *Higher Education into the 1990s*, higher education has been chilled by a dark demographic cloud. The gloomy presumption had been that the demand for places in universities, polytechnics and colleges had declined in the 1970s and because of the decline in the size of the appropriate age groups the actual number of students was likely to fall in the later 1980s and 1990s. These stark and, apparently, uncontestable facts seemed to sum up the public verdict on higher education. They seemed to justify, and so intensify, the post-Robbins post-Crosland hangover.

The Department of Education and Science now expects that higher education will enrol considerably more students over the next ten years than when it made a formal projection of future student demand in 1979. A revised projection published in April, *Future demand for higher education in Great Britain: DES Report on Education Number 99*, shows that despite the cuts imposed by the 1978-83 government there is still expected to be more students in 1990 than was anticipated in the last year of Labour rule. New figures reveal that the DES now predicts that: there will be between 13000 and 26000 more students in 1985-86 than expected in 1979; there will still be more students by the end of the decade than there are today despite a 10% fall in the 18-year-old age group; the number of students in 1994-95, the bottom of the demographic trough, will only be 14% less than today's total of 554000; the age participation rate will rise steadily from the present figure of 13·5% up to and into the 1990s to reach a new peak of 15·9% according to the most optimistic projection or 14·9% according to the most pessimistic. However, although the DES now admits that the demand for higher education is likely to be more buoyant, it also warns that 'if the number of places currently available were to be maintained, the supply of places would, sooner or later, exceed demand'.

The DES does assume that there will be some increase in demand for higher education among qualified young people because of high unemployment. The paper points out that the qualified participation rate, the proportion of those qualified to get places, has increased from 85 to 89% since 1979, and that during the same period unemployment has gone up from 1·5 million to more than 3 million. However the DES believes that unemployment has the opposite effect on mature students. 'Current evidence suggests that unemployment has caused mature entry rates to fall, perhaps because potential entrants would prefer to retain their existing employment rather than risk unemployment following a spell of full-time higher education'. These new DES figures cover full-time and sandwich students only. No estimates have been made of the future demand for part-time courses and more generally for continuing education.

The SRHE Leverhulme seminars were held in 1982 to propose any necessary restructuring of the British higher education system to make it correspond more closely to the realities and actual needs of society. The implications for art and design and certain areas of photography/film/television should be seen in relation to their historical context.

The existing structure of art and design education remains, despite the passage of some twenty years or so, a direct product of the first Coldstream Report. Coldstream's intentions, broadly speaking, were: to achieve parity for art and design teaching at the higher level with main-stream university teaching, in terms of academic status and career viability; to modernise the provision so that it would develop teaching and training appropriate to the needs of a complex industrial society. It is to Coldstream's credit and that of his committee, that the first report achieved, to a very considerable extent, both of its main objectives. Following a period of traumatic change in the colleges, which continued throughout the sixties, they emerged eventually with a greater diversity of courses, many of which were highly specialised and aimed at particular industrial or employment outlets and all of which were more cogently argued, both in academic and vocational terms, than had hitherto been the practice. There was, however, a negative side to Coldstream's strategy. For, in order to achieve his purpose, he and his committee determined upon a strongly isolationist approach to the problems of art and design education which had the effect of separating it from the mainstream of higher education, and more importantly perhaps, from the changing needs of secondary education. In his concern to preserve and to reinforce the academic autonomy of the colleges of art and design, he insisted upon the setting up of an independent validating body for degree courses in art and design and a distinct form of entry that would bypass the normal route into higher education through the General Certificate of Education. These two key decisions have resulted in the progressive distortion in the shape and balance of the provision on the one hand and the increasing isolation of art and design as a subject within the secondary school curriculum on the other. Coldstream's approach was perfectly understandable, given the

historic moment at which he was required to make his intervention. Nevertheless it has left a legacy of problems for art and design education on all levels.

These problems stem chiefly from a vicious inflexibility in the validating structure itself.

The Coldstream Report set up a separate validating body for art and design degree equivalent courses–the National Council for Diplomas in Art and Design under the chairmanship of Sir John Summerson. The Summerson Council, as it became known, was charged with the task of validating degrees under four main headings: fine art, which was to cover painting, sculpture and drawing; graphic design, which included illustration as well as all of the then extent areas of communication design; three-dimensional design, which was to provide courses in ceramics, and in industrial and product design as well as in theatre, interior and display design; textiles/fashion, which also took within its purlieu courses in embroidery. For the performance of the validating task itself, the council established committees or panels to correspond with these four main areas in both nomenclature and membership. It also established a separate committee to oversee the compulsory 15% of art historical and complementary studies as laid down in the Coldstream Report. This structure has proved itself to be remarkably resistant to change. Along with its parent committee, the Committee for Art and Design, it has survived intact the absorption of the NCDAD by the Council for National Academic Awards. Following this absorption, photography was added as a subject board within the art and design area.

The following summary of recommendations arising from the Leverhulme seminar would, if implemented, concern photography, film and television.

1 All degrees in art and design should aim to educate through training and should have future employment areas or opportunities for practice clearly identified.
2 All degrees in art and design should be based on structured curricula, an explicit set of educational objectives, and should ensure that students acquire a balanced range of perceptual, conceptual, motor and social skills.
3 The content of art and design degrees appropriate to future needs may well include relevant disciplines not normally covered by the present provision of art and design courses. With this in mind appropriate links with other disciplines on both sides of the binary line must be developed.
4 Where an art and design degree is not intended to lead directly to a specific career, it must provide transferable skills and have clear educational objectives and curriculum.
5 In the case of design and crafts subjects, the principle of sandwich courses is strongly supported. It is hoped that financial provision for a more imaginative range of placements can be achieved and that the question of funding placements (grants, tax advantages to companies, etc) can be given urgent consideration.
6 There should be one full-year placement on four-year courses.
7 In the light of the above, if the CNAA is to continue in validation of art and design degrees, the Council will need to adapt its structures as it will no longer be appropriate for it to operate within the existing degree categories: art and design will need to be considered within the total context of the Council's work.
8 The size of the fine art sector represents a serious imbalance within the system as a whole. It may well prove necessary to reduce the number of fine art courses in order to achieve much needed expansion elsewhere, as a matter of economic expediency.
9 Although there is a strong case for a large fine art provision, to meet the educational needs of individuals and of society as a whole, most fine art courses should be educational rather than professional in their thrust.
10 The study of craft should have as its target a particular small-scale sector of the economy which is currently expanding and is likely to continue to do so.
11 The artist/craftsman has good employment prospects. Existing courses should be rethought to take account of this and the number of places increased accordingly.
12 Graduates from these restructured courses should play a major role in developing craft teaching at secondary level, via PGCE courses.
13 The study of design should have as a target a particular sector of the economy rather than a particular identity.

The Art and Design seminar concluded 'As well as making specific proposals for its improvement in the medium term, we have sought to sketch out a broad direction for art and design education. This requires a greater social responsibility for art and design colleges and faculties, greater educational integration and flexibility and more realistic regulation and control. There is no doubting the importance of art and design education in a modern society, always supposing that it addresses the nature and needs of that society through its values and objectives.
We believe that:
 i Our proposals will reinforce the roles of sixth forms and FE colleges including the FE art colleges.
 ii The raising of the academic standard for entry will require bridging courses for talented but underqualified students.
 iii More part-time and retraining courses are necessary.
 iv The implications for postgraduate courses and postgraduate study will have to be investigated.
 v The proposals will require redeployment of resources, both nationally and within institutions.
All these factors will, in the long term, strengthen art and design education in the HE sector and provide a basis for innovation and response to radical economic technological and social changes.'

The current role of the Council for National Academic Awards in photographic education was defined in the correspondence column of the *British Journal of Photography* earlier in the year by Margaret Harker, Chairman, Photography Board, CNAA and Hywel James, Registrar for Art and Design, CNAA. The following extracts demonstrate the importance of the CNAA in the validation of photography courses and in the maintenance of standards of those courses in photography/film/television which

are recognised by its Council as leading to one or other of its awards.

'When photography was included amongst the subjects coming under the aegis of the CNAA, from its inception nearly twenty years ago, the Council worked closely with advisers from relevant professional bodies who became members of the appropriate boards or panels. As far as photography was concerned this was the Institute of Incorporated Photographers. This collaboration was both important and effective. The first course to gain recognition was the BSc degree (CNAA) in Photographic Technology (now the BSc(Hons) degree (CNAA) in the Photographic Sciences) at the Polytechnic of Central London. The course was geared to the needs of the scientific branches of the profession of photography and the photographic manufacturing industry and has proved highly successful in the establishment and maintenance of standards and in respect of the employment of graduates.'

The writers added that in subsequent years six undergraduate full-time specialist courses leading to BA Honours in photography/film/television and two courses in communication media and visual communications studies respectively which incorporate photography/film/television have been recognised. In addition there are two part-time courses, and three postgraduate centres for film studies. Two or three specialised undergraduate courses are under consideration.

The CNAA ensures that the standard of its awards is comparable to university awards although emphasis of a CNAA course will often differ from its university equivalent, for instance in the value placed on practical competence.

Professor Harker and Mr Davies continue 'Some considerable alarm is expressed from time to time at the large numbers of would-be photographers emerging from colleges each year and the lack of opportunities for their absorption into the profession. One doubts if the situation is very different from many other occupations. In examining course proposals and before granting recognition the CNAA is mindful of this important consideration and expects course designers to match course content to careers whenever appropriate. Most of the degree courses in photography/film/television are sufficiently broad to prepare students for careers which are ancillary to the main subject(s) studied as well as for the subjects themselves, which extends prospects for graduates.'

Following the establishment of the first chair in Photographic History in Europe at the University of Göteborg in Sweden the *British Journal of Photography* in an editorial during August 1982 continued the debate about the stature of the subject as an academic discipline. It commented that its 'concern in this matter is not so much whether or not photographic history merits a degree course, but over the more fundamental issue of the scholarship that is being brought to its study'. It concluded that 'possibly the American custom of introducing it as a sector of art history is the best approach. In that way it benefits from fellowship with the older, more established areas of art history, whilst retaining the ability to become a self-sufficient unit if this proves warranted.' More recently the CNAA validated the first course of this nature in the United Kingdom, to commence in September 1983, by approving a new 'special subject' in the history of photography as part of the Postgraduate Diploma/MA in History of Art and Design at the City of Birmingham Polytechnic.

Museum facilities and exhibitions which provide an interaction between courses of this nature have increased over the years. The British Council has made the decision that photography be considered a fine art and treated accordingly. A photography officer has been appointed to organise exhibitions of British work to tour abroad. The first will be the landscapes of Fay Godwin to travel to the Far East, Australia, America and Europe. This will be followed by a show of Bill Brandt vintage prints in time for his eightieth birthday and, in collaboration with the Hansard Gallery in Southampton a major exhibition of the work of Julia Margaret Cameron to tour France. While there are no arrangements for Council shows to be seen in Britain, collaboration with the Victoria and Albert Museum and the National Museum of Photography in Bradford may change that.

In March 1983 the new exhibition gallery constructed to display photographs in the Sir Henry Cole wing of the Victoria and Albert Museum was opened. This now houses the Museum's Department of Prints and Drawings, Photographs and Paintings. The accommodation provides for the archival storage of the Collection with photographs matted and conserved in acid-free boxes housed in glass fronted wooden cabinets. There will be both long-term exhibits and major shows on display for shorter periods.

The National Museum of Photography, Film and Television in Bradford will provide a further importance research resource. It is costing a projected £2·5 million to convert a building from a theatre to one which is usable as a museum. Like the National Railway Museum, the National Museum of Photography is an offshoot of the Science Museum. Its first Director, Colin Ford, has been appointed and sees the museum as covering the widest spectrum of photography. He suggests that 'photography is involved in everything we do in life nowadays and therefore if the Museum is dealing with the craft and application of photography, almost any subject matter may have something to do with us.' He says that while the Museum will support research, most members of the public take and collect photographs, understand what photography is about in a general everyday sense and that they will be the major audience.

The great uncertainty of the next twenty years or so is the impact of technological innovations on society. The widespread introduction of automation, communication and information systems based on the 'microchip' has started and will continue. Concepts of 'work' and 'leisure', 'employment' and 'unemployment' will be challenged and traditional values and modes of behaviour will be questioned. The pace of change is difficult to predict but it is reasonable to assume that by the year 2000 massive social change will have occurred.

Michael Hallett

GRAPHIC REPRODUCTION

The printing industry has been, in recent years, revolutionised by developments in lithography allied to electronics, followed by the introduction of the silicon chip and its marriage to photographic technology. New techniques and methods are essential to survival. Thus a feature of recent printing exhibitions has been the interest shown in computer estimating systems, offset presses and finishing equipment including folding and collating machines. Purchasers require machines which are versatile, space saving and embody microprocessor control; in essence, time and money-saving equipment. The mood now is to examine new technologies, their rationale and dynamics with sceptical detachment. It is realised that computers, and all that they imply have to be accepted as a fact of life.

Nevertheless, in the pre-press field the industry is not yet in a position to predict with any degree of accuracy the impact of digital technology. The 'information industry' today remains essentially pre-press and printing orientated; concerned with getting information on to paper. Whilst many of the skills involved are generally applicable to a variety of other forms of information dissemination, it is still the main source of information capture in digital electronic form. Newspapers and periodicals using computer-based editing systems and typesetters are, as a by-product, generating a data base of highly valuable information, but the evidence is clear that they will, in the foreseeable future, remain the best way of getting a package of diverse information to a wide range of people in a rapidly available and easily used and transportable manner. The alternatives to paper and ink through the medium of electronic dissemination are apparent and loom large on the near horizon.

Modern pre-press assembly systems

The development recently of integrated text and graphics systems has made possible interactive page make-up with direct output to typesetting. Collaboration between Triple I (Information International Incorporated) of America and Crosfield Electronics (UK) has produced a hybrid system in which the Triple I facility is an option to Crosfield Studio 840 and 860 page composition systems. Text keyed through visual display units is processed on a Triple I computer and re-displayed either on the input terminal, or through the optional 2500 Proofing System. This 'page view' terminal interprets the typesetting commands held in the file to produce realistic type faces and point sizes—a fair representation of how the file would look when typeset, but it is not an interactive device. Changes are made through a separate keyboard and terminal, the modifications being made in the computer before the revised file is sent to the proofing station. When the Triple I composition stage is linked to the Crosfield Studio 800 series, the 2500 proofer would

find few applications. It is practicable to send the text files direct to the 800 for merging with digitised data from Crosfield colour separations. Any adjustments to the text would be more appropriate at this stage, where copy can be fitted accurately around illustrations on a high resolution display terminal. With the ability to show 1024 pixels of information in each direction on its screen, the colour composition terminal on the Crosfield unit provides a faster response for changes than is possible on page view proofing systems.

A Crosfield subsidiary company in the US, LogEscan, have marketed the LogEscan second-generation 3600 large-format laser plate making system, which in combination with Studio 800 modular page composition system will form the output unit of a complete pre-press system for commercial web offset printers.

The Scitext organisation has followed the same course as Crosfield and Triple I by preparing text on a front end composition system for merging on-line with digitised graphics. The Scitext Vista system accepts text either from its own composition stage, or from an existing front end installation and is seen by Scitext as a complement to the Response 300 colour pre-press system, which handles the electronic make-up of full colour layouts without text. In the same way that the Crosfield Studio 800 can accept changes to incoming text files, the Vista terminal can handle hyphenation and justification independently of the text composing stage.

Using the Itek communications interface and software developed for the advanced Xenotron XV2-20E video composer, users of Itek Quadritek photosetting system have a low-cost area composition system working on-line with their photosetter. The result of this co-operation between Itek and Xenotron means that Quadritek users can now have all the benefits of interactive composition and can make-up pages to A4 size. Designs and layouts can be originated directly on the screen in a size for size format, following original layout positions using an electronic graphic pen. The operation can make use of all Quadritek functions for output, and the ability to mix type styles as required from the four type faces which are always available on-line. Output is in the form of a one-piece bromide and design changes can be executed by keyboard command, either through the Xenotron XVC2 or the Quadritek. Input from the Quadritek is originated as raw text and then transferred to the XVC2 for make-up and returned to the Quadritek with full typesetting commands for setting. Once the job is transferred from one memory to another, both terminals can function independently. Using the electronic graphic tablet, outlines can be traced so that text is fitted around the contours of an illustration, and layouts can be stored either on the XVC2 or Quadritek floppy disc. Once transferred to the Quadritek, the job is stored on disc for photosetting and the final output from the Quadritek photosetter is a bromide of the total job—up to A4 in size—with rules and boxes in position.

The Hell organisation have a different approach to the question of integrated page composition, which reflects their view of market requirements rather than any inability to develop a text and graphics merging facility. Current versions of the Chromacom software can handle the incorporation of high resolution text

through the input side of a Hell graphic scanner. Text is treated as a 'picture' file rather than as a conventional stream of ditigal character signals. Irrespective of how the text is originated, a hard copy version of the material–either on film or paper–is scanned. With the Chromacom Layout Programmer CIP307 the job preparation station is independent of the system and is used to input scanner settings and page make-up parameters. The new Digigraph 40A40 digitises continuous tone images and line drawings and simultaneously the existing image data can be processed via the monitor with illustrations at the same time 'set' from the image archive on magnetic discs.

DaiNippon Screen have marketed a C-951-B composing camera. The system uses a digitiser computer and montage camera into which the operator enters rules, tints, register marks, logos and lettering according to the layout instructions. Elements can be checked on a character display, and the programme can be stored on floppy disc. The disc is transferred to the computer controlling automatic make-up on the camera, in positive or negative film form and another job can be progressed during the automatic camera operation. Magnification can be set from 50 to 150% and exposure is automatically controlled. For multicolour work the camera has pin register and ball screws to position originals with high repeatability. Floppy disc store allows easy recall and update.

New scanning equipment
The new Chromograph 399 from Hell features laser multi-colour and programmed colour correction and efficient and reliable operation is the keynote of the new machine. The colour computer has four separate digital readouts for simultaneous display of density and halftone percentage values for all four colour separations. Eight fixed gradations can be selected by push-button and with speed and precision adapt the gradation to process, machines, inks etc. Stored tone programmes, allied with stored colour corrections, ensure minimum manual adjustment and the large format of 51×65cm permits simultaneous scanning of two double A4 pages. The duplo, double-duplo, quadro and multiple exposure functions of the multi-colour system provides the facility for outstanding productivity. The microprocessor is a bonus for the operator and takes over all calculations necessary for correct recording sequences as well as the control of the entire machine, excepting the control for scanned image dot data. Operator instructions are input via the operating panel, calculated and transferred to the associated control system for automated film linearisation, the scale of reproduction required (20-2000%), electronic silhouetting, an image position which is in correct register, freely selectable surround density, the recording of register marks and test grey scales and colour identification (several languages or two codes can be selected). Routine tasks are also input by operator push-button which considerably reduces the setting times when switching from positive to negative and selecting direction of scan (right-reading/laterally reversed), scanning transmission/reflection copy, number of recording lines and aperture size, or mono, duplo, double-duplo or multiple recording. The operator is thus relieved of routine tasks so that he can

concentrate on the 'creative' elements associated with the results required.

The colour computer in the Chromograph 399 embodies the four digital readouts to provide reliable information at all times, and three black separation variants (corrected black, uncorrected black and split filter black) make it possible for the operator to control the important black separation precisely in the way required by the copy characteristics plus customer requirements. With programmable colour and tone correction there is also permanently programmed standard colour correction feature for standard reproduction and rush jobs, as well as eight storable fixed gradations. Thus when using standard settings, setting-up times are very rapid and using interchangeable scanning drums, copy can be mounted, scaled and marked ready for scanning. The laser exposure unit is equally efficient for both continuous tone separations and screened halftones and the cost-efficiency of the machine is such that the recording time for four colour separations in A4 format is a mere five minutes.

The DaiNippon Direct Colour Scanner, SG808, employs many new functions including a dot generator which allows electronic screening, also a multisharpness head which controls generation of sharpness signals either through red filter or green filter, or mix use of the signals. There is a four-channel simultaneous display of output dot percentage and an original density setter (ODS) which makes calibration simpler and more accurate. Digital controls for higher data stability and repeatability include simultaneous multi-colour recording, magnification calculation control, image distortion compensation and maximum and minimum dot density setting.

A new Magnascan 640 four-colour scanner has been introduced by Crosfield Electronics suitable for about 250 colour sets per week with three different types of output units; the analysing unit being standard to all configurations, having a large and a small scanning drum. Special features of the 640 series is a scanning data terminal which has a twin floppy disc drive, a printer and a VDU (Visual Display Unit). Like its predecessor the Magnascan 530/540, the 640 has separate input and output units and drum loading of the analysing unit is semi-automatic. The three different types of output unit can be used either singly or in different combinations. The 640S uses an argon laser exposing light-source for conventional contact screening or continuous tone output on a 590×720mm film size. Separations can be made four at once around the drum up to A5 width, while an automatic re-scan, coupled with film stepping, produces an A4 set in one piece. The 640E incorporates a new electronic dot-generation unit, using a digitally-controlled argon laser to produce dots for separations at conventional screen angles and six rulings from 30 to 80 lines/cm. A complete A4 set with 60 line/cm ruling (150 lines/in) is exposed in a few minutes. The 640M fulfils very large output size needs, exposing a maximum film format of 830×1030mm. This model, intended primarily for poster work or fully made-up and imposed pages enables four A4 pages to be exposed in one pass, and also employs electronic dot generation for speed of exposure. Common to the Series 640 is the new scanning data terminal, which is not

available on the Magnascan 540. It enables the operator to set up and monitor the work in progress. Multiple transparencies and artwork mounted on the analyse drum can be allocated their own individual enlargement, colour adjustment and exposure. The instructions are stored on floppy disc so that exposures in all their variations can be made non-stop and the data recalled at any time. In addition, the SDT automatically determines the correct order of exposure for economy in use of film and indicates when the film has run out. The operator can specify borders and rules via the keyboard, thus achieving a degree of page composition and when second originals have been made to size and planned prior to scanning, pages containing a number of pictures and graphic elements can be exposed in a single pass.

Corrections and adjustments such as undercolour removal can be displayed either numerically or in the form of curves on the VDU. Output calibration, cast correction, tonal characteristics and the effect of any changes can be seen instantly in graphical form and even printed out, if required. On the separations themselves up to 80 characters keyed in by the operator on the SDT (scanning data terminal), can be exposed for identification purposes and register marks are added automatically. If required an extra feature can be added via the floppy disc reader, when a programme could be built up to generate automatically formats and grids and repetitive work, leaving the operator free to set up the originals. An on-site modification can convert the Magnascan 530 or 540, to the full 640. The addition of a disc drive converts the Series 640 scanner into off-line recording and output stations for the Crosfield Studio 800 page composition range of equipment. There are three levels of page composition systems under this latter heading, the first–Studio 820–being an enhanced version of the previous Magnascan 570, and Studio 800 forms the input for Lasergravure 700. The Crosfield association with Triple I resulted in the ability to interface the two most sophisticated levels of the Studio series, 840/860, with the powerful 3300 Tecs (text editing and composition systems).

Plate production and control

The employment of presensitised and multimetal plates is accepted as standard procedure today for the production of printing surfaces for offset or di-litho. Presensitised lithographic plates are essentially sheets of aluminium with a thin coating of light-sensitive material on the surface. After exposure and development, the coating acts as the image area and the exposed aluminium becomes the non-image areas. The techniques of graining and anodising to form a hydrated version of aluminium oxide increase the water receptivity of the metal and produce a better image/non-image contrast and a more resistant non-image area, all these factors helping to increase quality of result and length of run. Nevertheless, the durability of aluminium presensitised plates for the longer print run is suspect and multi-metal plates are preferred. A multi-metal plate relies on a combination of two metals, one of which attracts oil to form an image area and the other being water receptive provides the non-image area. They may consist of just two metals, but often include a third metal which acts as a support but serves no function as a printing surface. These plates are extremely durable, with improved image quality and run lengths of millions of impressions can be undertaken. The classic combination is copper and chromium, with the upper chromium layer attracting water in the non-image areas, and the lower copper area attracting the ink to provide the image areas. More recently etchless multimetal plates have been produced to meet a need for a plate with the durability of a multimetal plate but with the low cost and ease of preparation of a presensitised plate. They consist of a three-part sandwich with aluminium retained as the basic metal. A thin layer of chromium, electroplated onto the aluminium, acts as the non-image area, and a specially formulated presensitised coating becomes the image area after processing. Even without baking the coating provides a longer life than other presensitised plates and when baked, run lengths of the order now only possible with multimetal plates can be achieved. Image and non-image areas have comparable resistance properties and on the press, damper settings can be kept to a minimum, reducing the dangers of emulsification, tinting and image binding, and both positive and negative working plates can be manufactured for this new etchless multimetal plate system.

An alternative to baking, that provides a longer running and more stable litho plate whilst almost eliminating the high energy cost associated with the baking process, has been initiated and produced by Polychrome. The system combines the technology of resins and of uv curing, bringing them together in a method which has produced a virtually continuous plate performance which resists the wear and tear of life on the press. What Polychrome has achieved is to match a resin to a particular spectrum of uv light, and then build a processor with the appropriate uv light source. The result is that the uv energy is applied specifically and precisely to the image dot, after conventional processing rendering it more stable and bonding it even more firmly to the plate surface. This Permashield system comprises the already established Webrunner plate, plus an aqueous solution plate processor and a new Polycure uv curing unit. The Webrunner is capable of runs of up to 300000 and with Permashield this can probably be increased to one million impressions. Users who can benefit from the extended run life are newspapers, either short or long run, and di-litho users, cartons, plastics printing, metal decorating (tin printing), label printers, long run stationery printers, etc. Very important to any market is the ability of the plate to maintain image quality throughout the run, plus the amount of down time it can potentially eliminate by making the printer confident that quality will not change from day to day. Webrunner plates are negative working, and can be processed manually or by machine using an aqueous developer containing no solvents. In practice machine developing is preferable to match the simplicity of the Polycure processor. This unit is available in two sizes, the Polycure U/V32 and the U/V48 for plates 32 and 48in wide respectively and any required length. Since the cost of a multi-unit web press stoppage could be as high as £150-£170 an hour, the new long life plate can be claimed to be economical even when the printing run is within the scope of uncured plates, with considerable energy savings in eliminating baking.

Web-offset developments

A development recently has been the introduction of the mini-web press, also known as the half-width, narrow-width, or eighth-page press, which has all the attributes of its 16 and 32-page counterpart. Its structure includes a reel stand, an in-feed system for controlling the web tension as it comes into the printing units, a dryer, a set of chill rolls, a silicone applicator to prevent the printed web marking as it travels on to the folder or sheeter. The advantages of mini-web over sheet-fed litho are that the mini-web offers access to newer technology and is faster. The new presses appeal to both the sheet-fed and the web printer in that the latter can move down a size in format and supply a broader product base, whilst the former can increase his output and continue to provide a wide range of products to satisfy all types of customer. Its superior advantage is the ability to convert cheaper reels to a finished product printed in one operation. One problem to be faced when installing a mini-web press is the vast consumption of gas needed to dry the print and burn off the solvents of the ink, with the stringent control demanded and expected by health and safety inspectors; also paper wastage can prove catastrophic if the danger is not fully realised at an early stage. A report published by BIS Marketing Research stated that the most suitable jobs for a mini-web offset press were runs of over the 20000 mark for mail order and advertising literature. The presses are also being used in the provincial newspaper field. The quality of printing achieved from the presses is well within the standard set by large sheet-fed presses and it is possible to achieve a 35% saving compared with sheet.

In general the inking system employed in web offset printing can be broken down into the same basic parts as apply for sheet-fed printing—ink reservoir or duct, metering, distribution and plate inking. A number of basic divergences apply largely due to the fundamental differences between sheet-fed and reel-fed production. Inking systems on sheet-fed machines are designed to cater for the intermittent passage of sheets as they pass through the printing units, whereas on web-feed presses the supply of ink must be continuous. The speed of reel-fed presses is generally of a much higher order than that of sheet-fed presses. This will be reflected in the design of the press with a need for dynamic stability of the system, choice of roller covering material and suitable inks. This continuous inking at high volume means that bulk storage of ink must be considered and a continuous supply to the press, often by pumped systems, must be available.

Letterpress relief printing

The manufacture of relief plates for letterpress printing remains a viable industry. Whilst in the last two decades general commercial letterpress printing has been contracting in favour of offset litho, there is nevertheless today an even greater demand for relief plates in the specialised areas of newspaper, flexo and dry offset. The introduction and continuing development of photopolymer plates has been responsible for a growth in relief printing which has virtually cancelled out the decline in the use of the traditional zinc, copper and magnesium plates.

The number of companies manufacturing photopolymer relief plate materials has moved into double figures, the first in the field being Du Pont in 1957-60 and they have invested sums totalling many millions into their products. BASF Nyloprint, also with a multi-million investment in photopolymer plates has, over the past ten years, increased its annual turnover from 5·5 million to DM100 million. Grace Letterflex, with two production plants in the United States and one in Europe, has invested capital to the extent of $30 million on its liquid resin system. They have recently introduced a Letterflex photopolymer platemaking system that allows a single operator to produce up to 120 plates an hour, using a solid state control system. Plates backed with aluminium, steel or lightweight Polyfibron are coated with a liquid photopolymer which, after exposure, is removed with an air-knife from the unexposed portions and re-cycled. Operation of the LF2-120E system is automatic. A second development from W. R. Grace is a 70 plates-an-hour system linked direct to a new plate preparation machine which automatically punches, trims and bends the plates ready for mounting. This L2000 plate preparation machine is manufactured by Berth of West Germany. Napp Systems has its major production plant in the United States and has invested something in the region of $20 million, which is quite separate from the original plant development in Japan, and APR, whose major production plant is in Japan, also manufacture in the US. One of the major suppliers of plates in Europe, Uniroyal Flex-light, has its main production plant in the US with a second one, fairly recently established, in Europe.

At the present time in Europe, newspapers are being printed by either offset litho, letterpress with stereos, letterpress with photopolymer plates or di-litho. An estimated annual plate requirement for the industry is 36 million plates—11·5 million for offset litho, 12 million for letterpress with stereos and 12·5 million for photopolymer plates and di-litho, with the latter being a minimal amount of the total. It is anticipated that stereo production will fall in the foreseeable future to be replaced in part by the other three systems. In the USA offset was credited with 72·5% of the newspaper market in 1979, but this represented only 36·6% of the total circulation. More recently printing from relief plates apparently accounted for over 50% of the total newspaper circulation. Current developments in relief plate manufacture have led to flexo printing being recognised as a rapid growth area and it is becoming one of the major printing processes. In the USA it accounts for some 25% of the value of all their printing and the annual European flexo market is worth about $25 million. Types of work covered by users in Europe include flexible packaging, corrugated cardboard containers and paper, tags, labels, pressure sensitive labels, cartons, multi-wall bags, continuous stationery, rubber stamps and polyethylene films. Also for paperback bookwork it is the major alternative to offset litho. APR is one of the leading suppliers of photopolymer relief plates for flexo printing in Europe, providing a wide choice of resins for the large range of work printed by the process. Du Pont with their Cyrel plate and Uniroyal with Flex-light photopolymer materials are also busily engaged in supplying the expanding flexo market.

Progress in paper and ink

Paper consumption has always been a fairly reliable barometer of economic activity and the indications are that a revival can be anticipated. The growth in world paper making capacity continues and looks like exceeding demand for the foreseeable future. South America, particularly Brazil, with its large forest resources, is rapidly coming to the fore in market pulp and wood free papers and in the southern US an increased paper manufacturing capacity is apparent. European timber resources are a renewable asset but not unlimited and demands on them for other than pulping increases yearly. There are many new wood pulping processes and thermo-mechanical pulp, previously much in favour, is now superseded by pressurised ground wood (PGW) and improvements continue in the area of chemical pulping in an effort to give some increase in fibre yield, brightness and strength. There is no magic alternative to wood for papermaking; eucalyptus, kenaff and bagasse have their usefulness in certain localities and even if the price of oil drops drastically it is doubtful whether plastic papers will ever have more than a specialised end use. Waste paper is the main indigenous raw material in the UK. The EEC generates some 30 million tonnes a year, of which only a third is recycled, mainly in packaging grades. An upsurge in waste paper usage could provide a useful bonus to printers and publishers in assisting price control. There is nevertheless a large wastage incurred in magazine production—the large circulation magazines and supplements each spoil close on £500000 per year of paper in production and greater emphasis is necessary on the need for waste control. Because of high postage rates lighter substances in the 50-60gsm range are in demand, and in the US have been upgraded to near wood-free quality. Progress has been made in incorporating higher percentages of filler materials in the paper rather than on top of it to give a closer match to the characteristics of good coated stock. A new development from Tullis Russell has been a coated range of paper and board using twin-wire, base paper and a revolutionary new method of coating. Instead of conventional coating and then supercalendering to impart the gloss at the expense of bulk, the new process free-flows the coating mix on the surface and the gloss is imparted without calendering. This results in a paper with 25% more bulk, and therefore lighter substances without loss of bulk can be used to compensate for the comparatively high price.

A water-based ink seems an anomaly, but the use of water in this way to replace the traditional oil vehicle in newspaper inks for rotary letterpress machines has introduced the supply of relatively low cost advanced inks which provide benefits in reproduction quality, strike-through, rub-off and misting. In recent years inks employing a water-in-oil emulsion as the basic ink vehicle have been made available, following which it was recognised that only a completely water-based ink would achieve the maximum benefit subject to some modification of the conventional press. This became possible with the introduction of the Anilox short-train inking system to newspaper printing and the Crabtree Vickers Civilex system can be retrofitted to existing letterpress machines which use plastic plates for printing, the system being compatible with the new inks. The Ault & Wiborg Hydronews water-based news ink has been developed and subjected to satisfactory tests at the *Leicester Mercury*. The volatility of water means that aqueous inks will dry quickly on the rollers and forme and also in the etch of the Anilox roller. It is essential therefore that the dried ink film is quickly re-wetted by fresh ink when the press is restarted after a shut-down which has allowed it to dry. It was found that on re-starting the ink was re-wetted easily within three revolutions and no problems were indicated in terms of lubrication.

Eric Chambers

MICRO-GRAPHICS

Writing in the 1983 Annual, we pointed out that 1981-82 saw the introduction of a wide range of micrographic products designed to aid the integration of micrographics and electronic systems. The aim of the major micrographic companies was to ensure that microfilm had a role to play in the automated office of the future and areas with the most potential were seen to be Computer Output Microfilm (COM), where high speed microfilm recorders offered a fast, compact and cost effective alternative to paper for the dissemination and storage of electronically generated information, and Computer Assisted Retrieval (CAR) systems, where the combination of a high density, cost-effective storage medium such as microfilm with the powerful indexing and retrieval facilities offered by the current generation of low cost computer systems can provide the solution to most companies' record management problems.

1982-83 has seen this trend continue with a proliferation of CAR systems and the development of diskette-to-tape converters and low cost COM recorders so that users of micro- and mini-computers and dedicated word processing systems that do not have their own tape drive facilities, can now make use of COM to store their correspondence, reports and statistical records. We describe these new products in more detail later in this review.

It is something of an irony, however, that the very success of the micrographic companies in integrating micrographics with electronic systems may lead to the disappearance of the micrographics industry as we know it. For years the microfilm industry and associations have asserted their independence, arguing the case for microfilm against other competitive storage media and confining their interests to microfilm exclusively. Today, with micrographic systems increasingly being seen as just one element in the automated office systems of the future alongside word processors, a range of computer and telecommunication systems, videotex, facsimile devices and other alternative storage systems whether magnetic or optical disc based, the microfilm companies and the associations that represent the industry have had to widen

their sphere of interest and look closely at the entire range of office automation products in order to be able to argue the case for micrographic systems. In the development of integrated CAR, COM and videomicrographic systems they have had to make increasing use of people from the computer industry and cooperate with the major computer companies in the design of compatible software so that the CAR packages they create can be run on the computer systems already installed throughout the world. 1983, therefore, has seen a number of the major microfilm companies and associations change their names to indicate the fact that they have widened their sphere of interest.

In the USA, 3M has changed the name of its 'Micrographics Products Division' to 'File Management Systems Division' and Kodak has also changed the name of its microfilm division from 'Micrographics–Information Technology' to the more general 'Business Imaging Systems'. In the same way the two major industry associations have dropped the term micrographics from their names. The International Micrographics Congress (IMC) has changed its name to the 'International Information Management Congress' and the US National Micrographics Association has decided to call itself the 'Association for Information and Image Management'. All these moves can be justified but coming together they have led many in the micrographics industry to ask whether there will be anyone left to promote micrographics as opposed to magnetic or optical disc-based systems. Only time will tell whether this move is good for the micrographic business, bringing it to the attention of a much wider market, or whether it will lead to micrographics losing its identity.

Where the industry stands on this probably depends very much on whether its main products are sophisticated CAR, and videomicrographic systems or whether they are simply trying to sell Small Office Microfilm systems comprising a camera-processor and a reader-printer to small companies for whom microfilm itself is new technology. The suppliers of CAR systems will see these moves as inevitable, reflecting the general trend of convergence with previously discrete products being linked in integrated office automation systems. The suppliers of SOM systems will wonder where the industry is going and may feel that their associations have deserted the needs of the smaller members in favour of the up-market side of the business.

It should be said that the problem is not confined to the microfilm industry. Suppliers of word processing systems, copiers, facsimile machines, viewdata systems, computers and a range of other office automation equipment are all having to come to terms with the fact that their products are destined to play a small role in the integrated systems of the future and they must be designed to be compatible with other companies' products. Just how these industries will define their legitimate fields of activity in the future and how the office automation industry structures itself in that future is a matter for speculation. What all the industries must do, and what the micrographics companies are now beginning to do, is to look very closely at the needs of the market and to design systems that are specifically geared to meet them.

In the rest of this brief review of the micrographic industry we shall look at the most significant new micrographic products that were launched in 1982-83, many of which are destined to extend the range of applications for microfilm in the future.

Computer output microfilm

The past year has seen significant advances in the development of Word Processing Output Microfilm (WPOM) systems. The term WPOM is a little misleading as, basically, it refers to systems designed to enable users of micro/minicomputers and word processors who do not have access to tape drive facilities, to output the information created on their systems onto microfilm via a COM recorder. When first introduced COM recorders were designed to operate from standard half-inch magnetic tape produced from mainframe or powerful minicomputers. Then DatagraphiX and other COM recorder manufacturers introduced intelligent COM recorders capable of operating on-line from IBM and IBM compatible main-frame computers. Recently, with the massive growth in the use of small scale diskette-based computer systems, the COM bureaux and manufacturers have been looking at ways of providing diskette-to-COM or WPOM systems, but there have been a number of problems such as the wide range of incompatible formats used, the different sizes of the discs and the fact that the current range of COM recorders operate at such high speeds that online WPOM systems were not a practical solution.

In 1983 two UK COM bureaux–Microgen and Eurocom introduced sophisticated diskette-to-tape conversion systems so that users of diskette-based systems could output their data onto diskettes and send them to the bureaux who would then load them into the diskette-to-tape converters, transfer the data to tape and then use the tapes to run their conventional high speed COM recorders. This route is thought to be more practical and cost effective than attempting to convert the data on diskettes to COM directly as this involves the development of specific software for each type of diskette and the data cannot be read from the diskettes fast enough to make full use of the high output speeds of today's COM recorders. The Microgen system is based on the manual loading of individual diskettes into the converter but Eurocom have taken the process one step further and with their converter, which is based on an IBM Series I computer, the whole conversion process has been totally automated with no manual handling of diskettes required. The Eurocom system has been designed to handle multi-file, multi-diskette runs with one diskette containing a number of files or one file spreading over several diskettes. The key to this is the use of cassettes capable of holding 10 diskettes so customers can send their diskettes to Eurocom in these cassettes and there is no handling involved, the cassettes themselves are simply loaded onto the converter. Two cassettes containing 20 diskettes can be loaded at any one time and the computer can read a total of 120 diskettes in any one run. Both Eurocom and Microgen have made significant investments in the development of these WPOM systems in a bid to open up the market for COM services to include the tens of thousands of users of word processing and small business computer systems.

A second novel approach and one which, in the long term, may

prove to be more significant, has been taken by a US company called Microsize. Instead of adapting the output of small computer systems so it can be accepted by the current generation of expensive high speed COM recorders, they have simply developed a small scale low cost COM recorder that is geared to the needs of the small computer systems rather than the mainframes.

The Micro-COM 1000 is a COM recorder capable of producing microfiche directly from computer data sent on-line from a mini- or microcomputer. It is not a high speed unit but Microsize claim that due to its compact and low cost ($10–20000) it can function as an effective on-line dedicated COM device. It accepts the same page formatting and printing commands as standard printers for easy system integration and produces COM fiche at 42 or 48X reduction according to standard NMA formats. In operation standard ASCII data are transmitted via EIA RS232C serial interface or a Centronics compatible parallel interface which allows the Micro-Com 1000 to be connected to virtually any mini- or microcomputer on the market. In the future Microsize plan to bring out enhanced versions with roll film output, integral processing unit etc. If the system takes off, it will also, no doubt, spawn many imitators and open up a large new market.

The only other trend in the design of COM recorders has been the continuing move towards the use of dry process systems with Bell & Howell, NCR, DatagraphiX, Kodak and 3M, all now offering a dry process unit in their range of COM recorders.

Cameras

The year saw the launch of three significant new cameras, the Canon Canonfile planetary camera, the Kodak Reliant 800 high speed rotary camera and 3M's FS-6 Small Office Microfilm camera-processor unit. All three units are microprocessor controlled and have been designed to be simple to operate, reliable and more versatile than the previous generation of cameras. The Canon Canonfile 100 comes with a choice of two camera heads and can be set to film in roll or jacket mode. In jacket mode it records a blip every 14 frames and leaves a space between every recorded strip of film so that, once it has been processed the film can be loaded into jackets using an automatic jacket inserter unit. In roll film mode it has a tri-level blip encoding facility for users of CAR systems and records a sequential number under each frame. Other features include a range of reduction ratios and automatic exposure control. The Kodak Reliant 800 high speed rotary camera has been specifically designed to increase filming throughput in high volume applications. The 800 can be programmed to automatically imprint sequential numbers on original documents, microfilm them and encode three-level blip codes under each document image for fast automated retrieval on blip-sensing retrieval units. The 800 can operate at speeds of up to 2200ins per minute which corresponds to 720 cheque-sized or 225 A4 letter-size documents per minute and automatic feeders are available to help speed up the recording process.

The 3M FS-6 strip film camera-processor unit has been designed to resemble a desk top photocopier and be as simple to operate, hence further widening the potential range of applications for microfilm in the small office field. Documents are placed on a platen and the FS-6 is claimed to be able to operate at a speed of 1200 documents per hour, delivering fully processed 16 × 148mm strips of film for insertion into jackets. The FS-6 can be programmed to record any one of 7 filmstrip formats at a range of reduction ratios, producing 14 frames at 24X or 25 frames at 42X.

Computer assisted retrieval systems (CAR)

The market for CAR systems, particularly in the USA is growing rapidly and the major micrographic companies, after experimenting with low power turnkey systems based on dedicated microcomputers are all developing more powerful, minicomputer-based systems which are better suited to satisfy the sophisticated retrieval requirements of today's medium and large size organisations. 3M have introduced their Micrapoint II system which can be supplied with hard disc storage facilities and is capable of supporting a number of retrieval terminals and Bell & Howell have introduced Datasearch 2000, a more powerful version of their Datasearch 1000 system. The most significant launch of the year, however, was Kodak's KAR 4000 system, a sophisticated stand-alone CAR system based on a 256 K ADDS Mentor minicomputer and capable of supporting up to 8 IMT 150 terminals. The software for the system has been developed by Acctex Corporation in the USA and it marks the first full turnkey CAR system to be marketed by Kodak. Other turnkey systems launched in 1982-83 include the Viscopoint range of CAR systems jointly developed by Visco Corporation and Datapoint and a full range of minicomputer-controlled CAR systems from Minolta based on their popular range of reader-printers fitted with motorised roll film winds. Roll film still continues to dominate in CAR systems but Image Systems launched their new ISI 6000 integrated CAR microfiche system in 1983 and Consolidated Micrographics launched their Navigator CAR systems based on their 95 and 96 automatic cassette-based microfiche retrieval units.

The year's most novel launch was the Mnemos 6000 information storage and retrieval system, which makes use of electron-beam, optical and electronic technologies to produce a CAR system where the digital indexing data is contained on the microform itself, in this case a 12in diameter plastic disc capable of storing up to 6000 optically reduced document images plus some 150 K bytes of digital data. A master disc is produced in a Mnemos studio using an electron beam recorder. Data to be recorded onto the disc are contained on a standard reel of magnetic tape which is used to drive the recorder. The data are recorded onto a glass master disc which is then used to stamp out the plastic duplicate discs. Once produced the MnemoDiscs are read on a computer controlled work-station with a large rear projection screen and detachable keyboard. The digital data are then scanned and downloaded into the work-station's memory so users can carry out interactive searches, while the document images are displayed optically on the screen. Cost of producing a master disc varies between £1500 and £2000 making the Mnemos system a high volume dissemination system and main application areas are thought to be the distribution of parts catalogues, directories and timetables.

Readers and reader-printers

As in 1981-82 the main growth area has been for portable readers which are being used increasingly by sales representatives and field service engineers to look up their COM parts manuals or source document maps and plans. Agfa have recently launched their new Copex LK 203 briefcase reader to compete with the popular CASE range of briefcase readers from Microphax and in the hand held market, Bell & Howell have brought out their ABR 55, a larger version of their ABR 44 unit while Finlay have announced a number of major orders for their FM I reader. Another new unit from the UK is the new Otamat 102 portable microfiche reader which is being marketed by Microfilm Reprographics. This is a lightweight, compact unit featuring a large 215 × 290mm rear projection screen. Turning to desk top readers, the trend is towards lightweight plastic units such as the new XL series from Micron and the new range of Also readers, while the latest development is the provision of automatic frame retrieval facilities on a range of fiche readers from MAP, Saul, Rhône-Poulenc and a number of other suppliers. These units are set to compete with the wide range of blip counting automatic roll film retrieval readers and reader-printers now on the market including the new Kodak IMT 50 and the 3M 900 page search unit.

With reader-printers, the trend towards plain paper units has continued with Rhône-Poulenc launching their Regma LR7, a universal paper reader-printer which has the unique feature for a plain paper unit of being bi-modal and hence capable of producing a positive plain paper print from a negative or positive film. Moving up the scale too, Xerox are currently about to launch an automated plain-paper aperture-card enlarger printer onto the market capable of producing plain paper prints up to A2 size. Agfa-Gevaert, sensing competition from the Regma LR7, have launched their Copex LX16B, a roll film version of their microfiche plain paper reader-printer which can be fitted with a Visco type image controller for automatic retrieval.

The main thrust then, in the design of readers and reader-printers is to speed up retrieval and hence make them simpler to use and, in the case of reader-printers to offer faster, higher quality output options.

Tony Hendley

VIDEO

If there were any doubts left as to the success of video in the UK, the news in March 1983 that VTRs had displaced cars as the top value import from Japan must surely have dispelled them. It also turned domestic recorders into a political issue, with accusations of dumping, and demands for a restricted quota of exports to the EEC and more machines assembled in the UK and Europe. These demands the Japanese appear to be meeting, having agreed to an EEC quota of 4·55 million units in 1983/84, and with Mitsubishi and Sanyo expected to be producing VCRs in the UK by autumn 1983 (joining Thorn-EMI who are already assembling JVC machines here).

As to the hardware itself, the year has seen a number of developments, some of which are going to have long-term consequences, particularly on the domestic side where the pace is frantic by comparison with the more natural evolution of industrial and broadcast equipment. One consequence of this has been the inclusion of features that are largely redundant in the domestic setting–such as basic insert editing, but which have proved invaluable to the small scale user who previously couldn't have afforded video.

A little higher up the scale, there are industrial Beta and VHS recorders and players, and a VHS editing suite from Panasonic that some now see as a threat to the existence of low-band U-matic, while high-band U-matic they see threatened by the speeded-up professional versions of the half-inch formats. There's such a legacy, though, of hardware and software from the dozen years in which U-matic has been the sole representative in its class, that it isn't likely to be wiped out overnight.

The same can be said for 8mm cine now that 8mm video appears to be moving. At the time of writing the audio standard for the format had been agreed by the famous five–JVC, Hitachi, Panasonic, Philips and Sony–and they were apparently on the verge of agreeing the video. So the first prototypes could appear around Christmas 1983 and the first production camcorders could be on the Japanese market by the end of '84, with PAL models following in '85 (one expects the Japanese companies to react more quickly than Philips). In the meantime, Sony will have put their Beta-Movie camcorder, which takes a full size Beta cassette on the market–Japan and the States in '83, UK in '84. Whether it's intended merely as a stop-gap to open the market, or they're hedging their bets is unclear, but anyone buying it should have no problem obtaining cassettes for a long time to come.

Mavica may also be marketed in early '84, though, at the time of writing, Sony are holding back. Two reasons have been advanced for this: one–picked up by the UK technical press–is that they may not hold the rights to all of the necessary patents; and the other, favoured by the Japanese press, is that the behind-doors negotiations with other companies to achieve a standardised magnetic disc pack for the cameras–said to be resolved back in May–were responsible. Or a mixture of both, perhaps? Certainly any patent problems would have to be cleared up before production commenced.

Mentioning disc, RCA (should) have launched their Capacitance Electronic Disc system in the UK; while JVC have launched their Video High Density system in Japan, and may–just may–launch that in the UK in '84. As for LaserVision, that still doesn't seem to be moving very well, nor does it seem to be finding many industrial, educational and commercial applications. This is probably a result of the considerable number of copies that are needed to make disc manufacture viable–about 1000–which means that any programming must either be very general in content or be intended for a large organisation. The same applies to VHD, which

is also being marketed as a dual-identity system. And the disc players obviously lack the versatility of VCRs.

Which is why coming improvements to the latter's sound and picture quality enlarges the question mark hanging over the present disc systems. Sound improvements will be through what's become known as 'Hi-fi video', and the picture through metal tape.

Whereas previously audio has been recorded on a linear edge track at tape speeds of 1·873cm/s (Beta) and 2·339cm/s (VHS), the new machines will record the audio on an FM carrier through the video heads at 6·6m/s and 4·83m/s respectively (with the edge track left for compatibility). Thus, claims of a 20kHz bandwidth, dynamic range of 80dB and negligible wow and flutter seem quite reasonable.

On the video side, samples of metal coated tape have been given to VTR manufacturers–from domestic to broadcast–to enable the development of machines capable of exploiting the very fine particle coating. But, in the meantime, several companies have launched High Grade ferric tapes that give a small but still useful improvement over the standard formulations (and have cassettes manufactured to higher tolerances). These are being recommended for archive use, and to compensate in part for the quality loss experienced with the new half-speed VHS standard.

New to us, that is, NTSC machines–Beta, as well as VHS–have three tape speeds to choose from, though they normally make do with two (neither of which corresponds to the PAL speeds–designated Standard Play and Long Play). Fortunately, the quality loss is minimal on the video side, because the speed constitutes less than 0·5% of the writing speed, so what loss there is comes from the slightly narrower video tracks–which have their own pair of heads on the drum scanner. But the audio is directly affected, so it's a job for 'Hi-Fi Video'. Whether Beta will follow suit and halve their 20% slower speed remains to be seen. But the V2000 partners–Philips and Grundig–have been able to take advantage of their double-sided cassette to develop auto-reverse, giving eight hours without the associated loss of quality.

Both VHS and V2000 formats now have their compact offshoots, employing mini cassettes in the fashion of U-matic portables. The VHS-Compact cassette carries thirty minutes of tape, the Video Mini Cassette carries 2 × 1 hour; both can be fitted into adaptors for recording and playing in conventional machines. At the time of writing VHS-C had only recently been launched and VMC was still expected, so it's too early to judge whether they will answer the needs of the advanced amateur and light professional. VHS-C may well find a niche in Japan and the USA, and VMC in European countries like West Germany, but the vast majority of the UK buyers are staunchly domestic (or perhaps they're just waiting for 8mm video?), so the immediate impact here is likely to be slight to say the least.

It's the same with solid-state domestic cameras; they're unlikely to prove any more tempting than the tubed variety. But Hitachi has led the way with their VK-C2000–incorporating a Metal Oxide Semiconductor image sensor–and the impetus isn't likely to be stopped by the minimal response of the British public. Solid-state image sensors have advantages over conventional pick-up tubes: they're smaller and lighter, more robust, use less power, they resist after images and burn-in, and they have the potential for far cheaper mass-production. Though for industrial and especially professional use, where the reject rate is at present high, they're very expensive.

In this they're rather like the tiny, black-and-white flat screen LCD TVs launched by companies like Casio and Seiko. Gimmicky at the moment, but when their prices come down they'd make ideal viewfinders for solid-state cameras.

Not that pick-up tubes are dead yet. The vast majority of cameras, from broadcast studio down through ENG to industrial to domestic still use them. And in the last category upmarket tubes have been adapted and are being manufactured at cut price to provide a level of quality that would have seemed impossible only two or three years ago. The Saticon tube–originally developed by Hitachi–has virtually replaced the basic vidicon. In the process, spawning a scaled-down–12·7mm–version that gives results almost equal to the 17mm size, but with a lower power consumption, as well as reduced size and weight–enhanced by shorter focal length zooms. The Newvicon is another example: originally developed by Matsushita as a black-and-white tube for low light work, it's been turned into a 17mm colour tube that–in the first cameras from JVC–can give a usable picture in light levels down to 10 lux at $f/1.4$.

The cost of processing equipment is also falling. Such things as image enhancers, which can reduce the quality loss caused by dubbing from one tape to another when editing–just the thing for video weddings, and such like. Up in the broadcast category, digital post-production equipment continues to find favour, even among film companies who appreciate the instant effects.

But if all seems to be going reasonably smoothly on the hardware side, the same certainly can't be said for pre-recorded software. That's an area that continues to be enmeshed in problems: too many second-rate films, too little quality control, too many shops, too few customers; and, of course, piracy. The video software industry has managed to get itself some preferential legal treatment to fight it–largely due to the publicity–but it's still only tip-of-the-iceberg stuff, and organised piracy remains a good paying game.

It could be that it will take cable and satellite TV to put a stop to it, by removing most of the demand for software–legal and illegal. Though, if the cable experience in the States is anything to go by, it's not going to happen overnight–and neither will profits, it seems. Which would make it rather a pity that the go-ahead has been given without waiting for fibre optic technology, for that would have provided enough alternative applications to pay its way whatever became of cable TV.

And too much choice can be just as irritating as too little.

Reginald Miles

HOLOGRAPHY

Since this is the first review of holography to appear in the *Annual*, it looks back a little farther than just the past year.

As a practical technique, holography has been around for more than twenty years; but for much of that time it was regarded as of little more than academic interest. The ability of holography to produce a precise record of an object in three dimensions led to its eventual use in archives and in metrology, and its ability to make visible very small changes in shape resulted in its use in non-destructive testing, in stress and vibration analysis, and in quality control. The unique properties of the holographic image have attracted an increasing number of practising artists to the technique as a means of self-expression; and British display holography, which began life in earnest with the 'Light Fantastic' exhibitions of 1977 and 1978 at the Royal Academy in London, has reached a level of technical excellence unimaginable only a few years ago.

Science and technology

In the measurement of strain, wear and vibration, holographic interferometry offers a variety of techniques which are now becoming standard practice in test laboratories. They all depend on one or other variation of a multiple-exposure technique: any movement or distortion of the object under examination between the exposures is contoured in the holographic image by dark and light fringes, each pair of fringes representing a change in position equal to one half-wavelength of light. In the quality control of components which need to be manufactured to very fine limits, each component is successively placed in the image space of a hologram of the master pattern; more than the maximum specified number of fringes present means rejection. Recently, a broadly similar method based on laser speckle interference has been evolved at Loughborough University; in this technique the image of the pattern is held on an electronic storage tube for comparison. This avoids the need to expose and process a photographic plate. A second technique, holographic shear interferometry, uses double-pulse laser illumination, the pulses separated by an appropriate interval: this can clarify the nature of the motion of rapidly-moving objects. It is being routinely used in the examination of the behaviour of turbine and fan blades, car silencers and the soundboards of musical instruments. A third technique is a development from so-called time-averaged interferometry, which in its simplest form records the position difference in a vibrating surface at its stationary extremes of travel. Stroboscopic techniques make it possible to record all stages of the oscillation rather than only its extremes, so that by moving the hologram relative to the reconstruction beam the entire motion can be analysed, using the moving fringes for measurement. This, too, can be accomplished using laser speckle techniques, and is currently being employed in the design of high-quality loudspeakers.

Holography has taken its place alongside radiography and infrared photography in non-destructive testing. For example, retreaded aircraft tyres are checked for satisfactory bonding by making two holographic exposures of the inside of the tyre casing, changing the air pressure in the containing vessel between them. Any imperfect bonding is contoured by fringes. A similar technique is being used in Italy to study the layers of pigment in old paintings before making decisions concerning restoration techniques. By changing the ambient temperature by a few degrees between exposures, the differential expansion of partially-detached pigment is shown up by fringes.

In the Soviet Union it has become routine to record artefacts found at archaeological digs by holography; this not only provides a microscopically accurate record, but also saves a good deal of time. Holograms of Russian art-objects too precious to be sent on exhibition are regularly shown in foreign countries in their stead. Nearer home, holograms of jewellery and valuable objects are being used increasingly for insurance purposes.

An important role currently being played by holography is in the restoration of the renowned second-century bronze equestrian statue of Marcus Aurelius in Rome, in which the more heavily-stressed parts have become progressively distorted until the statue is now in danger of collapsing under its own weight. Holographic stress analysis has been a valuable source of information. At the same time, laser transmission holograms of the statue before and after restoration are providing an exact record that is of archival permanence: it will be possible to compare these with further records made perhaps hundreds of years later. A similar problem occurs in the somewhat different environment of a nuclear reactor. It is plainly important to keep accurate measurements of the fuel elements so that any distortion can be identified without delay; but viewing has to be through a window of lead bromide one and a half metres thick. Photographic material placed in the chamber is quickly fogged by radiation, and, in any case, from any practicable viewpoint the greater part of the fuel pins is obscured by the supporting brackets. Holographic emulsions are almost insensitive to ionising radiation, and a hologram can show the subject in depth. By projecting the real image into the laboratory space, measurements can be made with microscopic accuracy; and, as with the Roman statue, compared with measurements made many years earlier or later.

Holography is finding increasing uses in medicine. One promising area is indicated by a research programme by the New York Institute of Technology into improvements in prostheses such as artificial hip joints, using holographic stress interferometry and aiming at a design that gives the closest approach to the stresses present in healthy bone. The Department of Medical Physics at the Royal Sussex County Hospital is currently working on a project involving computerised tomography (body-scanning) in which a series of two-dimensional x-ray slices of the body are used to construct a three-dimensional image which can be stored holographically and used to set up equipment for radiation therapy. Holography is also helping at the administrative level: the

maintenance of dental records by holographic means is the subject of another piece of research at the same hospital. At present a large part of these records, namely those of dental impressions, is necessarily three-dimensional; central filing systems at present involve the storage of literally millions of dental moulds for up to twelve years. The demand for storage space is colossal, but the problem is neatly solved by holography; as a bonus, a virtual image of a dental impression becomes a real image of a dental cast merely by flipping the hologram through 180°.

The theory of holograms was fairly fully worked out even before the first viable holograms were made, but it was not until some years after this that it was appreciated that a hologram could be thought of as a rather special type of mirror (or lens). Although holograms operate by diffraction rather than by refraction or reflection, they still obey the laws of geometrical optics, and it is comparatively easy to make the holographic equivalent of lenses and curved mirrors. Holographic optical elements work for only a narrow band of wavelengths, but this is not necessarily a disadvantage. For example, in a holographic mirror, only a narrow band around the laser wavelength is reflected; other wavelengths pass through the hologram unaffected. This property has made it possible to construct head-up displays of very high efficiency for aricraft. The display, which originates on a video tube, has a wavelength range limited to the reflected band, and the holographic mirror (through which the pilot sees the terrain directly) is transparent to all other wavelengths. This results in a very bright display, coupled with excellent transmittance of the scene itself. In addition, the thinness of the optical component means that it is possible to cover a much wider angle than with conventional optics. Such displays are becoming standard in military aircraft, and are now beginning to be adopted for civil aircraft too. Such a display is particularly useful in low-level night flying, as it can superimpose an image-intensified view of terrain on what the pilot actually sees through the windscreen, with a realistically wide angle of view.

Holographic optical elements are beginning to appear in other places too: for example, Canon's up-market sound Super 8 movie camera the 1014XLS has a holographic indicator for the beginning and end of the film, projected into the viewfinder. Holographic images are also being introduced into a number of advanced video games.

For supermarket checkouts, a scanner has been designed which will read bar codes without the necessity for running the code area over a small detector. The new system generates a complex light-scan pattern using a holographic optical element which splits a laser beam into a large number of beams which intersect in space.

Holographic coding has replaced magnetic coding in some types of credit card. When inserted into a machine, a holographic strip contained in the card generates a pattern of spots which can be matched to an internally-generated pattern and identified as genuine. When the card is used for, say, telephone calls paid for in units, on insertion the credit value is read off the holographic code and displayed; during use the credit is progressively destroyed by heat; at the end of the call the remaining credit is shown.

Advertising and commerce

In this country at least, display holography has until recently had an insecure footing. This has not been because of inadequate technique; on the contrary, British holography has led the world in this respect, and still does. The trouble seems to have been a combination of bad marketing and lack of creative flair. Fortunately, the past two years have seen the beginnings of collaborations between excellent technicians and equally excellent art directors, and display holography has now unquestionably come of age. Large holograms are regularly appearing as the centrepieces of displays at exhibitions, and to an increasing extent in the boardrooms and foyers of manufacturing companies.

Perhaps the most important event in commercial holography has been the appearance of the embossed hologram. A hologram is basically an interference pattern, and by the use of suitable materials and processing this pattern can be produced in relief. A nickel replica grown on this relief can be used to make a metal stamper, making it possible to press long runs of holograms in reflective plastics material in much the same way as gramophone records. Last year the first book containing a hologram was published in the United States. A company, Applied Holographics, has now been set up in this country to manufacture embossed holograms; one of its first successes was the hologram which appeared on the cover of the rock album 'UB 44' in a limited(!) edition of 100000, which sold out in a few weeks.

Anyone might have thought that no new optical configuration for a hologram remained to be discovered, but Kaveh Bazargan at Imperial College, London, has found one. He has succeeded in producing white-light transmission holograms which are not only achromatic (uncoloured), but have vertical as well as horizontal parallax. Development is continuing with a view to using this new type of hologram in educational material.

Owing to advances in pulsed-laser technology holographic portraiture has become more manageable, and portraits of a large number of celebrities have been made and exhibited. The problems of dilated pupils and waxy skin texture have been overcome, and at least one company (Lasergruppen of Sweden) offers holographic portraiture on a commercial basis.

Holography on show

The biggest event of 1983 has undoubtedly been the Royal Photographic Society's exhibition 'Light Dimensions' at the National Photographic Centre in Bath. This was opened on 22 June by Princess Margaret, and continued, with record attendances, until 10 September. This was the most comprehensive exhibition of holography ever held. A gallery devoted to 'Pioneers of Holography' contained virtually all the 'firsts' up to 1980, including the very first hologram ever made. There was a large section devoted to applications of holography, and the whole of the Octagon area was given over to holographic art works, with contributions from all the foremost exponents of the medium. There was a special section for children, with exhibits hung at an appropriate height. In the Society's newly-completed lecture theatre there was a programme of lectures on various aspects of

holography by some of its leading figures, while in the basement Richmond Holographic Studios had set up a fully-operational holographic table and were running short courses in practical holographic technique.

On a more modest scale has been a travelling exhibition called 'The Holography Show', staged by Michael Wenyon and Susan Gamble. The works are by former students and staff of Goldsmiths' Holography Workshop (now, sadly, in suspension for lack of public funds). During the year the exhibition visited Cardiff, Bath, Wolverhampton, Newcastle and Stoke-on-Trent, attracting considerable interest at each venue. In London, the Light Fantastic Gallery in Covent Garden continues its permanent exhibition of art and display holograms, many of them made to its own commissions for sale to the public. Several establishments of higher education have introduced holography as an option for a final-year project in degree and diploma courses in visual communication, so that holograms have begun to appear in their summer exhibitions of students' work. All in all, 1983 has been a good year for holography.

Graham Saxby

COLOUR PHOTOGRAPHY

The twelve months from mid-1982 to mid-1983 have seen the introduction of a number of new colour negative films but relatively few reversal materials. The impetus for the larger number of negative materials has undoubtedly come from the introduction of Kodacolor HR film, the material specifically intended for the Kodak disc system, where the demands made for superior image quality led to the use of a number of improvements in colour film technology. These, in turn, appear to have led to the production of superior materials in other film sizes.

Colour negative films

The first of the competing manufacturers to offer a colour negative film in the disc format was Fuji with Fujicolor HR disc film. This product, first noted at photokina in October 1982, began to be marketed in the spring of 1983 and appeared to have excellent qualities.

An even more noteworthy film, also launched at photokina, was Kodacolor VR1000, a colour negative film with a speed rating of ISO1000, moderate graininess and excellent sharpness. Kodacolor VR1000 incorporates a number of innovations in colour film manufacture but the most notable of these is undoubtedly the use of silver halide crystals of tabular form. The 'T-grain' emulsions, so-called, are used in the fast red and green sensitive layers of VR1000 and are responsible for the extremely high speed and good image quality of this remarkable film.

In the spring of 1983 Kodak introduced three more new Kodacolor films, VR100, VR200 and VR400 with ISO speeds of 100, 200 and 400 respectively. These films, although not incorporating the tabular-grain technology, do use a number of other developments in colour film manufacture, all of which make a contribution to the improved image qualities of the new products. All of the Kodacolor VR negative materials are available only in 35mm format and are intended for processing in the standard C-41 solutions.

Slightly ahead of the Kodak announcement, Fuji also introduced two improved colour negative films, Fujicolor HR100 and HR400. A number of new manufacturing techniques are also claimed to be used in the production of these two films, which have speeds of ISO100 and 400 respectively, and these also make a discernible improvement to the quality of the images which the films display.

Also in the early months of 1983 Ilford re-entered the colour negative film market with two films, Ilfocolor 100 and Ilfocolor 400, with speeds of ISO100 and 400. These materials, manufactured for Ilford in Japan, are intended for the C-41 process and proved to have good qualities and to be fully compatible in processing – a characteristic which simplifies the handling by photofinishing laboratories.

A new and modified type of Sakuracolor 400 film was introduced by Konishiroku at photokina 1982 and this film, too, proved to be a good quality material on test, with a high level of sharpness and low graininess. Further improvements in Sakuracolor materials are promised with the introduction of Sakuracolor (or Konicacolor) SR100 and 400 materials.

Colour reversal films

Six new colour reversal films were announced by Fuji at photokina 1982 for introduction, it was said, sometime in the following spring. In the event the introduction of these materials took place only in Japan and at the time of writing they had not been made available in the rest of the world. Two of the new films are intended for amateur use and are to be available in 35mm format only. Speeds of these materials are ISO50 and 100 and both are claimed to have excellent sharpness and low granularity with clear and brilliant colour reproduction. These characteristics are said to stem from newly developed technologies of great significance. The Fujichrome professional colour reversal films comprise two daylight materials, one of ISO speed 50, the other ISO100, a tungsten balance film with a speed of ISO64 and a duplicating film. The daylight professional materials will be available in 35mm, 120 and sheet film formats, the tungsten balance film in 120 and sheet film sizes, and the duplicating film as sheet film only.

Although not mentioned earlier, 3M quietly introduced a colour reversal film with a speed of ISO1000 early in 1983. This film, under the name Color Slide 1000, proved to have good colour reproduction, moderate graininess and good sharpness when tested. Like the tungsten balance film with a speed of ISO640 introduced by 3M a year earlier, the ISO1000 daylight film is a unique product and one which greatly broadens the scope for

photography under poor lighting conditions or circumstances which call for the use of high shutter speeds with lenses of restricted maximum aperture. Like all the new Fuji reversal materials, 3M Color Slide 1000 is processed in E-6 solutions but the 3M film is available only in 35mm format.

Motion picture materials

Although little more than a year had gone by since Eastman Color High Speed negative film, Type 5293, was introduced, Eastman Kodak gave details of an improved and higher speed version of this film in November 1982. Coded 5294 (and 7294 for 16mm) the new film became available in the autumn of 1983; like all colour negative materials for motion picture use, 5294 is balanced for tungsten illumination and in this lighting has a speed of ISO400. The 16mm version has a speed rating of 320. Both films are characterised by high sharpness, fine grain and excellent colour rendition, according to the manufacturer.

Doubtless in response to agitation on the part of some producers Kodak have also introduced a new Eastman Color Print film with improved dark-keeping dye stability. Coded 5384 (and 7384 for 16mm) the new film has the additional advantage of a shorter processing time. A similar improvement in dark-keeping dye stability is claimed for another new print film, Eastman Color LC Print film, Type 5380 and 7380. This film is designed specifically for making low contrast colour release prints suitable for television use.

Finally, to complete the family of new colour negative films for the motion picture industry, Kodak have introduced a new 16mm film with a speed of ISO100. Formerly the ISO100 colour negative film in 16mm format from Kodak was identical to the 35mm product. The new 16mm film is an improved material designed specifically for the narrower gauge and has improved grain and sharpness, better dye stability and can be pushed in processing. The new film is coded 7291.

Colour print materials

Although announced at the end of September 1982 and demonstrated publicly at photokina in Cologne and 'Photography At Work' in Brighton in February 1983, Agfachrome-Speed, Agfa-Gevaert's revolutionary print process, became available only at the end of the year. Agfachrome-Speed is unique in that it is a single-sheet, single-bath process for making prints from transparencies and is relatively insensitive to variations in temperature of the processing solution. After exposure in the conventional fashion in an enlarger the sheet of Agfachrome-Speed is processed in a dish or drum for $1\frac{1}{2}$min in an alkaline activator solution between 18 and 24°C. The only further processing needed is a 5min wash. Gradation can be altered by dilution, or addition of potassium bromide solution to, the activator. Agfachrome-Speed will be available in a range of sheet sizes from 5×7in to 20×24in.

George Ashton

PROCESSING BLACK & WHITE

General Instructions

Making up solutions

Glass, plastic, new enamel or stainless steel vessels should be used. The chemicals should be taken in order and each completely dissolved before adding the next, using about three-quarters of the final volume of water. Cold or tepid (35-40°C) water should be used, *not* hot water (exceptions are given below). Distilled or deionised water should preferably be used in making up the solutions, particularly the first and colour developers, but this is not essential, and tap water may be used. If the water supply is too hard, it is helpful to add, particularly to water destined for black-and-white and colour developers, *before* dissolving any other chemicals, 2g/l of a sequestering agent: Calgon, sodium hexametaphosphate, or sodium tripolyphosphate.

Anhydrous carbonate should be dissolved separately in about three times its own bulk of hot water. Hot water must also be used to make up a hardener-bleach, which may throw down a white precipitate when cold, but this does not affect its working; stop baths are best made up cold. Time can be saved by using 20% solutions of thiocyanate and bromide instead of solid reagent. Phenidone should be dissolved after the hydroquinone and alkalis.

All solutions should be allowed to stand for about 30min and filtered before use.

Practical metric measures (g=grams; ml=millilitres (=cm³ for practical purposes); °C=°Celsius) are used throughout.

Chemical names and synonyms

As far as possible the current preferred names have been used for chemicals. These are the names under which they will generally appear in manufacturers' catalogues. However, earlier editions of the *Annual* and *Almanac*, and formulae from other sources, may make use of alternative names. The most important of these are listed here:

Acid EDTA (see EDTA)
Borax (=disodium tetraborate)
Calgon ([trade name]=sodium hexametaphosphate)
Caustic soda (=sodium hydroxide)
Chlorquinol (=chloroquinol *or* chlor-hydroquinone)
Chrome alum (=chromic potassium sulphate)
Diethylene glycol (=digol)
2,5-Dimethoxytetrahydrofuran (=tetrahydro-2, 5-dimethoxyfuran)
Disodium phosphate (=disodium hydrogen or orthophosphate)
EDTA (=ethylenedinitrilotetra acetic, often called ethylenediamino-tetra acetic acid *or* ethylene bisiminodiacetic acid). The acid has been referred to variously at times as Acid EDTA, EDTA, EDTAA, Ethadimil, Acide tetracémique, Havidote and tetracemic acid. Trade names include Irgalon and Sequestrene or Sequestrol (Geigy), Versene (Dow), Questex, Tetrine, Kalex, Trilon B, Komplexon, Complexone, Nervanaid (ABM Industrial Products Limited). Salts of this acid used photographically are EDTA NaFe (=EDTA ferric monosodium salt) and EDTA Na₄ (=EDTA tetrasodium salt). The name edetic acid for the acid, the salts being edetates, has recently made its appearance in the British Pharmacopoeia Codex and the US Pharmacopoeia.
Ethylene diamine (=1, 2-diaminoethane)
Formaldehyde (=formalin)
Glycin (=para-hydroxyphenylglycerine *or* para-hydroxyphenyl aminoacetic acid)
IBT ([trade name])=benziotriazole)
Kodalk ([trade name]=sodium metaborate)

Monopotassium phosphate (=potassium dihydrogen orthophosphate)
Monosodium phosphate (=sodium dihydrogen orthophosphate)
Potash or potassium alum (=aluminium potassium sulphate)
Pyrocatechin (=catechol *or* 1, 2-dihydroxybenzene)
Sequestrene NaFe ([trade name]—see EDTA)
Sodium bisulphate (=sodium hydrogen sulphate)
Sodium bisulphite (=metabisulphite)
Sodium hydrosulphite (=sodium dithionite)

Hydrated salts

Many of the salts used in these formulae may be obtained alternatively in anhydrous or hydrated forms, in some cases in several states of hydration. Some of the principal of these are as follows:

Disodium hydrogen orthophosphate—available with 2H₂O, 7H₂O (relatively rare) or 12H₂O. The relative quantities required are 1·00, 1·50, 2·00.

Ethylenediamine—in its hydrated form contains 80% of the pure substance: relative quantities to be employed are therefore 1·00 and 1·25.

Magnesium sulphate—has 1H₂O in its hydrated form or 7H₂O ('Epsom salts'). The relative quantities required are 1·00, 1·15, 2·05. The so-called dried form is of variable composition.

Sodium acetate—has 3H₂O in its hydrated form. The quantity relative to anhydrous required is 1·66:1·00.

Sodium carbonate—available anhydrous, 1H₂O (soda ash) or 10H₂O (washing soda). The relative quantities required are 1·00, 1·26, 2·69. Although specifications are frequently quoted in terms of the anhydrous salt, this is more difficult to dissolve than the stable monohydrate, sold as soda ash (note: this is available in a range of purities—many too impure for photographic use). The decahydrate, washing soda, tends to lose water of crystallisation and go powdery: its composition is then indefinite.

Sodium dihydrogen orthophosphate—usually with 2H₂O. The quantity required relative to the anhydrous material is 1·30:1.

Sodium sulphate is available in the anhydrous form and with 10H₂O. The relative quantities are 1·00 and 2·27. The anhydrous form may be unreliable unless dried before use.

Sodium sulphite—anhydrous, 7H₂O or 10H₂O. Relative quantities required are 1·00, 2·00, 2·27.

Sodium thiosulphate—has 5H₂O in hydrated form. Quantity required relative to anhydrous is 1·57.

Trisodium phosphate—has 12H₂O in hydrated form. Anhydrous and hydrate are not interchangeable by equivalent weight as the latter is more alkaline.

Alkali solutions

Sodium hydroxide—although the traditional form of sodium hydroxide is as sticks or pellets, a convenient form of purchase for the small user is as a 40 or 50% weight/volume solution, which keeps indefinitely if stoppered. The weights specified for pellets should be multiplied by 2·5 or 2 respectively. The pellets and sticks absorb both CO₂ and moisture readily.

Ammonium hydroxide—the standard form is '880 Ammonia', a reference to its density. This solution is 35% weight/volume. Dilution to 20 and 25% requires dilution with water in the ratios 100:75 and 100:40 respectively.

Activity

When strict accuracy is essential, the pH-value may be checked with a pH-meter (test papers are not suitable) and adjusted to the standard value by the addition of caustic soda (sodium hydroxide) pellets or flakes or the 40 or 50% solutions mentioned above—it is safest to use the dilute solutions—to raise the pH-value or, if necessary, sodium metabisulphite or acetic acid to lower it. Liquid pH indicators, eg BDH, may be useful to the amateur, available from pharmacies.

Chemical suppliers

Most chemicals quoted in *The British Journal of Photography Annual* are available from Rayco Limited, Rayco Works, Blackwater Way, Ash Road, Aldershot, Hants, telephone 22725, or Photo Chemical Supplies, 21 Lodge Close, Cowley, Uxbridge, Middx UB8 2ES (Tel: Uxbridge (0895) 35707). The companies are willing to add to their chemical lists, which can be obtained by sending a stamped addressed envelope, according to user requirements. Koch-Light Laboratories Limited, Colnbrook, Buckinghamshire SL3 0BZ, telephone: Colnbrook 2262-5, stock a very complete range of chemicals, especially organic ones, and are suppliers to the large scale user, trade, and industry. The Rexolin Division of W. R. Grace Ltd, Northdale House, North Circular Rd, London NW10 7UH supply EDTA, EDTA salts and chelating agents.

Negative Developers

FINE GRAIN FORMULAE

All the formulae included here will give some refinement of grain over the developers in the other sections at a given exploitation of a film's speed. The actual degree of refinement will closely relate to the film speed reached *vis-à-vis* the normal ASA rating. Any increase in speed will give some increase in grain, although this can be kept to a minimum in carefully balanced formulae. On the other hand, very fine grain will only be obtained at some, say 1/2 stop, loss of film speed. When maximum sharpness and definition are required, refer to the Acutance Developer section: this gain may be at the expense of a slight increase in granularity and some loss of middle-tone gradation.

MEDIUM FINE GRAIN

D-76

Metol	2·0g
Sodium sulphite, anhydrous	100·0g
Hydroquinone	5·0g
Borax	2·0g
Water to	1000·0ml

D-76 Replenisher
Metol	3·0g
Sodium sulphite	100·0g
Hydroquinone	7·5g
Borax	20·0g
Water to	1000·0ml

This developer has come to be taken as a standard against which the granularity, speed, sharpness and definition given by other developers is compared. Thus a formula will be said to give such and such speed increase or loss, increased or less granularity, or higher acutance than D-76. It is also marketed as ID-11. The use of the replenisher quadruples the life of the developer, which is otherwise about ten films per litre. Use of replenisher without dilution to maintain level of solution in tank D-76 gives some rise in activity on use and storage, the addition of 14g/litre of boric acid crystals provides additional buffering, which will even out its action and give greater contrast control, with a 10-20% increase in developing time.

Adox M-Q Borax

Metol	2·0g
Sodium sulphite, anhydrous	80·0g
Hydroquinone	4·0g
Borax	4·0g
Potassium bromide	0·5g
Water to	1000·0ml

This variant formula of D-76 gives slightly better sharpness with a slower contrast rise. Development times are 10-20% longer. It is closely related to the ASA developer for miniature films, and the Ansco M-Q Borax formula.
For a Phenidone variant of this formula, see FX-3 and FX-18 (preferred) below.

Adox M-Q Borax Replenisher

Metol	3·0g
Sodium sulphite, anhydrous	80·0g
Hydroquinone	5·0g
Borax	18·0g
Water to	1000·0ml

Add 15-20ml of replenisher for each 36 exposures of 35mm film or 120 size rollfilm in one litre or more, discarding some developer if necessary. This maintains quality and developing time.

ID-68 Ilford P-Q Fine Grain formula

Sodium sulphite	85·0g
Hydroquinone	5·0g
Borax	7·0g
Boric acid	2·0g
Phenidone	0·13g
Potassium bromide	1·0g
Water to	1000·0ml

This buffered borax formula gives a marked film speed increase over D-76—about 30-60%, with a minimum increase in granularity, and good sharpness. Times 6-12min at 68°F. The developer, to be used undiluted, has a minimum change of activity with use. Results are comparable to Ilford 'Microphen'.

D-23

Metol	7·5g
Sodium sulphite, anhydrous	100·0g
Water to	1000·0ml

Increase development time by 10% after each film, until 8-10 films per litre have been processed. Use of replenisher extends life to 25 rolls per litre. Negligible film speed loss.

D-23 Replenisher

Metol	10·0g
Sodium sulphite, anhydrous	100·0g
Kodalk	20·0g
Water to	1000·0ml

Add 20ml for each 36 exposure length or 120 size rollfilm, discarding some developer if necessary. The amount applies to replenishment of 1 litre of developer or more. Replenisher identical to that for D-25.
This developer by R. W. Henn and J. I. Crabtree is the simplest medium fine grain formula. In general it gives good sharpness with slight resolution loss on some films; it is softer working than the D-76 type, and may give a slight increase in granularity; film speed very closely approaches normal. Those

workers beginning to weigh and make up their own solutions are recommended to try this formula in use with slow, medium speed films. Diluted 1+3 it resembles the Windisch compensating formula—see page 169— developing time 20-30min approximately for slow and medium speed films. Use once and discard. With the Metol reduced to 5g it becomes Ferrania R23, giving still greater compensation for exposure errors and high contrast.

D-76d, D-76b, Agfa 14, Agfa 15

D-76d is a 'buffered borax' version of D-76 (see also notes to D-76) giving greater contrast control, more consistent results on re-use, with a slight speed loss, and 25-50% time increase. Agfa 14 gives results similar to D-23 with similar times. D-76b is a motion picture and variable density sound track developer giving softer results than D-76 with similar times. Agfa 15 is suitable for some modern films notably the slow and medium speed ones, times 25% less than D-76 or ID-11, times in which are given in manufacturer's data sheets. The use of these formulae has fallen off in recent years, with the exception perhaps of D-76d. (See also the Ilford published P-Q fine grain formula ID-68 for a Phenidone buffered-borax developer above.) The Ferrania developer R18 is identical to D-76d.

Constituents	Quantities in grams			
	D-76d	Agfa 14	D-76b	Agfa 15
Metol	2	4·5	2·75	8
Sodium sulphite, anhydrous	100	85	100	125
Hydroquinone	5	–	2·75	–
Sodium carbonate, anhydrous	–	–	–	11·5
Borax	8	–	2·5	–
Boric acid	8	–	–	–
Potassium bromide	–	0·5	–	1·5
Water			to 1 litre	

FX SERIES

This series of fine grain formulae was proposed by G. W. Crawley after lengthy research into the development process. *(Brit J Photog*, Vol 107, 2, 9, 16, 23, 30 December (1960) and *ibid*, Vol 108, 6, 13, 27 January (1961)). He found that when the third quality of acutance was added to the requirements of minimum granularity and full film speed, changes might be advantageously made to the type of alkalinity and buffer system employed in a developer. Furthermore, makes and types of film differed in the alkali-buffer restrainer system required to obtain best definition. FX-4 is a variant of the Adox and ASA evolution of D-76 referred to above, giving higher film speed and more compensation, FX-5 gives very fine grain with the natural concomitant slight speed loss. FX-11 is balanced solely to give the fullest possible speed increase with the minimum granularity increase. FX-19 is a D-23 type formula giving, however, fuller emulsion speed. All modern films may be developed in any of these developers. FX-15 is the more suitable for the very fastest, as it gives the biggest contrast rise on extended development for low brightness range subjects. FX-18 is a P-Q version of D-76 claiming slightly higher resolving power, with a slight reduction in grain and minimal speed increase allowing use at stock strength without speed loss. FX-15, added to the formulae series in the 1983 *Annual* is a further development of FX-3, now omitted, giving ⅓rd stop effective speed increase over FX-3, with similar grain and an improved characteristic curve, similar to Paterson Acutol-S, now discontinued.

Approximate meter-settings/makers rating

FX-5	−30%
FX-18	+30%
FX-19	+30%
FX-4	+60%
FX-15	+60%
FX-11	+80%-100%

Constituents	Quantities in grams					
	FX-5	FX-19	FX-15	FX-4	FX-11	FX-18
Metol	5	–	3·5	1·50	–	–
Phenidone	–	0·75	0·1	0·25	0·25	0·10
Hydroquinone	–	7	2·25	6	5	6
Glycin	–	–	–	–	1·50	–
Sodium sulphite anhydrous	125	100	100	100	125	100
Borax	3	–	2·5	2·5	2·5	2·5
Sodium carbonate	–	–	1·0	–	–	–
Sodium metabisulphite	–	–	0·5	–	–	0·35
Boric acid	1·5	–	–	–	–	–
Potassium bromide	0·5	–	1·5	0·5	0·5	1·6
Water			to 1 litre			

In the FX-4 and FX-5 formulae dissolve a pinch of the sulphite first, then the metol, next the rest of the sulphite. Always dissolve the hydroquinone with or before the Phenidone, to prevent any temporary oxidation of the latter.

Average Capacity

FX-5	4-5 films per 600ml, 20% increase after each film.
	8-10 films per 1200ml, 10% increase after each film.
FX-19	5 films per 600ml, 10% increase after each film.
FX-11, FX-15	5-6 films per 600ml, 10% increase after each film.
FX-18, FX-4	6-8 films per 600ml, 10% increase after second or third and the subsequent ones.

Development times

In minutes at 20°C (68°F), using one tank inversion a minute or the normal in larger vessels.

Ilford	FX-19	FX-15	FX-4	FX-11	FX-18
Pan-F (MF)		4	4		6·5
Pan-F (RF)	as for	5	5		7·5
FP4 (MF)	FX-15	5	4·5		9
FP4 (RF)	but	7·5	7		9
HP5 (RF)	slower	8	7	as for	8
HP5 (MF)	contrast rise	7	6	FX-15	7
Mark 5		7	6		7

Kodak	FX-19	FX-11 FX-15	FX-5	FX-4	FX-18
Pan-X (MF)		5	8	5	5·5
Pan-X (RF)	as for	6	9	5·5	6
Plus-X Pan (MF)	FX-15 but	5	9	5	5
Plus-X Pan Prof (RF)	slower contrast	6·5	9	6	7
Veripan	rise	7	10	7	7·5
Tri-X (MF)		7	10	7	8
Tri-X (RF)		9	12	9	10
Royal-X		10-15	Pointless	9-15	15

Changes in development times

Make a note of film batch numbers, and when using a new batch, watch for any unusual contrast change and adjust development time in future accordingly. The brief times above (e.g. on Ilford slow materials) will be

found most convenient once temperature and agitation are standardised. Alteration of times by 25% will not affect meter setting in normal work, if required for contrast adjustment. FX-18 times are usually similar to those for D-76 and ID-11.

VERY FINE GRAIN

FX-5b

Metol	4·5g
Sodium sulphite, anhydrous	125·0g
Kodalk (sodium metaborate)	2·25g
Sodium metabisulphite	1·0g
Potassium bromide	0·5g
Water to	1000·0ml

FX-5b Replenisher
Metol	7·0g
Sodium sulphite, anhydrous	125·0g
Kodalk (sodium metaborate)	25·0g
Sodium metabisulphite	—
Potassium bromide	1·0g
Water to	1000·0ml

Twenty per cent development time increase after first film until four or five films have been processed per 600ml or 10% increase until eight or ten films have been developed in 1200ml. Use replenisher to maintain level of tank until twenty-five rolls per litre are processed. Visual contrast is lower than the printing contrast. This formula gives true fine grain with good sharpness and the minimum loss of film speed (30-50%) necessary to achieve very fine grain. Results resemble those in the original two-powder pack 'Microdol', found very suitable for Ilford films amongst others, although replaced in Kodak usage by the later formula Microdol-X, giving improved definition on Kodak films.

Development times
In minutes at 20°C (68°F).
Pan F (MF)—10, Pan F (RF)—12, FP4 (MF)—8, FP4 (RF)—12, HP5 (MF)—11, HP5 (RF)—13.

ACUTANCE FORMULAE

For maximum sharpness at some loss of fine grain

Pyrocatechin Surface Developer (Windisch)

Stock A
Pyrocatechin	80·0g
Sodium sulphite, anhydrous	12·5g
Water to	1000·0ml

Stock B
Sodium hydroxide	100g in 1000ml

N.B. The excess Pyrocatechin with minimum sulphite gives the surface development effect.

Working solution
Take 25ml of *A*, 15ml of *B* and make up to 1000ml. Develop 15-20min at 20°C according to film type. The developer keeps reasonably in stock, but deteriorates rapidly when mixed. It is used once and then discarded. Specially recommended by Windisch for Adox/Efke films. Emulsion speed approximately doubled.

N.B. It is best not to make up more of *B* than will be used rapidly since the activity will decrease with solution of atmospheric CO_2. If possible hold only

A as a stock, and add sodium hydroxide weighed up and dissolved on the occasion of use. Working concentration is 1·5g sodium hydroxide per litre.

The Beutler Developer

Stock A
Metol	10·0g
Sodium sulphite, anhydrous	50·0g
Water to	1000·0ml

Stock B
Sodium carbonate, anhydrous	50·0g
Water to	1000·0ml

Working solution: 1 part *A*, 1 part *B*, 8 parts water.
Developing times: 8-15min at 20°C (68°F).
See notes on making up FX-1 below for further details of preparing concentrated liquid developers.

'FX' Acutance Developers
The following formulae were proposed by G. W. Crawley after research into the design of acutance developers.
FX-1 is fundamentally a variant of the Beutler formula claiming better contrast control, together with a mechanism to enhance 'adjacency' effects; these are also enhanced by the lower concentration of developing agent.

FX-1 High acutance developer, speed increase ½-1 stop

Working solution
Metol	0·5g
Sodium sulphite, anhydrous	5·0g
Sodium carbonate, anhydrous	2·5g
Potassium iodide 0·001% solution	5·0ml
Water to	1000·0ml

Use once and discard. Do not use Calgon, etc.

Concentrated stock solutions *(do not use Calgon, etc)*

A	Metol	5·0g
	Sodium sulphite, anhydrous	50·0g
	Potassium iodide 0·001%	50·0ml
	Water to	1000·0ml
B	Sodium carbonate, anhydrous	25·0g
	Water to	1000·0ml

Making up
A Use water boiled for just 3min then cooled to about 30°C. Dissolve a pinch of the weighed sulphite before the metol. Filter and bottle. This solution will keep a year unopened or until discoloration begins—a light tint can be ignored. If 50ml of the water is replaced by isopropyl alcohol, keeping qualities are improved and precipitation in extreme cold avoided. (See FX-2, Making up, *A*, for general observations on making up concentrated liquid developers.) Amber glass bottles are preferable to plastic ones.
B Dissolve in water prepared as for *A*.
The 0·001% solution of potassium iodide can be obtained by dissolving 1g in 1000ml of water; if 100ml of that solution is diluted to 1000ml, then 100ml of this solution again diluted to 1000ml will give a 0·001% solution. This keeps for two years at least.
Working solution—use once and discard.
One part *A*, one part *B*, eight parts water. Mix for 2min and allow to stand to ensure homogeneity.

Single solution concentrate
Quantities for *A* and *B* may be dissolved together in 1000ml of water to form a single solution developer, reject for use when discoloured. 50ml of the water may be replaced by isopropyl alcohol (see making up *A* above).

Agitation

4 inversions each minute in small tanks up to 300ml capacity, 6-8 in larger ones. (See also notes to FX-2.)

General Notes

FX-1 demands first-class lenses, precise exposure and no camera movement; also first-class enlarging lenses. Highest resolution and definition will be obtained on Kodak Panatomic-X which will then resolve a *BJ* classified advertisement page at 7-8ft from a suitable 50mm lens on the 35mm stock or 8-10ft from a suitable 75-80mm lens on the rollfilm.

Development times for FX-1 and FX-2 at 20°C (68°F):

Agfapan 25 (MF)	12min
Agfapan 25 (RF)	13min
Agfapan 100 (RF)	14min
Agfapan 100 (MF)	13min
Ilford Pan F (MF)	12min
Ilford Pan F (RF)	14min
Ilford FP4 (MF)	13min
Ilford FP4 (RF)	14min
Kodak Pan-X (MF)	13min
Kodak Pan-X (RF)	15min
Kodak Plus-X Pan (MF)	11min
Plus-X Pan Professional	12min
Kodak Verichrome-Pan	14min

Equipment contrast variations are more obvious in nonsolvent developers and these times may need individual adjustment, particularly in FX-2. For future 'Changes in development times', see under that heading in FX series of Fine Grain developers, page 168.

FX-1b* Acutance Developer, ½ stop speed increase

Add to FX-1 working solution (with or without iodide) 40g per litre of anhydrous sodium sulphite. The bare solvent action removes surface flare and image spread. Films faster than ASA 160 show a definition and grain disadvantage over normal solvent developers. A 2% acetic acid bath may sometimes be necessary to remove white scum. Times approximately two-thirds FX-1 and 2 (see above).
Formerly numbered FX-13.

FX-2 Acutance developer, 80% speed increase

Working solution

Metol	2·5g
Sodium sulphite, anhydrous	3·5g
Glycin	0·75g
Potassium carbonate, crystalline	7·5g
*Pinacryptol Yellow 1:2000 solution	3·5ml
Water to	1000·0ml

Do not use Calgon, etc.

Stock solutions (see making up below)

A	Metol	25·0g
	Sodium sulphite, anhydrous	35·0g
	Glycin	7·5g
B	Potassium carbonate (crystals, not dried)	75·0g
	Water to	500·0ml
C	*Pinacryptol Yellow 1:2000 solution	

Making up

Weigh all constituents of *A* and *B* and place on plain pieces of paper separately.
A In 1400ml of water, boiled for just 3min, then cooled to about 30°C, dissolve a pinch of the sulphite, next the metol, then the rest of the sulphite and add the glycin. If the glycin remains as a yellow suspension after 3min mixing, add a pinch from the weighed carbonate and restir, repeating the operation if it still fails to dissolve. Alternatively replace 50ml of the water by isopropyl alcohol which will dissolve the glycin. (Isopropyl alcohol is available without licence on order from any chemist quite cheaply. Its addition also improves keeping qualities and prevents precipitation in extreme cold, and it is used for these purposes in some commercial developers.) Make up to 500ml. Filter and store in filled bottles. This solution should keep a year unopened, but should be rejected when discoloured to a *deep* yellow (glycin developers are usually a golden tint on making up); partly used concentrate should also be rejected when deeply discoloured. Fresh glycin is a reflectant gold yellow in colour. For best keeping, do not aerate whilst mixing and use spotless vessels. Concentrated liquid developers keep indefinitely until oxidation commences, usually from foreign matter in the solution; deterioration then proceeds rapidly once initiated. The use of distilled water is unnecessary; if used, the mixed solution should still be filtered. Do not use Calgon or other sequestering agents in high dilution developers.
B Dissolve the potassium carbonate crystals (the bulk remaining if any was necessary to dissolve the glycin in *A*) in 400ml water prepared as for *A* and make up to 500ml. This solution maintains activity indefinitely in a full bottle, renew after two months if half used, for consistency.
C Keeps indefinitely away from strong light. After two years, however, reject as an increase in activity may occur thereafter. For working solution, take *A* 50ml, *B* 50ml, *C* 3·5ml to make 1 litre developer. Mix well. Use once and discard.
*Pinacryptol Yellow is available from Photo Chemical Supplies whose address appears on page 167.

Development times

As for FX-1.

General notes

If agitation is reduced to every other minute or third minute with an increase in time up to ⅓ to ½, negatives of interesting internal gradation and acutance may be obtained. Agitation can be abandoned altogether with a further increase in time. Dilution may be doubled or trebled to form stand developers over 1-2hr at room temperature. This developer is more 'pictorial' than FX-1, which is designed for maximum resolution and definition primarily; FX-2 is far less sensitive to flare, and less demanding on apparatus.

See also Diluted DK-50, page 171.

FX-16 (Grain effects on high-speed films)

This developer has been specially designed to produce an obtrusive grain structure on films of ASA 400 and over, whilst retaining excellent contour sharpness. This retention of sharpness assists in preventing the loss of image quality often found where grain texture has been utilised to give a special effect. The formula is related to the above FX-2 Acutance Developer for slow and medium speed films.

Working solution

50% speed increase	
Metol	0·5g
Glycin	0·5g
Sodium sulphite, anhydrous	4·0g
Sodium carbonate, anhydrous	50·0g
(*vide also* General Notes)	
*Pinacryptol Yellow 0·05% solution	250·0ml
Water to	1000·0ml

*For Kodak Royal-X Pan 350ml/1000ml.

If unavailable, 0·5g/litre potassium bromide must be substituted to balance the formula, at some sharpness loss but giving fluffier grain.

Making up

Dissolve the solids in half the total quantity of water at around 30°C, 90°F. Add the dye and make up to the total volume. Make up when required. Use within 6hr, adding dye just before use. Use once and discard. Pinacryptol Yellow is available from Photo Chemical Supplies whose address appears on page 167. Pinacryptol Yellow dissolves readily in hot, not quite boiling water. The 0·5% solution—1:2000—keeps indefinitely in a brown bottle away from the light: see note C to FX-2.

Development times at 68°F (20°C) in minutes

Kodak

Royal-X Pan	20
Tri-X (RF)	12
Tri-X (MF)	12

Ilford

HP5 (RF)	12
HP5 (MF)	10

Agitation

Should be thorough. 10sec/min either rotation or inversion.

General notes

The grain pattern texture produced by FX-16 disturbs resolution of fine detail but sharpness of contours and medium detail is enhanced markedly, hence print impact is excellent. FX-16 is primarily intended as a developer for operators wishing to experiment with grain structure for special effects, but it can also be used with advantage as an 'acutance' developer for fast films when big enlargements are not required. Texture obtrusiveness can be adjusted by varying the negative area used for enlarging, or using different focal length lenses from the same camera position. With slow and medium speed films there is no gain over FX-2 and 'acutance' developers, and contrast difficulties may occur.

If the carbonate is replaced by 50g/litre of sodium metaborate or 'Kodalk' a fluffier grain texture is produced. Development times remain the same or slightly shorter.

GENERAL PURPOSE FORMULAE

Although Universal formulae (see page 173) can be used for general purpose negative development, this term is usually applied to formulae unsuitable for development of enlarging papers, and in which some attempt has been made to obtain contrast control or some particular advantage or negative quality obtainable by the use of a developing agent of special properties. Such developers do not make use of a 'solvent' effect, and therefore are not classed as fine-grain developers (see Fine-Grain Developers), as they do not give the minimum graininess possible at a given film-speed. Best control is obtained when such formulae are buffered against changes of alkalinity, for example, D-61A and DK-50. Both these formulae can be used for Kodak Royal-X Pan; the Universal Formulae given on page 173 may give unacceptable fog.

Ilford General Purpose Negative Developer

free from organic restrainers

Sodium sulphite, anhydrous	75·0g
Hydroquinone	8·0g
Sodium carbonate, anhydrous	37·5g
Phenidone	0·25g
Potassium bromide	0·5g
Water to	1000·0ml

This concentrated developer is diluted as follows:
For *Dish development of plates and films:* 1+2 water.
Developing time: 4min.

For *Tank development:* 1+5 water.
Developing time: 8min.

Developing temperature: 20°C, 68°F.

Kodak General Purpose Negative Developers

Dissolve chemicals in this order	D-61A	DK-50
Metol	3·1g	2·5g
Sodium sulphite, anhydrous	90·0g	30·0g
Sodium metabisulphite	2·1g	–
Hydroquinone	5·9g	2·5g
Sodium carbonate, anhydrous	11·5g	–
Kodalk (sodium metaborate)	–	10·0g
Potassium bromide	1·7g	0·5g
Water to	1000·0ml	1000·0ml

These buffered developers are recommended for development of medium to highest speed rollfilm, sheet film, and plates. D-61A is used in the dish at 1+1 dilution or in tanks at 1+3. Development times for 1+3, between 5 and 10min at 20°C. DK-50 is normally used as recommended by Kodak at full strength. A diluted form of this developer has been proposed independently as giving a useful balance of natural acutance, gradation and speed qualities with controlled contrast rise, this can be made up as follows:

Diluted DK-50 *Film speed normal, good sharpness*

Working solution

Metol	0·5g
Sodium sulphite, anhydrous	6·0g
Hydroquinone	0·5g
Kodalk (sodium metaborate)	2·5g
Potassium bromide	0·125g
Water to	1000·0ml

Stock solutions. Calgon may be used

A Make up DK-50 from the full strength formula on this page or from the packaged powder as directed on the commercial pack.

B Dissolve 80g Kodalk in 1 litre boiled, cooled water.

For working solutions use two parts *A*, one part *B*, seven parts water. Use once and discard.

Development times at 68°F (20°C)

Pan F (MF) 6min	Pan-X (RF) 12min
Pan F (RF) 7min	Veripan 13min
FP4 (MF) 8min	HP5 (MF) 10min
FP4 (RF) 9min	HP5 (RF) 12min
Plus-X (MF) 10min	Tri-X (RF) 13min
Plus-X Prof (RF) 11min	Royal-X Pan 15-20min
Pan-X (MF) 10min	

MANUFACTURERS' SPECIAL FORMULAE

D-19b (Kodak)

A high contrast developer for X-ray and aero films, also useful for general applied photography. Used undiluted at 20°C, the average time for tank development is 5min. Suitable also for photomechanical and document materials. A well-balanced developer of good keeping properties.

D-158 (Kodak)

Recommended by Kodak Ltd, as a developer for photomechanical and document copying materials. Dilute 1:1 for use with above material.

D-163 (Kodak)

Mainly a bromide and chlorobromide paper developer. For papers and lantern plates it is used diluted 1:1, 1:2 or 1:3 according to development speed required, development times being 1½ to 2min at 20°C. Useful also as a negative developer diluted 1:3, giving good contrast and brilliance. Develop 4-6min in a dish and 5-8min in a tank at 20°C.

DK-50 (Kodak)

A normal contrast developer suitable for all types of plates and films but specifically recommended for Royal-X Pan film. Particularly suitable for commercial and engineering subjects. Clean working and fog free, giving excellent gradation on super-speed plates and films, also recommended for processing long out of date films. The presence of 'Kodalk' as the alkali prevents hot weather blistering of the emulsion in the acid fixing bath. Use without dilution. 'Kodalk' is sodium metaborate.

ID-2 (Ilford)

The standard M-Q developer for films and plates, and a non-caustic developer for high contrast graphic arts films and plates. For normal use dilute 1:2 dish and 1:5 tank. For line and screen work use at stock solution strength.

ID-62 (Ilford)

A general purpose Phenidone-hydroquinone formula for films, plates and papers. For films and plates dilute 1:3 dish and 1:7 tank. For contact papers, contact and special lantern plates dilute 1:1. For enlarging dilute 1:3.

ID-20 (Ilford)

A Phenidone-hydroquinone or metol-hydroquinone developer for all types of enlarging papers and specially recommended for Ilford bromide papers. For use when it is diluted 1:3, development time is 1½-2min at 20°C. With bromide paper the development time may be reduced to 1-1½min with double strength developer.
The formula of ID-20 P-Q is not published, the formula below being for ID-20 M-Q.

	Quantities in grams						
Constituents	D-19b	D-158	D-163	DK-50	ID-2	ID-62	ID-20
Metol	2·2	3·2	2·2	2·5	2	—	3
Hydroquinone	8·8	13·3	17	2·5	8	12	12
Phenidone	—	—	—	—	—	0·5	—
Sodium sulphite anhydrous	72	50	75	30	75	50	50
Sodium carbonate anhydrous	48	70	65	—	37	60	60
Kodalk	—	—	—	10	—	—	—
*Ilford IBT Restrainer solution	—	—	—	—	—	20ml	—
Potassium bromide	4	1·0	2·8	0·5	2	2	4
Water to 1 litre							

Where Ilford IBT or Kodak Anti-fog 1 is specified throughout the Annual formulae section, the same volume of a solution of 1% benzotriazole dissolved in hot water containing 10% anhydrous sodium carbonate may be substituted: e.g. 1g benzotriazole in 100ml water with 10g sodium carbonate.

Process Developers

These are used for copying and process materials, graticules, photo-mechanical papers, X-ray development, etc; they are not usually suitable for the development of ordinary general photographic materials.

Ilford formulae

Dissolve chemicals in this order

	High contrast	Med contrast
Sodium sulphite, anhydrous	150·0g	72·0g
Potassium carbonate, anhydrous	100·0g	—
Sodium carbonate, anhydrous	—	50·0g
Hydroquinone	50·0g	8·8g
Phenidone	1·1g	0·22g
Caustic soda	10·0g	—
Potassium bromide	16·0g	4·0g
Benzotriazole	1·1g	0·1g
Water to make	1000·0ml	1000·0ml
	Dilute 1:1 for use	Use undiluted

Medium high contrast hydroquinone caustic developer

A Stock

Sodium metabisulphite	25·0g
Hydroquinone	25·0g
Potassium bromide	25·0g
Water to	1000·0ml

B Stock

Caustic soda	45·0g
Water to	1000·0ml

For use mix equal parts of A and B and develop for 2min at 20°C. Rinse well before acid-fixing to avoid stain or use acid stop bath.

High contrast single solution hydroquinone-caustic developer Kodak D-8

Stock Solution

Sodium sulphite, anhydrous	90·0g
Hydroquinone	45·5g
Caustic soda	37·5g
Potassium bromide	30·0g
Water to	1000·0ml

For use take 2 parts stock solution to 1 part water. Develop for 2min at 20°C. This developer keeps for several weeks bottled, and retains its energy for several hours in the open dish. Without loss of density, the caustic soda may be reduced to 28g in which case the stock solution will keep longer still.

Monobath

FX-6a (no film speed increase)

Sodium sulphite, anhydrous	50·0g
Hydroquinone	12·0g
Phenidone	1·0g
Sodium hydroxide	10·0g
Sodium thiosulphate	90·0g
Water to	1000·0ml

The bath is adjusted to mean contrast. This can be varied to suit individual materials or conditions by altering the sodium thiosulphate content. Between 70g and 125g/litre this will give a continuously graded softening of contrast; softer results than obtained at 125g/litre are unlikely to be required. For still higher contrast, e.g. with process materials, increase hydroquinone to 15-17g.

Making up

A little Calgon may be used. The bath may be divided into two stock solutions; *A* developing agents and sulphite; *B* sodium thiosulphate. On mixing add 1 pellet of sodium hydroxide per working 30ml. This is quite accurate enough, and may be used whenever making up the bath.

Time

Slow and medium speed films will process in 4min. Normal processing time 5min for all films except Royal-X Pan (6min). Six minutes is the safe time for the bath at all stages. Agitate continuously for ½min on pouring in, then at each minute about 3-5 inversions according to tank size. Wash 5-20min.

Capacity

Nine to twelve films per litre according to density (over exposure prolongs life). Keep in full containers until *deeply* discoloured. A cloudy deposit should form and can be filtered off if desired. If overworked and film is not fully cleared immerse at once in an acid fixer (logically, a rapid one; such a bath may be temporarily reactivated by adding 15-25g/litre of thiosulphate in an emergency).

Black and White Reversal

Originally this process* was used basically for reversal processing of cine film in rapid high output machine processors. Slight modifications have been carried out to make it work with almost all kinds of line and continuous tone materials. The rated emulsion speed can be used as a guide to experimentation, but, in practice, it is found that the speed is doubled. On the other hand the exposure latitude is very small, i.e. ¼ stop with line emulsions.

The recommended first developer is 'Qualitol' developer (May & Baker), diluted 1+1 with slight modifications: to the developer is added a quantity of a 20% solution of potassium thiocyanate. A stock solution of this can easily be made by dissolving 200g of potassium thiocyanate in about 750ml of water and making up the solution with water to 1000ml.

Water	600ml
'Qualitol' developer concentrate	200ml
a for line films: 20% sol potassium thiocyanate	20ml
or	
b for tone films: 20% sol potassium thiocyanate	30ml
Water to make	1000ml

1 Before attempting processing, all the solutions are poured into beakers and the first developer into the developing tank and kept at 20°C. The exposed film after being loaded into the spiral in total darkness, is put into the developing tank and developed for 2min. The agitation is continuous.

2 The film is rinsed in running water for 1min.

3 The rinsed film is transferred to a bleach bath made up as follows:

Water	500ml
Potassium dichromate	10g
Sulphuric acid concentrated	12ml
Water to make	1000ml

The film is bleached in this solution for 1min.
N.B. It is very important always to add the concentrated sulphuric acid to the water very slowly, stirring the solution at the same time. Otherwise the mixture can boil and spit acid.

4 The film is rinsed in the running water for 1min.

*Y. S. Sahota, *British Journal of Photography* 16 May 1975.

5 After rinsing it is put into a clearing solution made up of 'Thiolim'—(M & B fixer eliminator) diluted 1+9.

Water	500ml
'Thiolim'	100ml
Water to make	1000ml

The film is left in the clearing solution for 1min.

6 The film is again rinsed in running water and room lights are turned on at this stage. The spiral can be taken out of the rinse bath and held about 1ft away from a darkroom negative viewing box for about 10sec. This is more than sufficient for second exposure. The film is rinsed for 1min.

7 Next, the film is redeveloped in 'Qualitol', diluted 1+7, for 2min. For higher contrast the dilution can be 1+6.

Water	500ml
'Qualitol' developer concentrate	125ml
Water to make	1000ml

8 After this the film is given a quick rinse, and fixed in a high speed fixer, e.g. 'Super Amfix' diluted 1+4 for 1min. To the fixer acidified hardener is added to harden the softened emulsion.

9 The final rinse in water is of only 3min duration. The total time for the process is only 13min. In actual practice this time can be further reduced by cutting the rinse time in steps 2, 4 and 6 to 30sec, if one has a very efficient water rinse available. It is very important to use continuous agitation throughout the steps. For repeat results it is essential that 'Qualitol' developer is used fresh. As soon as the colour of the concentrated developer changes to pale yellow, it is found that the results are no longer consistent.

Universal Formulae

The term 'universal' is applied to a formula suitable at various dilutions for the development of a wide range of sensitised materials—sheet films, enlarging and contact printing papers, etc. Used on negative materials, such formulae give rapid processing, but without any refinement of grain; they are therefore unsuited to the processing of miniature 35mm films except the slowest and then well diluted, or of rollfilms over ASA 160 if any real degree of enlargement is required. Their use is not recommended for Kodak Royal-X Pan, which should be developed in DK-50, or D-61a.

Dissolve chemicals in this order

	Ilford Universal P-Q	BJ Universal M-Q
Metol	—	3·2g
Hydroquinone	12·0g	12·5g
Sodium sulphite, anhydrous	50·0g	56·0g
Sodium carbonate, anhydrous	60·0g	63·0g
Phenidone	0·5g	—
Potassium bromide	2·0g	2·0g
Benzotriazole*	0·2g	—
Water to	1000·0ml	1000·0ml

Proprietary concentrated liquid antifoggants such as Ilford IBT or Kodak Anti-fog 1 may be substituted, about 35ml per stock litre is suitable. See also substitute organic restrainer solution under 'Manufacturers' Formulae for Specific Purposes' table, pages 171-172.

Print Developers

FX-12

This formula is recommended when a universal formula is more often to be used for development of printing papers and positive materials of all kinds, since it is balanced to obtain stable image colour over the various grades. Dilutions are: enlarging paper 1+3; contact papers 1+1; lantern slides 1+4; films in tanks 1+7. Development times for films will closely resemble those in recommended universal developers at the same dilutions. Warm-tone development of chlorobromides is possible by the usual dilution (e.g. 1+6) and over-exposure techniques. The chlorquinol should be obtained as fresh as possible—buff-brown not deep brown.

For chlorobromide development only, better control latitude may be obtained by adding 15g/litre of potassium or (less readily soluble) sodium citrate. For this purpose, benzotriazole can be reduced by one-third.

Sodium sulphite, anhydrous	60·0g
Hydroquinone	10·0g
Chlorquinol	6·0g
Phenidone	0·5g
Sodium carbonate, anhydrous	60·0g
Potassium bromide	1·5g
Benzotriazole solution*	35·0ml
Water to	10000·0ml

*See formula given under 'Manufacturers' Formulae for Specific Purposes' table, pages 171-172.

Stop Baths

Stop Bath 1

Acetic acid glacial	20ml
or	
Acetic acid 28%	75ml
Water to	1000ml

This bath is recommended for negative development and will remove any surface scum formed. It loses its vinegar smell as activity decreases.

Stop Bath 2

Sodium metabisulphite	25g
Water, to make	1000ml

An efficient and inexpensive bath, an acid smell denotes its acidity is maintained.

Stop Bath Hardener

Chromic potassium sulphate (chrome alum)	20g
Water to	1000ml

This stop bath has a hardening action and deteriorates in colour from its original purple to green blue as its action is lost. It is used for negative emulsions normally, although it can be used as a final hardener for paper based prints processed at high temperatures.

Fixers

1 Acid Fixing Bath

Sodium thiosulphate crystals ('Hypo')	250g
Sodium metabisulphite	20g
Water to	1000ml

This acid fixer is of standard composition and will work as a general purpose bath for all fixing purposes. If the acid smell is lost it can be topped up again with a little metabisulphite until it is regained.

2 Acid Fixing Bath (Buffered)

Sodium thiosulphate crystals ('Hypo')	250g
Sodium sulphite, anhydrous	25g
Acetic acid glacial	25ml
or Acetic acid 28%	80ml
Water to	1000ml

This is a 'buffered' fixing bath which has improved efficiency during use as a result—it has great tolerance to carry-over of developer.

3 Buffered Acid Fixer Hardener

Sodium thiosulphate crystals ('Hypo')	300g
Water to	1000ml

Add to the above whilst stirring slowly 250ml of the following stock hardening solution:

Sodium sulphite, anhydrous	75g
Acetic acid glacial	65ml
or Acetic acid 28%	235ml
Boric acid (crystals)	50g
Potassium alum	75g
Water to	1000ml

Dissolve these constituents in the order given in half the total quantity of water at about 50°C to dissolve the boric acid quickly.

4 Ammonium Thiosulphate High-Speed Fixer

Ammonium thiosulphate	175g
Sodium sulphite, anhydrous	25g
Glacial acetic acid (98-100%)	10ml
Boric acid (crystalline)	10g
Water to	1000ml

A high-speed fixer with long working life. If hardening action is required, add 10g per litre of aluminium hydroxychloride after a further 5ml of glacial acetic acid to prevent appearance of a cloudy suspension. Fixing time 30-90sec films, 30-60sec papers. For slower action dilute 1+1.

Toning current black-and-white papers*

There are some fundamental differences between modern materials such as Kodabrome II RC Paper, Type 2450 and the traditional papers for which most of the toning formulae and techniques were originally designed. One reason for the differences is that nowadays photographic paper has to be formulated to conform with modern environmental and health and safety legislation.

*These suggestions are based on an article by John Hayday, Kodak Applications Laboratory, Harrow, which appeared in *Kodak Professional News No 24*. They are specifically designed for use with Kodak papers: further information on these may be obtained from Kodak Ltd, Customer Relations Dept, PO Box 66, Hemel Hempstead, Herts.

Modern formulations, whether on resin-coated or non resin-coated support, do not always respond to traditional toning methods, which is why some users have experienced difficulties when attempting to produce toned prints. Vanadium (for green tones), gold (for blue tones) and selenium (for brown tones) are examples of traditional toners which do not convert modern formulations satisfactorily.

Toning methods

The techniques for toning print images fall conveniently into four broad categories, as follows:

1 Conversion of the silver image to silver sulphide or silver selenide.
2 Conversions of the silver image with a metal salt to give a coloured silver salt or insoluble double salt.
3 Conversion of the silver image to a mordant on which a suitable dye can be deposited.
4 Formation of dye during development, using a colour developer.

Sulphide-selenide toning

Of all the toning methods, indirect sulphide toning using a ferricyanide bleach followed by a sulphide bath is probably the most common. It is reliable and provides acceptable sepia tones with nearly all papers. Sulphide toning also imparts a useful degree of protection to the image against atmospheric pollution and adverse print storage conditions.

RC papers respond well to indirect sulphide toning giving yellow-brown tones when dried at ambient temperatures but tending to purple-brown tones with the application of heat. Kodak Sulphide Sepia Toner T-7a (published formula) and Kodak Sepia Toner can be used with these papers, but the bleach solution should be used in a more concentrated form that is indicated in the current literature, to reduce the bleach time to an acceptable period. One system is to use one-sixth the current dilution to achieve one minute bleach times. The following bleach formulation has been used successfully:

Potassium ferricyanide	30g
Potassium bromide	12g
Sodium carbonate (anhydrous)	15g
Water	to make 1 litre

This bleach is stable and can be reused until it is exhausted. After bleaching, and a brief wash, prints are normally sulphided using a solution of sodium monosulphide. Sodium sulphide $Na_2S.9H_2O$ is deliquescent, and exposure to air forms thiosulphate which will reduce density by acting on bleached prints in the manner of Farmer's Reducer. Dilute sulphide solutions also tend to form thiosulphate. For this reason the best practice is to prepare fresh sulphide solutions by dissolving one or two sulphide crystals in a small quantity of warm water each time toning is to be done. The crystals are kept in sealed jars, but they can be covered with a film of mineral spirit to prevent deliquescence. Sulphiding must be carried out well away from all stocks of sensitised material and from rooms in which they are handled, because the hydrogen sulphide liberated from the sulphide bath is a powerful fogging agent. It is also toxic and unpleasant to smell, so that good ventilation is required.

Selenium toning does not normally give image tone changes with modern papers, but silver selenide is formed nevertheless, and provides substantial image protection.

Kodak Rapid Selenium Toner can be used at a dilution of 1+3 as a protective treatment. At this dilution, using papers which give no tone change, one litre of solution will treat 150 25·4×20·3cm (10×8in) prints, or an equivalent area. Modern papers can be protected with selenium toner without showing significant shifts in image tone.

Metal toners

Toning by forming the coloured ferricyanide of various heavy metals formed the basis for numerous traditional toning formulae, and included cadmium, cobalt, copper, iron, lead, molybdenum, nickel, titanium, uranium and vanadium. Modern papers do not seem to respond to many of these formulae,

notable exceptions being iron (giving prussian blue tones) and copper (giving pink-brown tones). Copper-toned prints can also be treated with a weak acidified ferric chloride solution to produce green tones (ranging from cyan to dark green). In this process particularly some highlight loss in unavoidable so that prints should be made somewhat darker than normal before toning. A copper toning solution is marketed as a two-part kit by Berg (Berg Brown/Copper Toner). It appears to work well with all papers.

Gold toning does not give appreciable tone shifts with modern papers, although Kodak Blue Toner (which is a gold toner) will provide blue-black images with Kodabrome II RC Paper Type 2450. Prints which have been sulphide toned can be treated with gold toners to yield pleasing red tones, ranging from 'red chalk' to carmine. Red chalk is the desired tone, and is especially suited to portrait studies against a white background. Kodak Blue Toner can be used for this treatment, as described in the Eastman Kodak publication *Creative Darkroom Techniques* available from Patrick Stephens Ltd, Bar Hill, Cambridge. Satisfactory red tones appear to be possible with most papers.

Mordanting processes

The mordanting of silver images can be achieved using a copper toning bath, but the following formula which produces cuprous thiocyanate as a mordant, is more suitable:

Copper sulphate	20g
Neutral potassium citrate	60-100g
Acetic acid (glacial)	30ml
Ammonium thiocyanate (10% sol)	100ml
Water	to make 1 litre

The thiocyanate should be dissolved separately in a small volume of water and added to the main solution a little at a time, shaking the main solution after each addition. If mordanting is only required occasionally the thiocyanate should be stored separately and only added at the time of use. After mordanting, prints need to be washed until the whites are restored. They will then accept dye from a 1% solution of acetic acid which contains 1% of one or more of the following dyes: Thioflavine T, Methylene Blue, Fuchsine, Malachite Green and Methyl Violet. To clear the white after dyeing and washing, one method is to give a brief immersion in a weak solution of sodium hypochlorite (household bleach).

Dyed images are generally more prone to fading than image colours produced using metal salts. A convenient kit, containing a mordanting bath, a range of dyes, and a highlight clearing bath is available as the Berg Colour Conversion Kit For Black and White Photographic Images. Limited tests with one of these kits produced acceptable results with Kodabrome II RC Type 2450 and Kodabromide papers.

Rehalogenation and dye development

Black-and-white prints can be re-halogenised using the bleach formula given earlier for sulphide toning, and then re-developed in a colour developer containing appropriate colour couplers.

The colour couplers can be added to the colour developer singly, or mixed to provide appropriate image colours. It is generally more practical to produce the desired result using colour sensitised materials, with appropriate filtration on the camera or at the printer/enlarger stage.

Sepia, Blue and Red Toners are marketed under the 'Barfen' label. Paper users who wish to experiment will find a comprehensive description of traditional toning methods in L. P. Clerc's *Photography Theory and Practice* (1971 edition).

Attention of readers is drawn to the potential health hazards associated with the use of some toners. Great care should be taken to read any warning notices accompanying necessary chemicals.

Stability of black-and-white resin-coated papers

Prints made on modern resin-coated papers can be expected to remain in good condition for at least a generation and probably very much longer, given proper processing and correct storage. These papers incorporate features in base manufacture that help to keep the paper pliable for decades even when displayed under the sort of bright lighting that could cause cracks to appear in a few years with earlier papers. In this respect, modern resin-coated papers are at least as good as fibre-base papers but with the added advantages of short processing times, less curl and better dimensional stability.

Conventional processing of these papers in dishes using fresh solutions is accomplished in minutes, yet it can still produce an image that approaches optimum stability. When processed in correctly-operated processing machines, such as the Kodak Veribrom Processor Model 4, Kodabrome II Paper fully meets the optimum stability levels described in American National Standard, ANSI PHA4·32-1974, 'Method for evaluating the processing of black-and-white photographic papers with respect to the stability of the resultant image'.

Proper processing

The proper processing of resin-coated papers includes following the prescribed development, fixing and washing procedures. For optimum stability, however, adequate fixing and washing are particularly important. This means that not only should times be adhered to, but solutions should be fresh. In machine processing, processing times should be maintained and, most important of all, the solutions should be replenished at their correct rate.

Correct storage

Proper processing will produce prints that should have adequate life for most purposes. With reasonable care to protect them from chemical fumes and excesses of light, heat and humidity, they should last for at least a generation. Only when prints are expected to have an exceptionally long life is it necessary to consider storage conditions in more detail. Freedom from chemical contamination aside, the main requirements are:

1 Protection from direct sunlight or high ultraviolet radiation.
2 A stable temperature between about 15°C and 25°C.
3 A stable humidity level between about 30% RH and 60% RH.

The American National Standard, ASNI PH1·48-1974, 'Practice for the storage of black-and-white photographic prints', provides stringent temperature, humidity and handling recommendations for the storage of those processed black-and-white prints intended for record purposes. There is also information on the best way of protecting stored or displayed prints in the Eastman Kodak publication, *Preservation of Photographs*.

Treatment of prints for display

Prints on black-and-white, resin-coated papers that may be subjected to intense or extended illumination, exposed to oxidising gases or framed under glass or plastic should be treated with toners to extend image life.

Toning of prints can protect them only when the prints have received careful initial processing. Deterioration of a print from outside agents (including high temperature or humidity) can be accelerated by the presence of residual chemicals. Residual hypo and residual silver salts must be reduced to an acceptable level.

Monitoring residual chemicals

Quick, easy and reliable tests for the detection of residual hypo and residual silver salts are available. They should be used on a periodic basis to monitor residual chemical levels in processed prints—particularly those intended for display. Residual hypo can be detected with Kodak Hypo Test Solution, HT-2 prepared as follows:

Water	750ml
Acetic acid	125ml
Silver nitrate crystals	7·5g
Water	to make 1·0 litre

N.B. Store the solution in a screw-cap or glass-stoppered brown bottle, away from strong light.

Place a drop of the HT-2 solution on a clear (unexposed) area of a processed print. Allow the solution to stand on the sample for two minutes, rinse the print to remove excess reagent and compare the test spot with the tints shown in the Kodak Hypo Estimator, Publication No J-11. The Estimator provides a qualitative test for adequate washing.

Residual silver salts can be detected with a dilute solution of Kodak Rapid Selenium Toner mixed one part toner with nine parts water. Place a drop of the dilute toner on a clear area of the processed print. Remove any excess after two or three minutes with a piece of clean white blotting paper or absorbent tissue.

Any yellowing of the test spot, other than a barely-visible cream tint, indicates the presence of silver salts. This is a test for adequate fixing. The test cannot be used with stabilised prints or where a large excess of hypo is present, as in unwashed prints.

Treatment with toners

After prints have been carefully fixed and washed, they may be toned to extend image life. Recent tests indicate that treatment with the toners listed above will provide adequate protection from discoloration for prints on resin-coated paper base that are subjected to oil-based paint fumes and other oxidising gases.

Prints to be toned must be fixed and washed thoroughly. They may be toned directly after removal from the washing bath. Dry prints should be pre-wetted in a water bath before toning. After treatment, rinse any sediment from the print surface and wash for four minutes before drying.

Untreated prints

Untreated prints that cannot be removed from an area which is to be painted with oil-based paint can be protected with a tight wrapping of aluminium foil prior to painting. The wrapping should not be removed from the prints for at least 30 days after painting is completed. Polyethylene and other wrapping materials are inadequate for this purpose.

COLOUR FILMS

THIS tabulation includes, we believe, all the colour films for camera use manufactured and marketed throughout the world. Not all of them are available in all countries, of course, but there is an increasing tendency for distribution to become more and more universal.

In a number of cases films are sold under brand names which are not those of the manufacturer, the so-called house brands or own-label films. No attempt has been made to include comprehensive coverage of such materials and only those which are of more than local interest have been included. In some instances, also, the manufacturer of such house-brand materials may change from time to time: many buyers for such chains do not wish to be restricted to a single supplier.

The identification of colour films for the purpose of adopting the correct processing procedure is, today, of less importance than it was formerly; in almost all cases manufacturers have modified their films, both colour negative and reversal, to be suitable for the Kodak C-41 and E-6 processing solutions respectively. The exceptions, at mid-1983, are those manufacturers in Eastern Europe and Russia who continue to tailor their materials for the Agfacolor processes. It seems likely that this situation will change in due course.

This classification of colour films by the processing procedure, either Agfa or Kodak, should not be confused with the classification by colour principle. The latter designation was first used when this tabulation was first published thirty years ago and in the meantime this clear-cut distinction has become somewhat blurred. Formerly colour films of the substantive type, in which the colour forming material—the colour couplers—are incorporated in the emulsion layers at the time of manufacture, could be clearly differentiated into those which anchored the colour couplers in the appropriate layers by attaching a long hydrocarbon chain to the coupler molecule—Agfa-type couplers, and those which anchored them by dispersal in the emulsions after dissolving in a solvent with a high boiling point—Kodak-type couplers. Today films can incorporate couplers of both types and other methods of dispersing and holding immobile the colour forming components are commonly used. However, so long as materials of the older Agfa-type are still available it has been thought useful to maintain this classification.

Kodachrome is now the sole material in which the couplers are placed into the appropriate emulsion layers in processing. This system demands the use of a continuous processing machine and renders the extension of formats available into rollfilm difficult, if not impossible.

Where the entry 'Service' appears under the processing heading this means that the material is usually sold with the cost of processing included in the purchase price. This implies that the film will be returned to the manufacturer's laboratory for this service. Where an alternative to 'Service' is indicated the material may be processed by the user, although, of course, the processing component of the purchase price is forfeited.

In some cases films, both negative and reversal, are designated 'Professional' in their brand name. This generally means that they have been manufactured to give their optimum colour balance *ab initio* and carries the implication that they will be stored under refrigeration until used and processed promptly after exposure. Films essentially intended for amateur use are manufactured so that they will display optimum balance after storage at normal temperatures for a reasonable period and may be processed after some delay.

Colour Reversal Films

See pages 185-186 for explanatory notes.

Film	Manufacturer or Distributor	Daylight	Tungsten	ISO speed	110	126	135	127	120	220	Bulk 35	Bulk 70	Sheet	Colour principle	Processing	Comments
Agfachrome 50L Professional	Agfa-Gevaert, West Germany		●	50/18°			●		●		●		●	Agfa	Agfachrome 41 or Service	1, 2
Agfachrome 50S Professional	Agfa-Gevaert	●		50/18°			●		●		●	●	●	Agfa	Agfachrome 41 or Service	2, 3
Agfachrome 64 Professional	Agfa-Gevaert	●		64/19°			●							Agfa	Agfachrome 41 or Service	5
Agfachrome 100 Professional	Agfa-Gevaert	●		100/21°			●							Agfa	Agfachrome 41 or Service	
Agfachrome R100S Professional	Agfa-Gevaert	●		100/21°					●				●	Ektachrome	E-6	4
Agfachrome 200	Agfa-Gevaert	●		200/24°			●							Ektachrome	Service or E-6	
Agfachrome 200 Professional	Agfa-Gevaert	●		200/24°			●							Ektachrome	E-6	
Agfachrome CT 18	Agfa-Gevaert	●		50/18°			●	●	●					Agfa	Service	5
Agfachrome CT 18 PAK	Agfa-Gevaert	●		64/19°		●								Agfa	Service	5
Agfachrome CT 18 Pocket	Agfa-Gevaert	●		64/19°	●									Agfa	Service only	5
Agfachrome CT 21	Agfa-Gevaert	●		100/21°			●							Agfa	Service	
Agfachrome 64	Agfa-Gevaert USA	●		64/19°			●							Agfa	Service	5
Agfachrome 100	Agfa-Gevaert	●		100/21°			●							Agfa	Service	
Alfochrome DC 21	Ringfoto, West Germany	●		100/21°			●							Ektachrome	Service or E-6	6
Alfochrome DC 27	Ringfoto	●		400/27°			●							Ektachrome	Service or E-6	6
Barfen CR 100	Barfen Photochem Ltd, London	●		100/21°			●				●			Ektachrome	E-6	6
Batacon CD 18	Batacon, West Germany	●		50/18°			●							Agfa	Service	7
Batacon CD 21	Batacon	●		100/21°			●							Agfa	Service	7
Boots Colourslide 5	Boots, England	●		50/18°			●							Agfa	Service	8
Boots Colourslide 100	Boots	●		100/21°			●							Agfa	Service	8
Brillant Superchrome	Neckermann, West Germany	●		50/18°			●							Agfa	Service	9
Brillant High Speed	Neckermann	●		400/27°			●							Ektachrome	Service or E-6	10
Brillant Spezial	Neckermann	●		100/21°			●							Agfa	Service or Agfachrome 41	7
Ektachrome Infrared	Kodak	●		125/22°			●							Ektachrome	E-4	11
Ektachrome 50 Professional	Kodak		●	50/18°					●		●			Ektachrome	E-6	2
Ektachrome Professional Type 6118	Kodak		●	32/16°									●	Ektachrome	E-6	2
Ektachrome 64	Kodak	●		64/19°	●	●	●	●	●	●	●			Ektachrome	E-6	
Ektachrome 64 Professional	Kodak	●		64/19°			●		●	●	●	●	●	Ektachrome	E-6	2
Ektachrome 160	Kodak		●	160/23°			●							Ektachrome	E-6	
Ektachrome 160 Professional	Kodak		●	160/23°			●		●	●			●	Ektachrome	E-6	2
Ektachrome 200	Kodak	●		200/24°			●							Ektachrome	E-6	
Ektachrome 200 Professional	Kodak	●		200/24°			●		●	●			●	Ektachrome	E-6	2
Ektachrome 400	Kodak	●		400/27°			●		●					Ektachrome	E-6	

See pages 185-186 for explanatory notes.

Film	Manufacturer or Distributor	Daylight	Tungsten	ISO speed	110	126	135	127	120	220	Bulk 35	Bulk 70	Sheet	Colour principle	Processing	Comments
FK Color RD 21	Fotokemika, Yugoslavia	●		100/21°			●		●					Ektachrome	Service or E-6	10
Focal Color Slide 100	K-Mart, USA	●		100/21°			●							Ektachrome	E-6	10
Focal Color Slide 400	K-Mart	●		400/27°			●							Ektachrome	E-6	10
Focal Color Slide 640T	K-Mart		●	640/29°			●							Ektachrome	E-6	10
Fomachrom D 18	Fotochema, CSSR	●		50/18°			●		●					Agfa	Service or Agfachrome 41	
Fomachrom D 20	Fotochema	●		80/20°			●		●					Agfa	Service or Agfachrome 41	
Fomachrom D 22	Fotochema	●		125/22°			●		●					Agfa	Service or Agfachrome 41	
Fortechrom	Forte, Hungary	●		50/18°			●							Agfa	Service or Orwo 9165	9
Fotomat Color Slide	Fotomat, USA	●		100/21°			●							Ektachrome	E-6	12
Fujichrome 50 Professional Type D	Fuji Photo Film, Tokyo, Japan	●		50/18°			●		●				●	Ektachrome	E-6	
Fujichrome 50	Fuji Photo Film	●		50/18°			●							Ektachrome	E-6	
Fujichrome 64 Professional Type T	Fuji Photo Film		●	64/19°			●		●				●	Ektachrome	E-6	
Fujichrome 100 Professional Type D	Fuji Photo Film	●		100/21°			●		●				●	Ektachrome	E-6	
Fujichrome 100 (Improved)	Fuji Photo Film	●		100/21°			●							Ektachrome	E-6	
Fujichrome 400	Fuji Photo Film	●		400/27°			●							Ektachrome	E-6	
Ilfochrome 100	Ilford, England	●		100/21°			●							Ektachrome	E-6	13
Kodachrome 25	Kodak	●		25/15°			●							Kodachrome	Service only (except USA)	18
Kodachrome 40 Type A	Kodak		●	40/17°			●							Kodachrome	Service only (except USA)	
Kodachrome 64	Kodak	●		64/19°	●	●	●							Kodachrome	Service only (except USA)	18
Kodak Photomicrography Color	Kodak	●		16/13°			●							Ektachrome	E-4	14
Konicachrome 100	Konishivoku, Japan	●		100/21°			●							Ektachrome	E-6	15
Labaphot CR 100	Labaphot, West Germany	●		100/21°			●							Ektachrome	E-6	6
3M Color Slide 100	3M Company, Italy	●		100/21°			●							Ektachrome	E-6	
3M Color Slide 64	3M	●		64/19°	●	●								Ektachrome	E-6	
3M Color Slide 400	3M	●		400/27°			●							Ektachrome	E-6	
3M Color Slide 640T	3M		●	640/29°			●							Ektachrome	E-6	
3M Color Slide 1000	3M	●		1000/31°			●							Ektachrome	E-6	
Minochrome 64	Minox, West Germany	●		64/19°										Agfa	Service only	16
Ogachrome	Obergassner, West Germany	●		100/21°			●							Ektachrome	E-6	10
Ogachrome High Speed	Obergassner	●		400/27°			●							Ektachrome	E-6	10
Orwochrom UK 17	VEB Fotochemisches Kombinat Wolfen, GDR		●	40/17°			●		●				●	Agfa	Service or Orwo 9165	

Colour Reversal Films

See pages 185-186 for explanatory notes.

Film	Manufacturer or Distributor	Daylight	Tungsten	ISO speed	110	126	135	127	120	220	Bulk 35	Bulk 70	Sheet	Colour principle	Processing	Comments
Orwochrom UT 18	VEB FKW	●		50/18°			●		●				●	Agfa	Service or Orwo 9165	
Orwochrom UT 20	VEB FKW	●		80/20°			●		●				●	Agfa	Service or Orwo 9165	
Orwochrom UT 23	VEB FKW	●		160/23°			●							Agfa	Service or Orwo 9165	
Orwochrom Professional S	VEB FKW	●		40/17°					●				●	Agfa	Orwo 9165	17
Peruchrome C 19	Perutz, West Germany	●		64/19°			●							Agfa	Service	8
Polachrome Autoprocess	Polaroid, USA	●		40/17°			●							Autoprocess Linescreen	Desk processor	52
Porst S 18	Photo-Porst, West Germany	●		50/18°			●							Agfa	Service or Agfachrome 41	8
Porst S 19	Photo-Porst	●		64/19°	●									Agfa	Service only	8
Porst S 21	Photo-Porst	●		100/21°			●							Agfa	Service or Agfachrome 41	8
Porst S 24	Photo-Porst	●		200/24°			●							Ektachrome	Service or E-6	8
Prinzcolor Slide	Dixons, England	●		100/21°			●							Ektachrome	Service or E-6	10
Revue Superchrome CU 19	Foto-Quelle, West Germany	●		64/19°	●	●								Ektachrome	Service or E-6	10
Revue Superchrome CU 21	Foto-Quelle	●		100/21°			●							Ektachrome	Service or E-6	10
Revue Superchrome CU 27	Foto-Quelle	●		400/27°			●							Ektachrome	Service or E-6	10
Sakurachrome 100	Konishiroku, Japan	●		100/21°			●							Ektachrome	E-6	
Sakurachrome Professional 100	Konishiroku	●		100/21°			●		●				●	Ektachrome	E-6	
Svemacolor CO-22	Shostka Film Factory, Soviet Union	●		25/15°			●							Agfa	Own process	
Svemacolor CO-32	Shostka Film Factory	●		40/17°			●							Agfa	Own process	
Svemacolor CO-90 L	Shostka Film Factory		●	64/19°			●							Agfa	Own process	
Sears Color Slide 100	Sears, Roebuck & Co. USA	●		100/21°			●							Ektachrome	E-6	10
Sears Color Slide 400	Sears, Roebuck & Co	●		400/27°			●							Ektachrome	E-6	10
Tacma CO-22	Kujbishev Film Factory, Soviet Union	●		25/15°			●							Agfa	Own process	
Tacma CO-32	Kujbishev Film Factory	●		40/17°			●							Agfa	Own process	
Tacma CO-90 L	Kujbishev Film Factory		●	64/19°			●							Agfa	Own process	
Tudorchrome 100	Tudor Photographic Group, England	●		100/21°			●							Ektachrome	Service or E-6	10

Colour Negative Films

See pages 185-186 for explanatory notes.

Film	Manufacturer or Distributor	Daylight	Tungsten	ISO speed	Sizes										Colour principle	Processing	Comments
					Disc	110	126	135	127	120	220	Bulk 35	Bulk 70	Sheet			
Agfacolor 100	Agfa-Gevaert AG, Leverkusen, West Germany	●		100/21°	●	●	●	●	●	●		●			Kodak	AP-70/C-41	
Agfacolor 400	Agfa-Gevaert	●		400/27°		●		●							Kodak	AP-70/C-41	19
Agfacolor N 80 L Professional	Agfa-Gevaert		●	80/20°						●				●	Kodak+	AP-70/C-41	4, 1
Agfacolor N 100 S Professional	Agfa-Gevaert	●		100/21°						●				●	Kodak+	AP-70/C-41	4, 3
Barfen CN 100	Barfen Photochem Ltd, London	●		100/21°				●			●				Kodak	C-41	20
Boots Colourprint II	Boots, England	●		100/21°		●	●	●							Kodak	C-41	21
Boots Colourprint 400	Boots	●		400/27°				●							Kodak	C-41	21
Directacolor Print	PIAL, Canada	●		100/21°			●	●							Kodak	C-41	22
Dixons Colorprint 2	Dixons Colour Labs Ltd, Stevenage, England	●		100/21°		●	●	●							Kodak	C-41	21
Contec 5247	MSI/Heritage Color Labs, USA; Continental Technics, Frankfurt, West Germany	●	●	see comment				●							Kodak+	ECN-2	23
Contec 5293	MSI/Heritage/ Continental	●	●	see comment				●							Kodak+	ECN-2	24
Eastman Color Type 5247	Several distributors, USA	●	●	see comment				●							Kodak+	ECN-2	25
Eastman Color Type 5293	Several distributors, USA	●	●	see comment				●							Kodak+	ECN-2	26
FK Color NM 20	Fotokemika, Zagreb, Yugoslavia	●		80/20°				●		●					Kodak	C-41	21
Focal Color Print	K-mart Supermarkets, USA	●		100/21°		●	●	●							Kodak	C-41	21
Focal Color Print 400	K-mart	●		400/27°			●	●							Kodak	C-41	21
Fortecolor II	Forte, Vac, Hungary	●		100/21°		●	●	●		●					Kodak	C-41	21
Fortecolor 400	Forte	●		400/27°				●							Kodak	C-41	21
Fotomat Color Print	Fotomat Corp, St Petersburg, Fla, USA	●		100/21°		●	●	●							Kodak	C-41	27
Foxprint Color Film	Fox Stanley Photo Stores, USA	●		100/21°			●	●							Kodak	C-41	21
Fujicolor HR 100	Fuji Photo Film Co Ltd, Tokyo, Japan	●		100/21°		●	●	●		●					Kodak+	CN-16/C-41	28
Fujicolor HR 400	Fuji Photo Film	●		400/27°		●		●		●					Kodak+	CN-16/C-41	29
Fujicolor F II Professional L	Fuji Photo Film		●	80/20°						●				●	Kodak+	CN-16/C-41	1, 30
Fujicolor F II Professional S	Fuji Photo Film	●		100/21°						●				●	Kodak+	CN-16/C-41	3, 30
Fujicolor HR Disc Film	Fuji Photo Film	●		200/24°	●										Kodak+	CN-16A/C-41A	
Fujicolor 8518	Several distributors, USA	●	●	250/25°				●							Kodak+	ECN-2	31

Colour Negative Films

See pages 185-186 for explanatory notes.

Film	Manufacturer or Distributor	Daylight	Tungsten	ISO speed	Disc	110	126	135	127	120	220	Bulk 35	Bulk 70	Sheet	Colour principle	Processing	Comments
Ilfocolor 100	Ilford Limited, Basildon, Essex, England	●		100/21°		●		●							Kodak	C-41	13
Ilfocolor 400	Ilford	●		400/27°				●							Kodak	C-41	13
Kameracolor	Woolworth, USA	●		100/21°		●		●							Kodak	C-41	21
Kodacolor II	Kodak	●		100/21°		●	●	●	●	●					Kodak+	C-41	32
Kodacolor VR 100	Kodak	●		100/21°				●							Kodak+	C-41	33
Kodacolor VR 200	Kodak	●		200/24°				●							Kodak+	C-41	33
Kodacolor 400	Kodak	●		400/27°		●		●		●					Kodak+	C-41	34
Kodacolor VR 400	Kodak	●		400/27°				●							Kodak+	C-41	33
Kodacolor VR 1000	Kodak	●		1000/31°				●							Kodak+	C-41	
Kodacolor HR Disc Film	Kodak	●		200/24°	●										Kodak+	C-41A	
Konicacolor 100	Konishiroku Photo Industry Co Ltd, Tokyo, Japan	●		100/21°		●	●	●		●					Kodak	CNK-4/C-41	35
Konicacolor 400	Konishiroku	●		400/27°		●		●		●					Kodak	CNK-4/C-41	35
Kranzcolor 100	Kranz, GmbH, Düren, West Germany	●		100/21°		●	●	●							Kodak	C-41	36
Kranzcolor 400	Kranz GmbH	●		400/27°				●							Kodak	C-41	36
Labaphot Profi Film CN 100	Labaphot GmbH, West Berlin	●		100/21°				●							Kodak+	C-41	20
M-Film	Migros Supermarkets, Switzerland	●		100/21°				●							Kodak+	C-41	20
3M Color Print II 100	3M Company, Milan, Italy	●		100/21°		●	●	●		●					Kodak	CNP-4/C-41	
3M Color Print II 120 RP	3M Company	●		100/21°						●					Kodak	CNP-4/C-41	37
3M Color Print 400	3M Company	●		400/27°				●							Kodak	CNP-4/C-41	
3M Color Disc Film	3M Company	●		200/24°	●										Kodak	CNP-4A/C-41A	
Minocolor	Minox GmbH, Giessen, West Germany	●		80/20°											Kodak	C-41	38
Mitsubishi Color II	Mitsubishi, Toyko, Japan	●		100/21°		●	●	●							Kodak	C-41	27
Negracolor II	Negra, Barcelona, Spain	●		100/21°		●	●	●							Kodak	C-41	27
Negracolor 400	Negra	●		400/27°				●							Kodak	C-41	27
Novacolor II	Nova Cameras, Newcastle, England	●		100/21°		●	●	●							Kodak	C-41	39
Ogacolor 100	Obergassner KG, Munich, West Germany	●		100/21°		●	●	●							Kodak	C-41	21
Ogacolor 400	Obergassner KG	●		400/27°		●		●							Kodak	C-41	21
Orwocolor NC 19	VEB Fotochemisches Kombinat Wolfen, GDR	●	●	64/19°				●	●	●				●	Agfa	Orwo 5166	40
Orwocolor NC 20	VEB FKW	●		80/20°		●									Agfa	Orwo 5166	41

Colour Negative Films

See pages 185-186 for explanatory notes.

Film	Manufacturer or Distributor	Daylight	Tungsten	ISO speed	Disc	110	126	135	127	120	220	Bulk 35	Bulk 70	Sheet	Colour principle	Processing	Comments
Orwocolor NC 21	VEB FKW	●		100/21°		●	●	●	●					●	Agfa	Orwo 5166	42
Orwocolor Professional	VEB FKW	●	●	40/17°						●					Agfa	Orwo 5166	43
Orwocolor Professional L	VEB FKW	●		40/17°										●	Agfa	Orwo 5166	1, 43
Perucolor 100	Perutz, Munich, West Germany	●		100/27°		●		●							Kodak	C-41	36
Porst Color N 21	Photo-Porst, Schwabach, West Germany	●		100/21°		●	●	●	●						Kodak	C-41	36
Porst Color N 27	Photo-Porst	●		400/27°		●		●							Kodak	C-41	36
Revue Supercolor CN 21	Foto-Quelle, Nürnberg, West Germany	●		100/21°		●		●							Kodak	C-41	21
Revue Supercolor CN 27	Foto-Quelle	●		400/27°				●							Kodak	C-41	21
Revue Supercolor Disc Film	Foto-Quelle	●		200/24°	●										Kodak	C-41A	21
Sakuracolor II	Konishiroku Photo Industry Co Ltd, Tokyo, Japan	●		100/21°		●	●	●	●						Kodak	CNK-4/C-41	44
Sakuracolor 400	Konishiroku	●		400/27°		●		●	●						Kodak	CNK-4/C-41	44
Sakuracolor II Professional L	Konishiroku		●	64/19°						●				●	Kodak	CNK-4/C-41	1
Sakuracolor II Professional S	Konishiroku	●		64/19°						●				●	Kodak	CNK-4/C-41	3
Sears Color Print	Sears, Roebuck & Co, Chicago, Ill, USA	●		100/21°		●	●	●							Kodak	C-41	21
Sears Color Print 400	Sears, Roebuck	●		400/27°				●							Kodak	C-41	21
Shanghai Light Colour	People's Republic of China	●		100/21°				●		●					Kodak	C-41	45
Svema DS-5	Shostka Film Factory, USSR	●		40/17°				●		●		●			Agfa	Probably Orwo 5166	46
Svema LN-8	Shostka		●	100/21°				●		●		●		●	Agfa	Probably Orwo 5166	47
Tacma Color Film	Kujbyshev Film Factory, USSR	●	●	See comment				●		●		●		●	Agfa	Probably Orwo 5166	48
Tudorcolor II	Tudor Photographic Group Ltd, London, England	●		100/21°		●	●	●							Kodak	C-41	21
Turacolor II	Tura GmbH, Düren, West Germany	●		100/21°		●	●	●	●						Kodak	C-41	36
Turacolor II 400	Tura GmbH	●		400/27°				●							Kodak	C-41	36
Valcolor II	Valca, Bilbao, Spain	●		100/21°		●	●	●		●		●			Kodak	C-41	49
Vericolor II Professional Type L	Kodak		●	80/20°						●	●			●	Kodak+	C-41	1
Vericolor II Professional Type S	Kodak	●		100/21°						●	●	●	●	●	Kodak+	C-41	3, 50
Vericolor II Commercial Type S	Kodak	●		80/20°						●				●	Kodak+	C-41	3, 51
Vericolor III Professional Type S	Kodak	●		160/23°						●	●			●	Kodak+	C-41	3, 52
Voigtländer C 100	Voigtländer GmbH, Braunschweig, West Germany	●		100/21°		●		●							Kodak	C-41	36
Voigtländer C 400	Voigtländer	●		400/27°				●							Kodak	C-41	36

Colour Instant Picture Materials (self processing)

See pages 185-186 for explanatory notes.

Film	Manufacturer	ISO-Speed	Packaging and size	Type	Nominal processing time	Comments
Fuji Fotorama FI-10	Fuji Photo Film Co Ltd, Tokyo, Japan	150/23°	Film pack for 10exp 6·8×9·1cm	Integral single sheet	60sec	53, 3
Kodamatic Instant Color Film HS 144-10	Kodak	320/26°	Film pack for 10exp 6·8×9·1cm	Integral single sheet	4min	54, 3
Kodak Instant Color Film PR 144-10-2	Kodak	150/23°	Film pack for 10exp 6·8×9·1cm	Integral single sheet	4min	55
Polacolor 2 Type 88	Polaroid Corp, Boston, Mass, USA	80/20°	Film pack for 8exp 8·2×8·6cm	Peel-apart (two-sheet)	60sec	57
Polacolor 2 Type 108	Polaroid Corp	80/20°	Film pack for 8exp 8·3×10·8cm	Peel-apart (two-sheet)	60sec	
Polacolor 2 Type 668 Professional	Polaroid Corp	80/20°	Film pack for 8exp 8·3×10·8cm	Peel-apart (two-sheet)	60sec	56
Polacolor 2 Type 808 Professional	Polaroid Corp	80/20°	Sheet films 8×10in	Two-sheet lamination in special processor	60sec	57
Polacolor Type 58	Polaroid Corp	80/20°	Sheet films 4×5in	Peel-apart (two-sheet)	60sec	57
Polacolor ER Type 59	Polaroid Corp	80/20°	Sheet films 4×5in	Peel-apart (two-sheet)	60sec	57, 58
Polacolor ER Type 559	Polaroid Corp	80/20°	Film pack for 8exp 4×5in	Peel-apart (two-sheet)	60sec	57, 58
Polacolor ER Type 669	Polaroid Corp	80/20°	Film pack for 8exp 8·2×8·6cm	Peel-apart (two-sheet)	60sec	57, 58
Polacolor ER Type 809	Polaroid Corp	80/20°	Sheet film 8×10in	Two-sheet lamination in special processor	60sec	57, 58, 59
Polaroid 600 High Speed Colour Land Film	Polaroid Corp	640/29°	Film pack for 10exp 8·7×10·8cm	Integral single sheet	90sec	54, 3
Polaroid Super Color Time-Zero SX-70 Land Film Type 778	Polaroid Corp	100/21°	Film pack for 10exp 8·7×10·8cm	Integral single sheet	4min	54, 57
Polaroid SX-70 Land Film Type 708	Polaroid Corp	100/21°	Film pack for 10exp 8·7×10·8cm	Integral single sheet	4min	60
Polaroid SX-70 Land Film Type 779	Polaroid Corp	640/29°	Film pack for 10exp 8·7×10·8cm	Integral single sheet	4min	57, 61

EXPLANATORY NOTES

Colour sensitisation type

Daylight Balanced for use in daylight (conventionally assigned a colour temperature of 5500°K) and for electronic or blue bulb flash.

Tungsten Balanced—with one exception—for use with studio incandescent lamps with a nominal colour temperature of 3200°K; such films are usually coded Type B, L or T. The exception is Kodachrome 40 Type A which is balanced for a nominal colour temperature of 3400°K.

Note: Most ISO 400/27° (ASA400, 27 DIN) and faster films, both reversal and negative, although basically of daylight balance have the peak sensitivites of the three colour layer sensitisations adjusted to minimise the differences in rendering under mixed or lower colour temperature lighting. A few negative films are claimed to be of 'universal' type for both daylight and tungsten (e.g. Contec, Orwocolor NC 19). Most daylight colour negative films can be exposed under artificial lighting with correction by filtration during printing, at the expense of some exposure latitude.

Film sizes

Disc Disc film for disc cameras only (negative size 8×10·5mm, 15 exposures).

110 16mm film in cartridge (12, 20 or 24 exposure pack) for exposures 13×17mm.

126 35mm single-perforation film in cartridge (12, 20 or 24 exposure pack) for exposures 28×28mm.

135 35mm double-perforated film in metal or plastic cassette (12, 20, 24 or 36 exposure loadings) for exposures 24×36mm, or less commonly 24×24mm or 18×24mm with correspondingly more exposures per packing.

127 Paper-backed rollfilm on narrow-diameter spool for 8 exposures 4×6·5cm, 12 exposures 4×4cm or 16 exposures 3×4cm.

120 Paper-backed rollfilm on large diameter spool for 8 exposures 6×9cm, 10 exposures 6×7cm, 12 exposures 6×6cm and 15/16 exposures 4·5×6cm or 4×4cm.
Some specialised wide-angle cameras and backs for sheet-film cameras use this size for panoramic formats 6×17cm and 6×12cm. **620** is an obsolescent version of 120 on a small diameter spool with minor differences in backing paper and film length; now available only in a restricted range of very commonly used amateur films.

220 Rollfilm with paper leader and trailer of same width as 120 rollfilm but allowing twice the number of exposures per loading. Absence of backing paper necessitates special film holder or adjustment to film pressure plate by comparison with 120.

Bulk 35 Bulk rolls of 35mm wide double-perforated film in a range of standard lengths. Minimum length is generally 30 metres or 100ft.

Bulk 70 Bulk rolls of 70mm wide double-perforated film in a range of standard lengths. Minimum length is generally 30 metres or 100ft, but occasionally 15ft.

Sheet Flat film on heavy acetate or polyester base for use in the appropriate film holders. Not all films marked in this category will be available in all sizes but all will be available in 4×5in and most in 5×7 and 8×10in.

Colour principle—reversal films

Agfa Dye couplers incorporated in emulsion and immobilised by long-chain hydrocarbon residue to prevent diffusion.

Ektachrome Resin-protected dye couplers dispersed in emulsion after being dissolved by solvent with high initial boiling point.
The distinction between the Agfa and Kodak or Ektachrome methods of holding colour forming components immobile in the correct emulsion layers is today becoming less distinct. The materials intended for processing in the E-6 process solutions may actually use a mixture of colour forming components. The old distinction is, however, maintained in the tabulation for the time being to avoid confusion in processing.

Kodachrome Dye couplers incorporated in separate colour developer solutions: film is selectively light reversed, layer by layer.

Autoprocess line-screen Black-and-white film emulsion for silver salt diffusion process having small colour filters (red, green, blue) in line form for additive colour reproduction.

Colour and masking principle—negative films

Agfa Dye couplers incorporated in emulsion and immobilised by long-chain hydrocarbon residue to prevent diffusion. Automatic azo masks are based on the Kodak principle, but with Agfa-type couplers.

Kodak Resin-protected dye couplers dispersed in emulsion after being dissolved by solvent with high initial boiling point. Masking by azo dye components (Kodak principle).

Kodak + Dye coupling as mentioned before, but red azo mask coupler is of the Agfa type. (This variation is said to be used in Kodak and Fuji colour negative films.)

Note: All '**instant**' films use diffusion-transfer principles. Further details are given under the heading 'type' in the appropriate table.

Processing—reversal films

Agfachrome 41 Agfachrome Professional Process 41 (not to be confused with Kodak C-41 colour negative process).

E-4 Old Kodak Ektachrome Process E-4.

E-6 Kodak Ektachrome Process E-6 or equivalent (for instance Agfachrome Process AP 44 or Fuji Process CR-56).

Orwo 9165 Orwochrom processing formula No 9165.

Service Film processing charge included in purchase price. With some films mounting in cardboard or plastic slide mounts is also included.

Processing—negative films

AP-70 Agfacolor Process AP-70 (compatible with C-41).

C-41 Kodak colour negative process C-41.

C-41A	Variation of C-41 for disc films (with high agitation in developer solutions).
CN-16	Fuji colour negative process CN-16 (compatible with C-41).
CN-16A	Fuji colour negative process CN-16A (compatible with C-41A).
CNK-4	Sakura colour negative process CNK-4 (compatible with C-41).
CNP-4	3M colour negative process CNP-4 (compatible with C-41).
CNP-4A	Expected code for 3M disc film process in preparation (process is compatible with C-41A).
ECN-2	Eastman Color cine film process ECN-2 (not compatible with C-41).
Orwo 5166	Orwo colour negative process No 5166.

Comments

1 Film balanced for longer exposure times
2 Exact batch speed (to 1/3 stop) is given on the instruction leaflet packed with film
3 Film balanced for shorter exposure times
4 Material made by Fuji to Agfa specification, packed by Agfa-Gevaert in West Germany
5 To be replaced by a new medium-speed E-6 compatible material
6 Fujichrome material
7 Fomachrom material
8 Agfachrome material
9 Orwochrom UT18 material
10 3M Color Slide material
11 Infrared-sensitised 'false-colour' material (colour rendering varies according to filter used: for general or technical photography it is designed to be used with yellow or orange filter in which case infrared reflecting subjects are rendered red-magenta)
12 Sakurachrome material
13 Material made in Japan (by Konishiroku) to Ilford specification
14 High-contrast material with high resolving power for technical and scientific photography
15 New trade mark for Sakuracolor, Europe and USA
16 Minox miniature film cassette only
17 Orwochrom Professional Film is available only on the East German home market in small quantities; it has polyester base
18 Kodachrome Professional 25 and 64, manufactured to colour balance aim point available at premium price from end 1983
19 Improved type replacing former Agfacolor CNS 400 film
20 Fujicolor material (old type)

21 3M colour film material
22 Probably Agfacolor material
23 Actually Eastman Color Negative Film Type 5247 for both prints and slides. Can be exposed at EI 100-400
24 Actually Eastman Color Negative Film Type 5293 for both prints and slides. Can be exposed at EI 400, 800 or 1600 (by pushing)
25 Cine negative films distributed for making prints and/or slides. Can be exposed at EI 100-400
26 Cine negative films distributed for making prints and/or slides. Can be exposed at EI 400, 800 or 1600 (by pushing)
27 Sakuracolor material
28 New improved film which replaces former Fujicolor FII
29 New improved film which replaces former Fujicolor FII 400
30 Replaced by improved type ('HR')
31 Cine negative film distributed for making prints and/or slides
32 35mm replaced end 1983 by new Kodacolor VR100
33 Introduced end 1983. Improved film based on disc film technology
34 35mm replaced end 1983 by new Kodacolor VR400
35 New trade mark for Sakruacolor, Europe and USA
36 Agfacolor material
37 Professional film
38 Probably Kodak colour film, available in Minox miniature cassette only
39 Probably 3M material
40 Also available in 'SL' rapid loading 35mm cassette. NC 19 will be replaced by new NC 21 film
41 Available in 'Cassette 16' which is not fully compatible with 110 pocket cassette although

having same negative size. It is expected to be replaced by new NC 21 film
42 Higher speed Orwocolor film in preparation. Processing may remain the same as with NC 19
43 Available in German Democratic Republic only
44 The trade mark 'Sakuracolor' is being restricted to South-east Asia and some other markets only in favour of 'Konicacolor' for Europe and USA
45 This film is said to be an own development of the Chinese photochemical industry (otherwise it could be Sakuracolor material)
46 There might be other film types available besides DS-5. They are not exported
47 Compare note 46
48 Same material as 'Svema', available in different types in USSR only
49 Probably Sakuracolor material
50 To be replaced by new improved and higher speed Vericolor III
51 Film has higher contrast
52 New film in preparation
53 Available in Japan only
54 Picture is seen with 90% of final saturation and density, result can be judged but development continues at an exponentially slowing rate for a time to effective equilibrium
55 Film is compatible with older Kodak instant cameras when 'lighten' control on camera is changed for two steps
56 Balanced for electronic flash. To be replaced by ER Type 669
57 Balanced for electronic flash.
58 Extended tonal range film
59 Improved version of Type 668
60 Without battery pack in film cassette
61 For endoscopic photography

PROCESSING COLOUR

General Instructions

Storage

The keeping time of used solutions may be diminished by 20-65% depending upon conditions of use and storage (fullness and sealing of bottles, darkness and temperature). Well stoppered dark glass bottles should be used at temperatures not exceeding 20°C. However, first and colour developers should, in any case, be used as fresh as possible. If bleach and fixer are made up as triple-strength stocks, they will be found to have excellent storage properties.

Temperature

Maintenance of constant temperature throughout first (black-and-white) development in reversal processing and (colour) development in negative processing is absolutely essential if consistent results are to be achieved. In the other solutions, the tolerance is wider, although the specified limits should be respected. Even so, it is important that excessive temperature differences between successive solutions and wash water, especially in transferring to the wash following colour development, be avoided, otherwise there is a risk of reticulation. The washing times given in the procedures apply at the recommended temperatures; if water at lower temperatures is used times must be extended by 50% per 5°C.

Colour developing agents

N,N-Diethyl-p-phenylenediamine hydrochloride = Activol H (Johnson), Colour Developer 1 (chloride) (Merck), CD-1 (Kodak).

N,N-Diethyl-p-phenylenediamine sulphate = Colour Developer 1 (sulphate) (Merck). More sulphate than hydrochloride will be needed in the ratio 262:200.

N,N-Diethyl-p-phenylenediamine sulphite = Genochrome (May & Baker), Activol No.1 (Johnson), S28 (3M/Ferrania).

2-amino-5-diethylaminotoluene hydrochloride = Tolochrome (May & Baker), Colour Developer 2 (Merck), CD-2 (Kodak).

4-amino-N-ethyl-N-(ß-methanesulphonamidoethyl)-m-toluidine sesquisulphate monohydrate = Mydochrome (May & Baker); Activol No 3 (Johnson), Colour Developer 3 (Merck); CD-3 (Kodak).

4-[N-ethyl-N-2-hydroxyethyl]-2-methylphenylenediamine sulphate = Colour Developer 4 (Merck), CD-4 (Kodak).

N-Ethyl-N-(ß-hydroxyethyl)-p-phenylenediamine sulphate = Droxychrome (May & Baker), Activol No 8 (Johnson), T32 (Orwo), Colour Developer 32 (Merck).

N-n-butyl-N(4 sulpho-n-butyl)1,4-phenylediamine = Ac60 (Agfa), Colour Developer 60 (Merck).

This list is retained although some of the chemicals are no longer available under the trade names indicated here, since readers have found it of assistance in tracking them down. The main suppliers are: Rayco Ltd, Ash Road, Aldershot, Hants. Telephone: 0252 22725, and Photo Chemical Supplies, whose address appears on page 167.

Making up solutions

Difficulties are sometimes encountered in making up colour developing solutions when the developing agent is dissolved in the otherwise complete solution. With developers containing carbonate, the strongly acid nature of the agent may cause effervescence with loss of carbon dioxide changing the acidity and thus the activity of the resulting solution. Whatever alkali is being used, it is possible for the agent to be released as the free base which floats in oily globules difficult to redissolve. To avoid these effects with any of the solutions given on the following pages, the agent together with the hydroxylamine salt (if any) should be dissolved in half of the water and the remaining ingredients in the other half; the first solution is then poured slowly into the second with continuous stirring. After mixing it is advisable to let the solution stand for four to twenty-four hours before use. In addition, the precautions regarding containers suitable for the mixing of solutions on page 166 of the general instructions for black-and-white processing should be followed carefully.

Times

All times, including those for washing or rinsing, should be adhered to in order to obviate the possibility of colour casts. The specified treatment times include 10-15sec drainage.

Agitation

The recommended agitation is indicated immediately after the procedure. It should be adhered to strictly in the developers but in other solutions should be regarded as a minimum: more vigorous agitation can only be advantageous in expediting solution changes in the emulsion.

Lighting

The individual procedures clearly show at what stage normal room lighting may be resumed when use of an open processing tank necessitates initial darkroom working. At the same stage, the lid of a light-tight tank may be removed.

Second exposure

Where second exposure to light is the manufacturer's recommended procedure the recommended lamp wattage and distance are shown at the appropriate point. The film should preferably be removed from the spiral and see-sawed through a dish of cold water below the lamp, front and back being exposed approximately equally. If the exposure is carried out with the film in a transparent-ended spiral, best immersed in cold water in a white bowl, the time should be extended 1½ (35mm) or 2½ (120) times. Care should be taken not to splash the hot lamp with water and not to work near the sink or taps unless the lampholder is properly earthed. Three or four electronic flashes on each side of the film may also be used although this may give odd colour casts with some films.

Wetting agents

If a final wash completes the procedure, the material should be passed for about 1 min through water containing around 1 ml/l of wetting agent in order to accelerate draining and drying, thereby inhibiting drying marks. The wetting agent may be either of the anionic type—eg American Cyanamid Aerosol OT (sodium di-iso-octylsulphosuccinate), Union Carbide Tergitol 7 and Ciba Invitol—or the non-ionic type—eg Rohm and Hass Triton X-100, Francolor Sunaptol OP and Union Carbide Tergitol NPX. The wetting agent is conveniently stored as a 10% solution and made up as a 10% solution of this, thus forming a 1% solution. The working strength solution keeps indefinitely but should be discarded after use.

Drying

Should be performed under protection from air currents and dust.

General

The formulae quoted produce results closely corresponding with those from official kits, but deviations occasionally occur owing to variations in reagents from different suppliers. To compensate for these, where necessary, or to

provide controls to suit the individual user's taste, the following notes on the less usual ingredients may be helpful:

Citrazinic acid (CZA or 2,6-dihydroxyisonicotinic acid) is employed as a *specialised restraining agent* and serves to prevent what would otherwise be an excessively dense and contrasty dye image. A deficiency produces a dense greenish image, but an excess produces a thin pinkish image; a 10% change in concentration shows markedly in the result.

Ethylenediamine tetra-acetic acid tetrasodium salt (EDTA Na_4) acts as an *accelerator*. A deficiency produces a thin yellowish image, whereas an excess produces a heavy bluish image; a 10% variation has a quite noticeable effect.

Benzyl alcohol acts as a *penetrating agent* making the otherwise waterproof dye-former particles accessible to the colour developer products. It is particularly important to ensure that this liquid is completely dissolved before any other reagent of the colour developer is added.

Variations in the amount of *colour developing agent* produce effects rather similar to those of the EDTA salt, the balance travelling from thin and warm to dense and cool as the concentration is increased.

Precaution

Colour developers contain derivatives of para-phenylenediamine, which in certain persons may produce a form of skin irritation. Persons who are sensitive to chemicals of this kind should take precautions to avoid contact with the developer by using rubber gloves. In all cases, when the skin has been in contact with the solution, it should be rinsed well in clean water, preferably made acid with a few drops of acetic or hydrochloric acid, before using soap. Where processing chemicals are used in premises subject to the provisions of the Health and Safety Act, 1974 (eg in professional use or in commercial processing plants) the Act should be consulted for the safety precautions to be observed. In all cases warnings printed on chemical package labels should be strictly complied with. Fuller details of precautions to be observed in the handling of particular materials may be found in the Royal Society of Chemistry publication, *Hazards in the Chemical Laboratory* (3rd edition) by L. Bretherwick.

Reversal Films

AGFACHROME 50S, 50L and 100
(and AGFACOLOR CT18, CT21 and CK20)

Agfachrome 50S, 50L and 100 are intended for professional use and are sold without processing rights. Agfa CT18, CT21 and CK20 materials are of similar type but are intended for amateur use and are sold inclusive of processing: available in the usual formats. **Agfachrome 200** is sold in the United Kingdom both exclusive and inclusive of processing and mounting but is intended for the E-6 process and *not* the solutions which follow.

Formulae
First developer (pH:10·2±0·1)

Calgon	2·0g
Metol	3·0g
Sodium sulphite (anhydrous)	40·0g
Hydroquinone	6·0g
Sodium carbonate (anhydrous)	50·0g
Sodium thiocyanate	1·8g
Potassium bromide	2·0g
Potassium iodide, 0·1% solution	6·0ml
6-nitrobenzimidazole nitrate 0·2% solution* (optional)	20·0ml
Water to	1000·0ml

* If 6-nitrobenzimidazole is available a 0·2% solution of the nitrate may be prepared by adding 1g to 500ml water previously acidified by the addition of 0·4ml nitric acid. The mixture should be shaken to dissolve the compound.

Stop bath (pH: 5·2±0·2)

Acetic acid 98-100% (glacial)	10·0ml
Sodium acetate ($3H_2O$)	40·0g
Water to	1000·0ml

Colour developer (pH: 11·8±0·2)

Calgon or sodium tripolyphosphate	2·0g
Sodium sulphite	2·0g
Potassium carbonate (anhydrous)	80·0g
Hydroxylamine sulphate	2·0g
or hydrochloride	2·2g
Ethylenediamine (anhydrous)	8·0g
or ß-phenylethylamine	3·0g
Potassium bromide	2·0g
Water to	1000·0ml

Add before use:

Droxychrome or Activol X	6·5g
(or the equivalent quantity of a 20% solution)	

One may also use as the colour developing agent diethyl paraphenylenediamine sulphate or hydrochloride or even Genochrome may also be used at 5·0g/litre.

Bleach (pH: 5·4±0·2)

Potassium ferricyanide	80·0g
Potassium bromide	20·0g
Diosodium hydrogen orthophosphate ($12H_2O$)	27·0g
Sodium or potassium bisulphate	12·0g
Water to	1000·0ml

Fixer (pH: 7·0–7·8)

Sodium thiosulphate (crystalline)	200·0g
Sodium sulphite (anhydrous)	10·0g
Water to	1000·0ml

Ammonium thiosulphate, 120g/litre, may be used to accelerate fixing, replacing the sodium salt.

Stabilising and wetting agent

Wetting agent 10% soln	5-10ml
Formaldehyde 35-40% soln	10ml
Water to	1000ml

Procedure

		At 20°C	At 24°C
1	First developer	18-20min 20±0·5°C	13-14min 24±0·25°C
2	Rapid rinse	30sec 16-20°C	30sec 20-24°C
3	Stop bath	4min 18-20°C	3min 22-24°C
4	Wash	10min 16-20°C	7min 20-24°C
5	Re-exposure	500W at 3ft, 1min each side	

6 Colour developer	14min 20±0·5°C	11min 24±0·25°C
7 Wash	20min 16-20°C	14min 20-24°C
8 Bleach	5min 18-20°C	4min 22-24°C
9 Wash	5min 16-20°C	4min 20-24°C
10 Fixer	5min 18-20°C	4min 22-24°C
11 Wash	10min 16-20°C	7min 20-24°C
12 Stabiliser and Wetting agent	1min 16-20°C	1min 20-24°C
13 Dry	Maximum 30°C	
Total	94·5min	70·5min

Notes

A Recommended agitation is 30sec continuous then two periods of 5sec every minute.

B After Stage 4, the processing may be interrupted and the film dried, processing being completed later. In this case, washing should be prolonged to 5min, and the re-exposure to artificial light may be dispensed with. Once dry, the film should be kept in darkness to obviate any possibility of solarisation. If the intermediate drying procedure is followed it is *not* necessary to wet the film before proceeding to Stage 6.

KODAK EKTACHROME FILMS

The generic name for Kodak user-processable reversal materials is Ektachrome and all current materials of this type except two—Ektachrome Infrared and Photomicrography Color Film 2483—are processed by **Process E-6**. These two exceptions continue to use the earlier **Process E-4**, which introduced for the first time the use of a chemical reversal bath to replace reversal by a second exposure. The reversal bath used in Process E-4, however, contains components which are toxic and require care in handling which may not be appropriate to some amateur circumstances.

EKTACHROME E-6

The Ektachrome E-6 process, like its predecessor the E-4 process, is intended for machine use and is usefully shorter, needing around 40min in the solutions. The shorter process time is achieved by raising the solution temperatures to 38°C. From the user's point of view the process has been improved in two directions; the somewhat aggressive preliminary hardener has been eliminated by hardening the film emulsion in manufacture and the highly toxic tertiary butylaminoborane used as a reversing agent in the colour developer has been replaced by the much less dangerous stannous chloride in a reversing bath which precedes the colour development stage.

Like the C-41 process for colour negative development the E-6 process uses separate bleach and fix stages but with the bleach action performed by a ferric-EDTA complex as is now common in bleach-fix solutions. Intermediate rinses are practically eliminated, and washing times are shortened, thus permitting substantial economies in water consumption (and probably in energy also, despite the high working temperature). And, thanks to the hardened emulsion, which is more resistant and less retentive of water, drying is much more rapid, the more so as it withstands the necessary higher air temperatures.

Formulae

These formulations give results of comparable quality to those obtained by the use of the manufacturers' chemistry. In one or two of the baths deriving from the E-6 process we propose some variants as in the first developer and the bleach. They are both derived from E-4 and only require adaptation for the new products; this should make the work of preparation easier. Quantities are indicated in grammes per litre or ml per litre.

First Developer (pH: 9·6±0·1)

Calgon	2·0g
Sodium sulphite (anhydrous)	15·0g
Potassium hydroquinone monosulphonate (pure)	20·0g
Diethylene glycol	15·0ml
Potassium carbonate (anhydrous)	15·0g
Phenidone	0·4g
Sodium thiocyanate (20% solution)	8·0ml
Potassium bromide	1·8g
Potassium iodide (1% solution)	4·0ml
Water to	1000·0ml

Alternative First Developer (pH: 9·6±0·1)

Calgon	2·0g
Sodium sulphite (anhydrous)	15·0g
Potassium carbonate (anhydrous)	15·0g
Hydroquinone	6·0g
Phenidone	0·4g
Sodium thiocyanate (20% solution)	8·0ml
Potassium bromide	2·0g
Potassium iodide (1% solution)	5·0ml
Water to	1000·0ml

Reversal Bath (pH: 5·8±0·1)

Propionic acid	15·0ml
Stannous chloride (crystalline: $2H_2O$)	1·8g
Sodium (or potassium) hydroxide (40% solution)	12·5ml
Water to	1000·0ml

Notes: 1 If reversal is carried out by exposure to light the reversal bath must be replaced by a stop bath consisting of 2% acetic acid for 1min at 38°C, followed by a rinse for the same time and temperature in running water. The operation is carried out in the dark. **2** If the chemical reversal bath goes milky as a result of the stannous chloride hydrolysing, this will not influence the results. It may however be advisable to filter before use.

Colour Development (pH: 11·6±11·7)

EDTA Na_4	3·0g
Trisodium phosphate (crystalline, $12H_2O$)	40·0g
Sodium sulphite (anhydrous)	4·0g
Potassium bromide	0·5g
Potassium iodide (1% solution)	3·0ml
Citrazinic acid	1·2g
Hydroxylamine hydrochloride	1·5g
Water to	1000·0ml
Add before use: CD-3	10·0g
or CD-4	7·5g

These two chemicals can be kept without difficulty as 20% stock solutions with the addition of 2-3g per litre of potassium or sodium metabisulphite.

Conditioning Bath (pH: 6·1±0·1)

Sodium sulphite (anhydrous)	10·0g
EDTA Acid	8·0g
Thioglycerol	0·5ml
Water to	1000·0ml

Notes: 1 If only EDTA Na_4 is available or EDTA Na_2 then 12g of the former or 10g of the latter may be used with the pH adjusted with dilute acetic acid. **2** The inclusion of thioglycerol is optional. **3** For our purposes, perfect results have been obtained with the use of the E-3 clearing bath with a small

modification and with the pH adjusted if necessary by adding alkali—sodium or potassium carbonate. The bath is as follows:

Potassium metabisulphite (crystalline)	15·0g
Hydroquinone	1·0g
Water to	1000·0ml

Bleach (pH: 5·5-5·7)

Potassium nitrate (crystalline)	30·0g
Potassium bromide	110·0g
EDTA NaFe or NH₄Fe (Merck)	110·0g
Water to	1000·0ml

Note: The nitrate is optional and acts as a protection for stainless steel tanks.

Alternative Bleach (pH: 6·7-6·9)

The formulae established for the E-4 process also gives excellent results. Here is a simple and efficient variant of it:

Potassium ferricyanide (crystalline)	100·0g
Potassium bromide	35·0g
Disodium phosphate (crystalline)	20·0g
Water to	1000·0ml

Fixer (pH: 6·6-6·7)

Ammonium thiosulphate (crystalline)	70·0g
Potassium metabisulphite (crystalline)	12·0g
Sodium sulphite (anhydrous)	7·0g
Water to	1000·0ml

Note: The E-3 or E-4 fixing baths work just as well.

Stabiliser

Wetting agent (Aerosol OT, anionic or any similar product) (10% solution)	5·0ml
Formaldehyde (35-40%)	6·0ml
Water to	1000·0ml

Stock concentrated solutions

Solutions prepared as concentrates and diluted just before use have markedly increased shelf life—by a factor of two or three. The solutions we have used are as follows and they give a worthwhile saving of time and effort.

	Concentration	Dilution
First developer	X2	1+1
Colour developer	X4	1+3*
Reversal	X10	1+9
Conditioner	X10	1+9
Bleach	X2	1+1
Fixer	X5	1+4
Stabiliser	X20	1+19

*If a concentrated solution is prepared it is best to replace the trisodium phosphate which is sparingly soluble by potassium carbonate: 160g per litre in the concentrated solution—40g per litre in the working solution.

The CD-3 or CD-4 may be kept separately by making a 20% solution from which may be measured the required quantity by pipette.

CD-3 or CD-4	20·0g
Potassium metabisulphite (crystalline)	3·0g
Water to	100·0ml

Influence of pH

The E-3 process used solutions whose pH differed considerably from one bath to the next. These variations were considerably reduced with E-4. The high temperature working proposed with E-6 allows only minor pH differences between baths—with the exception of the first and colour developers. Fluctuations, intentional or not, in the colour developer pH, can result in variations in the colour balance of the subject matter of the exposures. Variations in first developer pH chiefly affect its activity, raising or lowering its reducing power, and resulting in an increase or reduction in the speed of development.

Colour Developer
 pH too low: blue cast
 pH too high: yellow cast
 Colour developer too dilute: magenta cast
 If the reversing bath is too dilute or exhausted: green cast.

Notes

A The *temperature* of the developer must be maintained with the utmost possible accuracy. We recommend the use of a stainless steel tank immersed in a tank of water at a temperature of 39°C, from which it is removed for agitation, and immediately re-immersed.
B The *times* given include the time needed to empty the tank: this should not exceed a maximum of 10sec.
C Each operation should be timed from the moment the tank is filled with the processing solution.
D An initial agitation of 20sec should be given, during which the tank should be tapped on a hard surface (table or sink) to disperse the bubbles of air trapped in the spiral against the emulsion surface.
E For *drying*, the spiral should, after removal from the stabiliser, first be well shaken to remove so far as possible loose drops of solution; the film is removed and then allowed to dry in a well aired but dust free situation (left overnight at a temperature of 22-25°C) or stretched in special drying clips for this purpose, or otherwise suspended. (At 20-25°C drying will then take about ½hr.)

Processing at temperatures other than 38°C

The physico-chemical processes which are involved in processing photographic material are intrinsically related to working temperature. In other words, there is a relationship between the speed of a chemical and physical reaction and the temperature at which it occurs, the speed increasing with the temperature.

 For black-and-white development stage it is particularly necessary to have as exact a knowledge as possible of this parameter (speed), since it is this

Processing times as a function of temperature in the range 32-40°C. Line 1—black-and-white developer and EDTA Fe bleach; 2—ferricyanide bleach; 3—fix; 4—reversal bath and conditioner; 5—wash.

which determines the quality of the image: gradation, colour, rendering, density of the silver deposit in the various zones of the image and hence the dyes in the final image.

The diagram illustrating the relation between temperature and development time is the result of our own experimental work; it can be of use to those who wish (or who are obliged) to work at a temperature other than 38°C. This must not however be below 32-33°C since this will seriously affect the colour rendering of the transparency. (The permeability of the emulsion diminishes too greatly to permit adequate exchange of solutions through the gelatine.)

Modification of processing procedure

A Reversal: It is possible to dispense with *chemical* reversal and instead have recourse to the classic procedure of re-exposure of the emulsion to light: 2 electronic flash exposures to each side of the tank spiral after removal from the tank and preferably kept immersed in water, at a distance of about 30cm; or two 2min exposures to a photoflood at a distance of about 1 metre; or yet again intermediate drying in diffused light (not direct sunlight!)

B Recourse may be had to *intermediate drying* in order to defer completion of processing to a later time. After drying, the film should be kept in relative darkness. For completion of processing, it is rewound into the spiral and, preferably, soaked in water for 1min before treatment in the colour developer (this is recommended but not obligatory).

C Should the re-exposure procedure be adopted in place of chemical reversal, this soaking treatment should be replaced by 1min in a stop bath of 2% acetic acid and followed by 1min wash before opening the tank.

D Bleach: It is possible to bleach the film in 2-3 minutes by treatment in a potassium ferricyanide bleach bath of the E-3 or E-4 type, adjusted to a pH of 6.4 ± 0.2 followed by 2min rinse before fixing. The temperature of 38°C should also be maintained throughout these stages.

E Where it is desired to *keep* these various solutions, in view of the fact that there is a risk of each solution being contaminated by traces of the previous bath, we recommend an *intermediate rinse* of ½ to 1min after each bath. The small increase in overall processing time thus occasioned can only be of benefit to working capacity and keeping quality.

Exposure for a speed other than the nominal rating

Films compatible with the E-6 process can be 'uprated' to higher emulsion speeds by up to 2 stops or downrated by 1 stop compared with nominal values. To compensate for this, first development should then be modified in accordance with the table below:

Exposure	Relative speed	Development modification
−2 stops	4x	+5½min
−1 stop	2x	+2min
+1 stop	0.5x	−2min

Colour rendering is slightly affected:

+1 stop	overexposure:	reduction of contrast and deterioration of colour rendering
−1 stop −2 stops }	underexposure:	diminution of maximum density diminution of exposure latitude shift of colour rendering increase of contrast

From our personal experience, underexposure by 1 stop (as for example ASA800 for Ektachrome 400) still gives excellent results, of quality not perceptibly inferior to that resulting from correct exposure. Not all E-6 process films from other manufacturers behave identically and these development times may require modification in the light of experience.

Keeping properties and working capacities

	dm² per unit of			
	0.5l	1l	2l	Keeping
First developer	22	46	100	8-10 weeks
Colour developer	22	46	100	12 weeks

Reversal or stop bath	50	130	280	8 weeks
Conditioner	50	130	280	8 weeks
Bleach	50	130	280	6 months
Fixer	50	130	280	4-6 months
Stabiliser	preferably use fresh			

NB: one 36exp 35mm film = 5.8 dm²; one 20exp 35mm film = 3.8 dm²; 1 × 120 film = 5.1 dm²; 1 × 220 film = 10.2 dm².

Partially used solutions and working solutions generally have their keeping life reduced by 50% and their useful capacity reduced by 20%.

Procedure for large tanks (exceeding 2 litres)

Stage		Time min	Temp °C	Agitation
1	First development	6	38±0.3	1×20sec, then 2×5sec per min
2	Rinse	2	33-39	1×10sec then leave undisturbed
3	Reversal	2	33-39	1×10sec then leave undisturbed
4	Colour development	6	38±0.6	1×20sec then 2×5sec/min
5	Conditioner	2	33-39	1×10sec then leave undisturbed
6	Bleach	6	,,	2-4×5sec/min
7	Fix	4	,,	2-4×5sec/min
8	Wash, running water	4	,,	at least 2 changes per min
9	Stabiliser	½	,,	no agitation
		32.5		

Procedure for small tanks (½ litre)

1	First development	7	38±0.3
2	Wash	2	33-39
3	Reversal	2	,,
4	Colour development	6	37-39
5	Conditioner	2	33-39
6	Bleach	7	,,
7	Fixer	4	,,
8	Wash	6	,,
9	Stabiliser	1	,,
		37	

Drying: max 49°C
Agitation: as for large-scale processing (above); agitation may be by inversion, if tank is water-tight.

EKTACHROME E-4

Special attention is drawn to the warnings as to the extremely noxious nature of some of the chemicals used in these formulae. Their use should not be attempted by workers unaccustomed to handling such chemicals.

The Kodak E-4 process was designed *a priori* for the mechanised processing of Ektachrome materials (EX, EH, Reversal Print, Infrared Aero) with the exception of professional-type films (then processed by the E-3 method), but it may also be used for hand processing, provided scrupulous attention is paid to the times of treatment in the respective baths. These times were noticeably shortened in comparison with those of the E-2/E-3 procedures, but this very fact introduced greater risks for the amateur should he fail to observe them meticulously.

Process E-4 presented two departures from earlier processes.

1 Re-exposure before colour development was discontinued; reversal is effected by chemical fogging of the emulsion during colour development.

This solution contains an organic chemical—TBAB (tertiarybutylamino-borane)—which enables all parts of the emulsion which have not been developed by the black-and-white first developer to react to the colour developer. TBAB is *very toxic* and must be handled with the greatest care to avoid contact with the skin and respiratory organs. It should be noted, however, that in the substitute formula for the colour developer this additive may be dispensed with, provided the film is re-exposed to light in the customary fashion; the colour characteristics of the film are practically unaffected. Chemical reversal with TBAB is also possible when working at 24°C (E-3) but only with Ektachrome EX, EH, and Infrared Aero.

2 To improve the mechanical resistance of emulsions destined for Process E-4 treatment at 29°C, it is necessary to treat them in a preliminary hardening bath containing, in addition to formaldehyde, 2,5-dimethoxytetrahydrofuran (DMTF), a liquid whose vapour is very aggressive in its action upon the respiratory system and eyes, and is very rapidly absorbed by the cutaneous tissues. It is therefore essential to avoid any contact with the liquid. Should the skin become contaminated with it, the affected part should be very thoroughly washed for 15min. Should the eyes exhibit symptoms of irritation a doctor should immediately be consulted. So far as formaldehyde is concerned, amateurs will already be familiar with its very active tanning and irritant properties, and we are confident that they will automatically take the utmost precautions.

Formulae
Pre-hardener (pH: 4·9-5·0)

6-nitrobenzimidazole nitrate	0·03g
Sodium or potassium bisulphate	0·8g
Tetrahydro-2,5-dimethoxyfuran	5·0ml
Sodium sulphate (anhydrous)	136·0g
Formaldehyde (35-40% solution)	30·0ml
Potassium bromide	3·0g
Water to	1000·0ml

Neutraliser (pH: 5·1-5·2)

Hydroxylamine sulphate	20·0g
Acetic acid, 100%	10·0ml
Sodium acetate (3H$_2$O)	24·0g
Potassium bromide	16·0g
Sodium sulphate (anhydrous)	25·0g
Potassium metabisulphite (crystalline)	5·0g
Sodium hydroxide	6·0g
Water to	1000·0ml

First developer (pH: 10·1-10·3)

Calgon, sodium hexametaphosphate or tripolyphosphate	2·0g
Metol	6·0g
Sodium sulphite (anhydrous)	50·0g
Sodium carbonate (anhydrous)	30·0g
Hydroquinone	6·0g
Potassium bromide	2·0g
Sodium thiocyanate	1·3g
Sodium hydroxide (pellets)	2·0g
Potassium iodide (0·1% solution)	6·0ml
Water to	1000·0ml

Stop bath (pH: 3·4-3·6)

Sodium acetate (3H$_2$O)	5·3g
Acetic acid (98-100% glacial)	30·0ml
Water to	1000·0ml

Colour developer (pH: 11·8±0·2)

Calgon or sodium tripolymetaphosphate	2·0g
Trisodium phosphate (12H$_2$O)	40·0g
Sodium hydroxide (pellets)	5·0g
1,2-diaminoethane (hydrate)	3·8ml
or ethylenediamine sulphate (crystalline)	7·6g
Benzyl alcohol (35% solution*)	10·0ml
Tertiary butylaminoborane (TBAB)	0·1g
Citazinic acid	1·3g
EDTA Na$_4$, EDTA tetrasodium salt	3·0g
Sodium sulphite (anhydrous)	5·0g
Potassium bromide	1·0g
Potassium iodide (0·1% solution)	20·0ml
Water to	1000·0ml

Add before use:

Kodak CD-3	11·3g

*Benzyl alcohol, 35% solution

Benzyl alcohol	35·0ml
Diethylene glycol (digol)	45·0ml
Water to	100·0ml

Bleach (also for E-3) (pH: 6·6-7·0)

Potassium ferricyanide	112·0g
Potassium bromide	24·0g
Disodium hydrogen orthophosphate (12H$_2$O)	62·0g
Monosodium dihydrogen orthophosphate (anhydrous)	15·6g
Sodium thiocyanate	10·0g
Water to	1000·0ml

Fixer (also for E-3) (pH: 4·5-4·9)

Ammonium thiosulphate (crystalline)	120·0g
Potassium metabisulphite (crystalline)	20·0g
Water to	1000·0ml

Stabiliser (also for E-3)

Formaldehyde (35-40% solution)	3·0ml
Wetting agent (10% solution)	10·0ml
Water to	1000·0ml

Procedure

1	Preliminary hardener	3min	29·5±0·5°C
2	Neutraliser	1min	28-31°C
3	First developer	6min	29·5±0·25°C
4	First stop bath	2min	28-31°C
	Normal room lighting may be resumed		
5	Wash, running water	4min	27-32°C
6	Colour developer	9min	27-32°C
7	Second stop bath	3min	27-32°C
8	Wash, running water	3min	27-32°C
9	Bleach	5min	27-32°C
10	Fixer	6min	27-32°C
11	Wash, running water	6min	27-32°C
12	Stabiliser	1min	27-32°C
13	Dry		43°C max
	Total	49min	

Notes
A Recommended agitation is continuous for the first 15sec, then 5sec every minute.

B Complete transparency of the film is reached only when it is perfectly dry. It should be noted that it is permissible to *dry off the film temporarily* after completion of Stage 5. The film should then be stored in diffused light or preferably in total darkness until processing is to be completed.

C The pre-hardener chemicals should be dissolved in water at 38-40°C with continuous agitation until solution is complete. At least 10min must be allowed to elapse before use to allow the DMFT to become transformed by hydrolysis into succinicaldehyde, a powerful gelatin tanning agent. The solution becomes effective after this transformation is complete.

D Should it not be possible to obtain the commercial ethylene diamine (1,2-diaminoethane) hydrate (80% ethylene diamine) (beware of noxious fumes) for the colour developer, the sulphate, which is easier to handle, may be used. In this case, the pH-value may need to be adjusted by adding a few millilitres of a 10%.solution of caustic soda. The TBAB, supplied by Kodak Limited in pellet form, should be crushed in a little water, using a glass rod or small pestle, then the remaining solution added. The TBAB can be dispensed with if the usual procedure of reversal by exposure to light is followed (see above). The developer in this form can then also be used for Process E-3.

E It should be emphasised that any contamination of one solution by another must absolutely be avoided. As the intermediate washes have been reduced to a strict minimum, all utensils employed in processing must be thoroughly cleansed and dried before use for a succeeding solution.

F The two stop baths should be kept separate to avoid contamination.

G Time of development in the first developer should be increased in accordance with the use it has had. For 20exp 35mm films, or approximately 0·37sq ft material per film, the times should be as follows:

1-4 films	6min
5-7 films	6min 15sec
8-10 films	6min 30sec
11-12 films	6min 50sec

H Prolonging or shortening the first development results in the following increases or decreases of effective emulsion speed with E-4 process films.

Effective emulsion speeds (ASA)

Development Time (min)	Ektachrome-X	High Speed Ektachrome (Daylight)	High Speed Ektachrome (Tungsten)
10½	250	640	500
9	160	400	320
8	125	320	250
6(normal)	64	160	125
4¼	32	80	64
3	16	40	32

For critical work test exposures on the batch of film to be used are recommended. At extreme departures from normal development some slight corrective filtration may be necessary.

J This process is also suitable for use with Kodak Photomicrography Color Film PCF 2483 and Ektachrome Slide Duplicating Film 5038. In the latter case a first development of 4½min is recommended.

Keeping properties and working capacities

Solution	Keeping time	135-20	135-36	120	sq ft
Pre-hardener	4 weeks	12	7	8	430
Neutraliser	3 months	12	7	8	430
First developer	3 months	12	7	8	430
Colour developer:					
without CD-3	6 weeks	–	–	–	–
with CD-3	4 weeks	12	7	8	430
Stop baths	6 months	12	7	8	430
Bleach	6 months	18	10	12	650
Fixer	6 months	12	7	8	430
Stabiliser	6 months	should be used fresh			

Working capacity per litre

Other manufacturers' materials compatible with the E-4 process

As a result of the worldwide dissemination of the Kodak Ektachrome E-4 process, many other manufacturers produced materials suitable for processing in E-4 solutions. Reference should be made to the tabulations of colour reversal films on pp 178-180. By now all have been superseded by E-6 process films: particular care should be taken to distinguish between older E-4 and the current E-6 process materials.

ORWOCHROM UT18 and UT21

Introduction

The procedure is in accordance with the manufacturers' instructions. The working temperature is 25°C, which is much easier to maintain than the traditional 18°C of the old emulsion. The manufacturers have succeeded in sufficiently hardening the emulsion, which formerly had a reputation for being very susceptible to mechanical damage, to allow processing at the higher temperature.

Formulae

Apart from that for the first developer, which makes use of Phenidone, all formulae are as specified by the manufacturers.

First developer: (pH: 10·2-10·4)

Calgon, sodium hexametaphosphate or tripolyphosphate	2·0g
Sodium sulphite (anhydrous)	40·0g
Sodium carbonate (anhydrous)	34·0g
Phenidone	0·8g
Hydroquinone	6·0g
Potassium bromide	2·5g
Sodium thiocyanate	1·2g
Potassium iodide (0·1% solution)	6·0ml
Water to	1000·0ml

Alternative first developer: (pH: 10·3±0·1)

Calgon, sodium hexametaphosphate or tripolyphosphate	2·0g
Sodium sulphite (anhydrous)	40·0g
Sodium metaborate	5·0g
Phenidone	0·8g
Hydroquinone	5·0g
Potassium bromide	2·5g
Sodium thiocyanate	0·8g
Potassium iodide (0·1% solution)	6·0ml
Caustic soda (pellets*)	about 0·8g
Water to	1000·0ml

To adjust pH to required value.

Stop bath G37 (pH: 4·2±0·1)

Sodium acetate (3H₂O)	15·0g
Acetic acid (98-100%)	25·0g
Water to	1000·0ml

The sodium acetate is $3H_2O$.

Colour developer C15 (pH: 10·7±0·2)

Calgon, sodium hexametaphosphate or tripolyphosphate	4·0g
Hydroxylamine sulphate	1·2g
Sodium sulphite (anhydrous)	2·0g
Potassium carbonate (anhydrous)	75·0g
6-Nitrobenzimidazole nitrate (0·2% solution)	5·5ml
Potassium bromide	2·5g
Water to	1000·0ml

Add before use:

Diethyl paraphenylenediamine sulphate	3·0g

Bleach bath C57 (reinforced) (pH: 4·2±0·2)

Potassium ferricyanide	100·0g
Potassium bromide	30·0g
Sodium dihydrogen orthophosphate (2H$_2$O)	5·8g
Disodium hydrogen orthophosphate (12H$_2$O)	4·3g
Water to	1000·0ml

Fixer C73 (for quick fixing) (pH: 6·6±0·3)

Sodium thiosulphate (crystalline)	200·0g
Ammonium chloride or sulphate	80·0g
Water to	1000·0ml

Procedure

1	First developer	10min	25±0·25°C
2	Wash, running water	1min	13-24°C
3	Stop bath	2min	18-24°C
	Normal room lighting may be resumed		
4	Re-exposure, 500W at 1m	2×2½min	
5	Colour developer	12min	25±0·25°C
6	Wash, running water	20min	13-24°C
7	Bleach	5min	18-24°C
8	Wash, running water	5min	13-24°C
9	Fixer	5min	18-24°C
10	Final wash	15min	13-24°C
11	Wet	1min	18-24°C
12	Dry		30°C max
	Total	81min	

Note

A Recommended agitation is continuous for 2min, then 5sec every minute.

Negative Films

AGFACOLOR 80S and CNS2 (and PERUCOLOR)

Agfacolor 80S was supplied in the usual 'amateur sizes': 120/620, 35mm (20- and 36-exposures and 30m rolls) and 126 cartridges for 12 and 20 exposures. It was balanced for daylight (approximately 5500°K), xenon lamps or electronic flash.

Agfacolor CNS2, introduced originally as Agfacolor Pocket Special for 110-format cameras, was available in sizes up to and including 120 roll film. *Note* that **Agfacolor 400 and 100** films are intended for Process AP70 which is equivalent to Kodak C-41: these newer materials are in course of replacing the CNS2 and 80S materials. Fuji-manufactured film marketed as **Agfacolor Professional N100S and N80L** is also intended for Process AP70/C-41.

Mask formation
The two masks in Agfacolor 80S and CNS2 films are each formed in a special way, which differs from the coloured coupler process employed by, among others, Kodak, 3M, Orwo and Fuji.

The red mask of the cyan layer is formed in the bleach bath by oxidation coupling of the residual coupler (which has not reacted during the colour development) with an auxiliary mask-forming substance incorporated in this layer of the emulsion. (The process is the same as that which characterised the old Gevacolor Mask, where the mask formed was an alkyl derivative of 3-amino-guanidine.)

The yellow mask former (which is actually a slight yellow-tinted coupler) is transformed into a colourless derivative in those parts of the image where the magenta dye is formed in direct proportion to the amount of magenta dye (by coupling of the oxidation product with the colour former). The residual yellowish coupler is transformed into a definite yellow mask by oxidation in the bleach bath.

Comparative colour rendering and quality
Prints made from a double-masked negative, when compared with those from an unmasked negative, show a very decided improvement in general colour rendering: yellow is more saturated, blue is more luminous, green is purer and less blue, magenta is more bluish and less intense, red is more saturated and cyan is greener and more luminous. The grain is relatively fine; definition is sufficient easily to permit enlargement of 12-14 diameters (30×40cm from a 24×36mm negative). The exposure latitude is sufficient to give good-quality images over a range of −1 to +2 stops, equivalent to a range of speed ratings from ASA20 to 160.

Formulae
Colour developer (pH: 11·0-11·3)

Calgon, sodium hexametaphosphate or tripolyphosphate	2·0g
Hydroxylamine hydrochloride or sulphate	1·4g
Sodium sulphite (anhydrous)	2·0g
Potassium carbonate (anhydrous)	75·0g
Potassium bromide	2·5g
Water to	1000·0ml

Add, some hours before use:

Diethyl paraphenylenediamine sulphate	2·8g

Intermediate bath (pH: 10·2-10·5)

Magnesium sulphate (crystalline)	30·0g
Colour developer (used)	30·0ml
Water to	1000·0ml

Bleach (pH: 5·8-6·2 (critical))

Potassium ferrocyanide	5·0g
Potassium ferricyanide	20·0g
Potassium bromide	12·0g
Sodium dihydrogen orthophosphate (2H$_2$O)	0·9g
Disodium hydrogen orthophosphate (12H$_2$O)	2·7g
Water to	1000·0ml

Fixer (pH: 7·0-7·8)

Sodium sulphite (anhydrous)	10·0g
Sodium thiosulphate (crystalline)	200·0g
Water to	1000·0ml

Keeping properties and working capabilities

Solution	Keeping time	Working capacity per litre		
		135-36	120-620	sq ft
Colour developer: without diethyl ppd	4 months	—	—	—
Complete*	2 weeks	4-5	5	2½
Intermediate bath	should be used fresh			
Bleach	4-6 months	8	10	5
Fixer	4 months	6	8	4
Wetting agent	1 year	should be used fresh		

*To ensure greater uniformity in negative characteristics, we advise using fresh colour developer every time.

Procedure (as specified by Agfa)

1	Colour developer	8min	20±0·2°C
2	Intermediate bath	4min	20±0·2°C
3	Wash, running water	14min	14-20°C
4	Bleach	6min	20±0·5°C

Normal room lighting may be resumed (actually after 1 min in bleach bath)

5	Wash, running water	6min	14-20°C
6	Fixer	5min	18-20°C
7	Final wash	10min	14-20°C
8	Wetting agent	½min	14-20°C
	Total	52½min	

Notes

A Recommended agitation is continuous for the first 15sec, then 5sec twice a minute.

B Any increase in treatment time or excessive agitation in the bleach (Step 4) may result in the formation of a too dense mask. In our opinion, it is preferable to give 5sec agitation only once a minute in this bath and (from our own experience) to cut the time to 4min.

C Depending upon the contrast required, development may be for 7-9min.

D Diethyl paraphenylenediamine sulphate has an annoying tendency to form oil droplets of the free base when dissolved in the remainder of the colour developer. It is of advantage to dissolve it separately in 20ml pure water and add this solution with continuous agitation. It is also possible to prepare a 20% stock solution, measuring off the requisite quantity as required:

Diethyl paraphenylenediamine sulphate	20·0g
Potassium metabisulphite	2·0g
Water to	100·0ml

This solution keeps for 2-3 months in a well-sealed bottle in the dark.

KODAK COLOUR NEGATIVE FILM PROCESSES

All Kodak colour negative emulsions currently available—and those from most other major manufacturers—are designed for **Process C-41**. These include amateur Kodacolor II and 400 and professional Vericolor II and III films in cartridge, miniature, roll and sheet formats as well as specialised materials for making intermediate negatives from colour transparencies and print transparencies from colour negatives. However, some colour negative films, particularly 'own brand' types sold by retail chains and multiple stores, required the earlier **Process C-22** and details of that process are given here. There is some very limited compatability between the two types of material and the two processes: this topic was discussed in an article in *The British Journal of Photography* ('C-41 and C-22: the question of compatability', Neville Maude, p405, 9 May 1975 issue).

C-41 PROCESS

Introduction

Until mid-1983 there were two 'amateur' colour negative emulsions supplied by Kodak, Kodacolor II with a speed of ASA100/21 DIN and Kodacolor 400 rated at ASA400/27 DIN. Both are available in 110, 135 and 120 formats. The ASA100 version is additionally available in some of the less used miniature and roll sizes. In 1979 an improved version of Kodacolor 400 was introduced, first in the USA, the packaging being identified by a red blob. Improvements in granularity and colour differentiation over the earlier material are claimed.

During 1983 a new range of Kodacolor VR films was introduced, with speeds of ASA100/21 DIN, ASA200/24 DIN, ASA400/27 DIN and ASA1000/31 DIN. Improved sharpness and colour rendering, coupled with reduced graininess is claimed for the three slower films. They incorporate experience and methods gained during development of materials for the ultra-miniature 'disc' format. Kodacolor VR1000 incorporates thin plate-like silver halide grains which, aligned parallel to the emulsion surface, show

enhanced sensitivity without as large a penalty in graininess as shown by conventional emulsions. All these VR films are available in 35mm only.

Vericolor II Professional Films Type S (daylight balance, exposures shorter than 1/10sec) and Type L (3200K balance, exposures from 1/50 to 60sec) were introduced in June 1975. The type S material (ASA100) is available in 35mm, 120/220 and 70mm roll formats and in sheet sizes up to 8×10in; Type L (ASA25-80, dependent on exposure time) is supplied in 120 roll and in sheet sizes. In 1979 Vericolor Commercial Type S in 120 and sheet formats was introduced. This material has a higher contrast than Type S—in this it resembles Type L—but a similar ASA100 speed rating. Improved Vericolor III materials were announced at photokina in October 1982 and are intended eventually to supersede Vericolor II films.

As with the earlier C-22 process, many manufacturers now produce materials compatible with C-41 processing. Reference should be made to the tabulation of colour negative films on pp 181-183.

The brevity of the processing steps of the C-41 process may well *a priori* worry the amateur: it is true that it is difficult simultaneously to maintain a high processing temperature together with regular agitation for a time calculated 'to the second', especially in colour development. This is a process intended primarily for automatic processing installations with a view to increasing throughput and profitability. Our experiments have confirmed that the C-41 procedure *can* be carried out efficiently in a small spiral tank—so long, that is, as the time, temperature and agitation recommendations are carried out. One advantage, however, is that the solutions contain only chemicals of weak toxicity; environmentally undesirable substances have been banned from the formulation.

C-41 Procedure (after Kodak)

1	Colour development	3min/15sec	37·8±0·15°C
2	Bleach	4min/20sec	24-40°C
3	Wash	1min/05sec	24-40°C
4	Fix	4min/20sec	24-40°C
5	Wash	3min/15sec	24-40°C
6	Stabilisation	1min/05sec	24-40°C
7	Dry	–	<43°C
	Total	17min/20sec	

Operational Steps

1 Prepare a water bath at 41°C: this provides a thermal reservoir.

2 Bring the solutions up to 38°C before use.

3 Fill the developing tank with the necessary quantity of developer, agitate continuously for 20sec, then plunge it in the water bath to within 2-3cm of the top of the lid.

4 Take the tank out again and agitate—preferably by inversion—for 5sec. Put it back in the water bath. Repeat this cycle giving 6 agitations each minute.

5 Empty the tank 10sec before the elapse of the required time. Shake it well so that as little colour developer as possible is left inside.

6 Pour in the bleach and carry out the same agitation rhythm as above.

7 When the bleach stage is finished, the tank may be opened to simplify washing.

8 Once it has come out of the stabilising bath, the film is hung up to dry in the usual manner. In a normally heated and ventilated room it will be dry in about 30-40min.

Variations When processed mechanically, the film is wiped before passing into the bleach bath. When working with a spiral tank this is unfortunately not possible, so that a rapid contamination of the bleach oxidising solution takes place, together with a rise in pH. We have therefore introduced a small variation to overcome this inconvenience: after the end of colour development, we pour into the tank a stop—1% acetic acid or the C-22 stop bath—and agitate continuously for 30sec. The solution is then poured out and a 30sec wash in water at 38°C given before pouring in the bleach bath. The Kodak procedure is then resumed. It is also possible to work with the classic ferricyanide bleach bath, using the following procedure:

1	Colour development	3min/15sec	38±0·2°C
2	Stop bath C-22	0min/30sec	38±0°C
3	Wash in running water	2min/30sec	38±3·0°C
4	C-22 bleach	2min/30sec	38±3·0°C
5	Wash in running water	1min/30sec	38±3·0°C
6	C-22 fix	4min/20sec	38±3·0°C
7	Wash in running water	3min/15sec	38±3·0°C
8	Stabilisation	1min/05sec	38±3·0°C
9	Drying	–	<43°C
	Total	18min/55sec	

Results with this procedure are identical to those obtained following the official process.

Formulae

The quantities are given in grams per litre. The chemicals are dissolved in the indicated order.

Colour Developer (pH: 10·0-10·1)

Water (70-80°F, 21-28°C)	800ml
Calgon, sodium tripolyphosphate	2·0g
Sodium sulphite (anhydrous)	4·25g
Potassium bromide	1·5g
Potassium carbonate (anhydrous)	37·5g
Hydroxylamine sulphate	2·0g
Water to make	1000·0ml

Add 6hr before use:
CD-4	4·75g
or CD-4 (20% solution)	24·0ml

CD-4 stock solution

The following keeps well for about 2 months in the cool away from light.
CD-4	20·0g
Potassium metabisulphite (crystalline)	3·0g
Water to make	100·0ml

Bleach (pH: 5·9-6·1)

EDTA NaFe	100·0g
Potassium bromide	50·0g
Ammonia 20%	6·0ml
Water to make	1000·0ml

Fix (pH: 5·8-6·5)

Ammonium thiosulphate	120·0g
Sodium sulphite (anhydrous)	20·0g
Potassium metabisulphite (crystalline)	20·0g
Water to make	1000·0ml

Stabiliser

Wetting agent (10% solution)	10·0ml
Formaldehyde (35-37% solution)	6·0ml
Water to make	1000·0ml

Capacity (1 litre) and shelf life of fresh solutions

Solution	Keeping	110/ 20ex	126/ 20ex	135 36ex	120	dm² approx
Colour developer without CD-4	6 weeks	–	–	–		–
Colour developer with CD-4	1 month	30	12	5	6	30
Bleach	8-12 weeks	120	45	20	24	100-120
Fixer	8-12 weeks	60	22	10	60	
Stabiliser	1 year	use once only				–
Stop bath	1 year	use once only				–

Notes

1 Partially used solutions have a 30-50% lower shelf life, depending on the actual storage conditions (darkness, well-stoppered bottle, temperature 14-20°C).

2 Work whenever possible with fresh solutions to ensure optimum consistency of results. However, for 110 format film, Kodak advise the division of 1 litre of developer into two 500ml quantities. This enables films to be developed in batches of 3, and 5 or 6 batches can be processed before throwing the developer away. If this is done, processing times should be modified according to the following table.

Development time for 110 format (min/sec)

Film	No of films developed at once	1st batch	2nd	3rd	4th	5th	6th	Total films (in 500ml)
110/20ex	3	3/15	3/22	3/30	3/37	3/45	–	15
110/12ex	3	3/15	3/20	3/26	3/31	3/37	3/43	18

3 It is desirable to keep the bleach solution, unlike others, in a half full container. It should be shaken vigorously after use for about 10sec to reoxidise the ferrous complex Fe^{++} (formed during bleaching) to the ferric complex Fe^{+++}, so that its activity can be maintained. Replenishment is not advisable in amateur usage and the solution should therefore be thrown away after the indicated number of films has been processed.

4 The C-41 colour developer is also suitable for processing Ektacolor 78RC Paper, adding 45ml/l benzyl alcohol.

5 Instead of separate Bleach and Fixing baths, the use of a combined bleach/fix is possible. That given for 78RC paper is suitable (4min): pH 5·8-6·2.

Other major manufacturers' materials compatible with C-41 processing:
Agfacolor 100 and 400, Agfacolor Professional N100S and N80L
Sakuracolor II and Sakuracolor II 400 (also known as **Konicacolor**)
Fujicolor F-II and F-II 400, Fujicolor HR films
Ilfocolor 100 and 400
3M Color Print and Color Negative 100 and 400

C-22 PROCESS

Formulae
Colour developer (pH: 10·6-10·7)

Calgon or sodium tripolymetaphosphate	2·0g
Benzyl alcohol	5·0ml
or benzyl alcohol (solution 35%) (see E-4)	15·0ml

Sodium metaborate (crystalline) or Kodalk	85·0g
Sodium sulphite (anhydrous)	2·0g
Potassium bromide	1·6g
CD3	5·3g
Water to	1000·0ml

Stop bath (pH: 4·3-4·7)

Glacial acetic acid	20·0ml
Sodium sulphite (anhydrous)	10·0g
Water to	1000·0ml

Hardener (pH: 10·4-10·8)

Formaldehyde (35-40% solution)	20·0ml
Sodium carbonate (anhydrous)	10·0g
Water to	1000·0ml

Bleach (pH: 6·6-7·0) (See also formula E-4 bleach, which acts faster)

Potassium nitrate (crystalline)	25·0g
Potassium ferricyanide	20·0g
Potassium bromide	8·0g
Boric acid	5·0g
Disodium tetraborate	1·0g
Water to	1000·0ml

Fixer (pH: 4·4-4·6)

Ammonium thiosulphate (crystalline)	120·0g
Potassium metabisulphite	20·0g
Water to	1000·0ml

Keeping properties and working capacities

Solution	Keeping time	Working capacity per litre		
		Roll films (120 or 620)	35mm (20 exp)	Sheet film 4×5in
Colour developer:				
with CD-3	2 weeks	6-8	8-10	25
without CD-3	6 months	–	–	–
Stop bath	indefinite	6-8	8-10	25
Hardener	1 year	12-16	16-20	50
Bleach	6 months	12-16	16-20	50
Fixer	6 months	12-16	16-20	50

Procedure
The several stages are those specified by Kodak:

1	Colour developer	13min	75±0·5°F
2	Stop bath	4min	68-76°F
3	Hardener	4min	68-76°F
	Normal room lighting may be resumed		
4	Wash	4min	68-76°F
5	Bleach	6min	68-76°F
6	Wash	4min	68-76°F
7	Fixer	8min	68-76°F
8	Final wash	8min	68-76°F
	Total	51min	

Notes
A Recommended agitation is continuous for the first 15sec, then two periods of 5sec every minute.
B For electronic flash exposures, it was established that the colour characteristics of the negative are often improved by increasing the development time by 2min to 16min.

C Films are transferred from the colour developer direct to the stop bath, taking care to carry as little developer over as possible. However, it was confirmed that a brief rinse (20sec) does no harm and extends the life of the stop bath. The same applies to transferring the film from the stop bath to the hardener.
D For sheet films after every three 4×5in films the time of development should be increased by 35-45sec. For example:

Film number:	1-3	4-6	7-9	10-12 etc
Minutes:	14	14¾	15½	16¼ etc

For maximum uniformity of results it is advisable to develop at least 2-9 films together (by the use of suitable dishes) and to use considerable quantities—5l or more—of solution. In this case an increase of developing time will be necessary only every 12-15 4×5in films.
E Here, as in all photographic processing, scrupulous cleanliness throughout is essential. Care should be taken to avoid contamination of one solution by another except in the case of the stop bath and hardener, where as officially prescribed by Kodak the film passes straight from the developer into the stop bath and thence into the hardener without any intermediate rinse. It is, however, as well to drain films before immersing them in that solution. It is in fact possible to increase considerably the life of the stop bath and hardener by giving the film a quick rinse (5sec) in water between solutions. For our part we prefer this method which better conforms with our own niceties of practice.
F The pH-value of the solutions may be adjusted if need be by varying the buffer proportions (disodium hydrogen orthophosphate, disodium tetraborate, boric acid).
G It is recommended that the CD-3 be added immediately before use; this greatly extends the life of the stock solution. A practical procedure is to make up a 20% stock solution of CD-3, the requisite quantity being abstracted with a pipette immediately before use:

Potassium metabisulphite	5·0g
CD-3	20·0g
Water (30°C) to	100·0ml

H By adjusting the proportion of potassium bromide in the colour developer, contrast can be controlled to an appreciable degree: within limits a higher bromide content increases contrast. It can be reduced to as little as 1g/l, which at the same time gives a gain in emulsion speed of about ¼ stop but with the risk of increasing colour fog (depending upon the emulsion).
I For roll films and 35mm films the time of development should be increased by 30-45sec for each film developed.

Other manufacturers' materials designed for C-22 processing
The following major manufacturers' materials may be processed by the C-22 process. Note that these and most of the 'own brand' types have been superseded by C-41 process materials. Care should be taken to avoid confusion. Most of the C-22 process materials are by now many years beyond their expiry date.
Fujicolor N100 and **NK**
GAF (Ansco) **Color Print Film**
Sakuracolor N100

Colour Print Papers

AGFACOLOR MCN 310/317/319 TYPE 4 (RC resin coated)

Introduction
The characteristics of these colour papers are adapted to the presence of the masks in Agfacolor films. The manufacturers recommend that the paper should if possible be stored at a temperature below 10°C (in a refrigerator)

and that the relative humidity should not exceed 60%. In view of the high sensitivity of the paper, it should not be exposed for more than 2min to the light of an Agfa-Gevaert 08 safelight, using a 15W lamp at a minimum distance of 30in.

Formulae

The formulae are as specified by Agfa. The developing agent recommended by the manufacturers is N-n-butyl-N(4-sulpho-n-butyl)1,4-phenylenediamine (Ac 60). This substance may be replaced by a number of other colour developing agents: the use of one or other of these agents requires slight modification of filter values. Diethyl paraphenylenediamine sulphate is also very suitable and gives results which are close to those obtained with Ac 60, without modification of the developing time.

Colour developer (pH: 10·8-11·0)

Calgon, sodium hexametaphosphate or tripolyphosphate	1·4g
Hydroxylamine sulphate	2·7g
Sodium sulphite (anhydrous)	2·7g
Sodium bromide	0·7g
Potassium carbonate	67·0g
Water to	1000·0ml

Add, some hours before use:

Ac 60 (Agfa) or Colour Developer 60 (Merck) or	4·0g
T32 or Droxychrome or S5 or	3·3g
diethyl paraphenylenediamine sulphate	2·0g

Bleach-fixer (pH: 7·4-7·7)

EDTA Na$_4$	25·0g
Disodium tetraborate (crystalline)	30·0g
EDTA NaFe	30·0g
Potassium dihydrogen orthophosphate (anhydrous)	15·0g
Sodium sulphite (anhydrous)	2·0g
Thiosemicarbazide*	3·0g
Sodium thiosulphate (crystalline)	290·0g
Water to	1000·0ml

* Provided replenishment of solutions is carried out, this substance may be omitted.

Stabiliser (pH: 6·5-8·0)

Brightening agent	4·0g
Sodium acetate (3H$_2$O)	3·0g
EDTA Na$_4$	2·0g
Formaldehyde (30% solution)	80·0ml
Water to	1000·0ml

Brightening agents—an industrial product such as:

Leucophore B, R (Sandoz)
Blancophore BBU, BUP, BP (Bayer)
Uvitex CF conc, PRS (Ciba)
Tinopal BV (Geigy)
Photine C, B (Hickson & Welch)
Celumyl, B, R, S (Bezons)

Substitute solutions

It is possible to replace the original stop-fixer and bleach-fixer solutions by alternative formulae without any sacrifice of quality. These are simpler and therefore easier to prepare, and since they can be used equally well with the majority of current colour papers, this simplification has an obvious advantage.

Stop bath: use 2% acetic acid.

Bleach-fixer (pH: 6·7-7·2)

EDTA NaFe	50·0g
EDTA Na$_4$	5·0g
Sodium carbonate (anhydrous)	1·0g
Sodium sulphite (anhydrous)	10·0g
Sodium thiocyanate (20% solution)	50·0ml
Potassium iodide	2·0g
Ammonium thiosulphate (crystalline)	120·0g
Water to	1000·0ml

The use of ammonium thiosulphate enables the time of treatment to be almost halved (3min at 20°C, 2min at 25°C). For the rest, we suggest the following modifications in procedure.

1 After colour development, immerse the prints for 10-15sec in a 1% solution of acetic acid instead of rinsing in running water.

2 Rinse the prints for 15sec in running water before passing them into the bleach-fixer.

Procedure

Hand processing in dishes		25°C	30°C
1	Colour development	5min	3min
2	Stop (5% acetic acid)	1-2min	1min
3	Rinse	1-2min	1min
4	Bleach-fix	4-5min	3-4min
5	Wash	3-5min	2-3min
6	Stabilise	2min	1min
7	Rinse	¼min	¼min

Recommended agitation is continuous for the first 15sec in the colour developer, then 5sec 3-4 times per minute. In other baths agitation is continuous.

Small drum processing		30°C	35°C
1	Preheating (water temperature is indicated by drum manufacturers' nomogram)	1min	¾min
2	Colour development	3min	2min
3	Stop (5% acetic acid)	¾min	½min
4	Rinse	¾min	½min
5	Bleach-fix	2¼min	1½min
6	Wash	2¼min	1½min
7	Stabilise	1min	½min
8	Rapid rinse	10sec	5sec

The prints should be dried at temperatures not exceeding 90°C.

Keeping properties and working capacities

Solution	Keeping time	Working capacity per litre 10×15cm	sq ft
Colour developer:			
without Ac 60	3 months	—	—
Complete	3-4 weeks	40	6
Bleach-fixer	3-4 months	120	18
Stabiliser	3 months	120	18

Other manufacturers' materials compatible with MCN310/4 processing

The following materials may be processed in the same manner as MCN310/4:

Fomacolor PM, Type 30 (RC) paper
Valcolor RC paper (Spain)
Fortecolor CN4, Type 4 (resin-coated) Hungary.

EKTACOLOR 74RC and 78RC

Introduction

Ektacolor 74RC is basically a faster version of the earlier 37RC, the increase in speed being achieved by changing the relative sensitivity of the layers. The blue sensitivity remains virtually unchanged, the green is appreciably increased, while the red-sensitive layer is some 4-5 times faster. Filtration adjustments are thus necessary but processing is as for 37RC. 74RC is being progressively replaced by 78RC for which higher colour saturation and contrast are claimed. Processing characteristics are unchanged.

Procedure

1 Dish processing

The times given below include 20sec for draining at the conclusion of each processing stage.

Solution	Time (minutes)	Temperature (°C)
Colour developer	3½	31·1±0·3
* Bleach fix	1½	31·1±1·2
Wash	2	31·1±1·2
Stabiliser	1	31·1±1·2
Total	8	—
Drying		not above 107°C

* To obviate an excessive rate of exhaustion of the bleach fix solution due to carry-over contamination, the print may be treated for one minute in a stop bath (for example Stop bath C-33, or a 3% solution of acetic acid) followed by one minute rinse.

Clearing

Normal room lighting may be resumed following the bleach fix stage, or even before it, if the stop bath has been used.

Agitation

If only one print is processed at a time, the dish may be lightly rocked, 3 or 4 times per minute. If a number of prints are processed together, immerse the first print, emulsion side down, then, at 20sec intervals, the second print, the third, and so on, in each case emulsion side down. When all prints are immersed, bring the bottom print to the top, and the others in succession. Continue this procedure until the processing time of each has elapsed.

Capacity

One litre of colour developer will develop 3 to 4 20×25cm prints. It should then be discarded. So far as the other solutions are concerned, they should serve to process (in 1 litre) 7-8 prints of the same format. If the additional stop bath is employed, it is even possible to process at least 1 to 1½m² of paper in 1 litre of 'blix'.

2 Processing in small drums

The advantage of this procedure is obvious: the quantity of colour developer used is so very small (60ml for the smallest model, sufficing for development of one 20×25cm—8×10in—print); this corresponds to a capacity of 0·8m²/litre. For the other solutions the capacity is at least doubled: that is to say, one could use the 60ml twice, or alternatively use four times as much solution (250ml), permitting the consecutive processing of at least 10-12 prints before discarding it. Bearing in mind the cost of chemicals, the economy this represents is obvious, quickly offsetting the initial cost of the drum. This is over and above the immense advantage of being able to work in ordinary light, once the print has been inserted and the drum closed.

Below is a table of procedure for each of three different temperatures from which the most suitable can be chosen to meet local conditions.

Treatment times (min)

Solution		t=31°C	33°C	38°±0·3	Remarks
1	Pre-warming/wetting	¾	¾	¾	
2	Colour developer	3½	3	2	
3	Wash*	¾	¾	½	2 changes
	or				
3a	Stop Bath C-22	½	½	½	
3b	Wash*	½	½	½	2 changes
4	Blix	1¾	1½	1	
5	Wash*	2	1½	1	
6	Stabiliser†	1	¾	½	
	Total	10	8¼	6-6¼	

Drying temperature 107°C

*Four changes of water may be considered equivalent to one minute of wash.
†The use of a stabiliser is now optional. The simplified 2-bath process gives equally good results.
In this case the final wash must be prolonged to 4, 3 and 2min respectively.

Agitation

About 20-30 cycles/min (according to size of drum). The times given include 10-20sec for emptying the drum. Note that in the case of large models, treatment times should be prolonged by 15sec for the developer and 30sec for the other solutions to allow for the greater quantities of liquid which have to be emptied.

Temperature

In the case of drums where this information is provided this will be determined by reference to the nomograms provided with the drum; this takes account of the ambient temperature (=temperature of solutions) to indicate that of the water for pre-warming and washing. Other small drums including the Paterson and the Unicolor are also supplied with full temperature instructions.

3 Processing with the Kodak Rapid Processor Models II and 16K

Operation	Remarks	°C	Time (mins)
1 Preliminary soak	in a dish of water	21-39	½
2 Colour development	Safelight No 10	38±0·3	2
3 Wash	running water	38±1	½
4 Bleach-fix	Normal room lighting	38±1	1
5 Wash	running water	38±1	½
6 Stabiliser	—	38±1	½
Drying*	—	107	—
		Total time:	5min

The time for each operation includes 10 seconds for draining.

*A brief rinse of 3-5sec in water is permissible; this obviates the emission into the atmosphere of fumes of acetic acid, which are both disagreeable and noxious.

Alternative formulae

The formulae which we give below yield results which are comparable, both qualitatively and quantitatively, with those obtained with the official procedure. Quantities are quoted throughout in grams or millilitres. Where water is the base of a solution, the components should be dissolved in the order indicated in water at 30-35°C.

Colour developer (pH: 10·1-10·2)†

1 Working solution	
Water at 30-35°C	700·0ml
Calgon (sodium tripolyphosphate)	2·0g
Hydroxylamine sulphate	3·4g
Sodium sulphite (anhydrous)	2·0g

Potassium carbonate (anhydrous)	32·0g	
Potassium bromide	0·4g	
Benzyl alcohol (50% solution)*	30·0ml	

Add before use:

CD-3	4·4g	
(or 22% solution)*	20·0ml	
Water to	1000·0ml	

See 2—preparation of concentrated stock solutions.

2 Preparation of Concentrated Stock Solutions

Quantity to be taken per litre of working solution

Solution A

Benzyl alcohol	500ml	
Diethyleneglycol	500ml	30ml
Total	1000ml	

Solution B

Water at 30-35°C	700ml	
Calgon	20g	
Hydroxylamine sulphate	34g	
Potassium bromide	4g	100ml
Sodium sulphite (anhydrous)	20g	
Potassium carbonate (anyhydrous)	320g	
Water to	1000ml	

The potassium carbonate should be added slowly in small amounts because of the evolution of CO_2.

Solution C

Potassium metabisulphate crystalline	2g	
CD-3	22g	20ml
Water to	100ml	

Bleach Fix (pH: 6·2-6·5)

1 Working Solution

Water at 30-35°C	700ml	
EDTA NaFe or NH_4FE (Merck)	40g	
EDTA Acid	4g	
Potassium iodide	1g	
Ammonia (20% solution)	10ml	
Ammonium thiosulphate (crystalline)	100g	
Sodium sulphite (anhydrous)	2g	
Sodium thiocyanate (20% solution*)	50ml	
Water to	1000ml	

pH: to be adjusted to 6·2-6·5 by the addition of ammonia or acetic acid as necessary.
**Ammonium thiocyanate may be used in place of the sodium salt in the same proportion*

2 Preparation of Concentrated Stock Solutions

Quantity to be taken per litre of working solution

Solution A (pH: 7·2-7·5)

Water at 30-35°C	700ml	
EDTA NH_4Fe	200g	
EDTA Acid	20g	200ml
Ammonia (25% solution)	60ml	
Water to	1000ml	

Solution B (pH: 5·8-6·2)

Water at 30-35°C	500ml	
Ammonium thiosulphate (crystalline)	500g	
Sodium (or ammonium) thiocyanate	50g	200ml
Potassium metabisulphite (crystalline)	10g	
Potassium iodide	5g	
Water to	1000ml	

Stabiliser (pH: 3·6±0·1)

1 Working Solution

Quantity to be taken per litre of working solution

Sodium carbonate (anhydrous)	2·5g	
Acetic acid (glacial)	12·5ml	
Citric acid (crystalline)*	7g	
Water to	1000ml	
*or tartaric acid	8g	

2 Concentrated Stock Solution

Acetic acid (glacial)	170ml	
Citric acid (crystalline)	95g	
(or tartaric acid)	106g	75ml
Sodium carbonate (anhydrous)	33g	
Water to	1000ml	

Substitute for CD-3 in the Colour Developer

A number of other colour developing agents currently used in colour laboratories have been examined as possible substitutes for CD-3 in the colour developer. The results obtained with many of them have been excellent and the colour quality has been comparable with that obtained with the original formula with CD-3. The activity of each agent is a function of its chemical structure and account has been taken of this in modifying the concentrations in the colour developer. In addition the effective emulsion speed of the paper is also affected and exposure and activity factors are given based on the use of CD-3 and 4·4g/litre of working solution.

Developing agent	g per litre	pH	Relative activity	Relative exposure
CD-3 Kodak	4·4	10·16	100	1·0
CD-4 Kodak	3·0	10·18	130	0·75
Ethylhydroxyethyl-ppd H_2SO_4	5·0	10·10	115	0·85
Diethyl-ppd H_2SO_4	2·4	10·10	145	0·70
Ac60 Agfa	4·0	10·7	50	2·0
CD-2 Kodak	2·4	10·2	145	0·70

The filtration required during printing was very similar with all the agents examined. Using a test negative on Ektacolor Professional Film Type S, the values were near 80Y 40M, except with Agfa developing agent Ac60 which required a filtration adjustment to 100Y 60M and a correction of the pH of the solution to 10·6±1·0 by the addition of 0·5 to 1·0g/litre of caustic soda. The findings are summarised in the table.

Notes

All processing was carried out using the three-bath process. At the concentration given the diethyl-paraphenylenediamine produces a light greenish overall fog. It is necessary to reduce the concentration to 2-2·2g/litre to improve the result.

Other major manufacturers' materials compatible with Ektaprint 3 processing

The following materials may be processed in the same manner as Ektacolor 74 and 78RC papers:

Agfacolor Type 589 Paper, RC and Type 6
Fujicolor Type 8967 Paper, RC
Sakuracolor Paper, PC
3M Colour Paper, RC

Reversal Papers

CIBACHROME PRINT

Historical introduction

The practical realisation of a system of positive-positive colour reproduction by the silver dye bleach process, i.e. the image-wise selective destruction of dyes, has remained just short of achievement for many years, indeed for decades.

It was only in 1963 that Ciba (later Ciba-Geigy Photochimie) at Basel and Fribourg, Switzerland, following several years of fundamental research in this field, presented the professional with the 'Cilchrome Print'.

Twelve years later, the Cibachrome print, as it is now called, entered the domain of colour reproduction, thanks to its characteristics which place it among the most interesting photochemical products of the present era.

The Cibachrome print is in fact the only positive-positive colour material which enables a transparency to be duplicated direct, i.e. without the need for reversal of a black-and-white negative image.

The characteristics of Cibachrome

In the traditional procedure for colour reproduction (colour development), the dyes which ultimately form the colour image are produced during development by reaction between the dye couplers incorporated in the emulsions and the oxidation products of the developing agent, the dye formation being linked with the formulation of the silver image. The Cibachrome process, on the contrary, is based upon the selective destruction of dyes already present in the emulsion. In a way it is a sort of inversion of the traditional procedure.

The dyes formed by colour development are azomethines or quinone-methines, and have only limited stability to external influences: light, humidity, and vapours, oxidisers and reducers. There is only a relatively restricted choice, since only a few developing agents can be thus used in practice: diethylparaphenylene diamine and its homologues, CD-2, CD-3, CD-4, Ac60. Against this, the mechanism of development of the Cibachrome print permits a choice of dyes offering the maximum of favourable characteristics: a high degree of chemical purity in the dye; resistance to chemical agents during and after processing; very great stability to light; non-diffusibility; a very selective absorption for each dye; great purity of hue; the complete elimination of products of destruction without affecting the colour of the print or the purity of the whites; proportionality between destruction of dye and metallic silver of the image. The dye also has no detrimental effect on the sensitometric characteristics of the emulsion.

The dyes used in the Cibachrome print are the polyazos (combining the maximum of properties required by the process), derivatives or parents of the most stable dyes used in the textile industry.

In consequence of the presence of the subtractive colours yellow, magenta, and cyan in the unexposed emulsion, this is very dark in colour; one result of this is an appreciable reduction in effective sensitivity, a drawback which in the material currently available has been very largely overcome. The actual speed is about equivalent to half (one stop less than) that of traditional papers. As against this, this coloration of the emulsion spectacularly diminishes irradiation or diffusion of light in the emulsion at the time of exposure, and this greatly increases the resolving power, which averages 50 lines/mm. Another advantage inherent in the paper is the non-existence of coloured grain in the emulsion, as is characteristic of dyes formed by chromogenic reaction. The only grain to be seen on the finished print is that already existing in the original transparency, which is faithfully reproduced.

Since all those Cibachrome materials which used the P-10 and P-18 processing formulations have now been discontinued for more than two years it is felt that no useful purpose would be served by reprinting the alternative solution formulas worked out by Ernest-Charles Gehret for these materials. The new Cibachrome II amateur and professional print materials are, respectively, processed in P-30 and P-3 solutions, the formulations for which have not been dislosed. None of the older formulations are satisfactory due to the rather special requirements of the black-and-white developer which has to generate what is, in effect, a chemical mask. This novel and elegant improvement to the process has the effect of lowering the rather steep gradation of these silver-dye bleach materials and improving the blue colour reproduction.

EKTACHROME 14RC Improved

Introduction

The positive/positive photographic print process has long remained a poor relation, compared with the negative/positive. Mainly used by the professional, who works it via the expedient of an internegative or even through colour separations (Dye Transfer), it was not within the reach of the average amateur. The breakthrough of Cibachrome and the very warm welcome which colour photographers gave it, certainly contributed to taking the mystery out of positive/positive, a development which did not succeed at that time in giving an impulse to the vintage Kodak Ektachrome paper, already known for more than a decade. The appearance in 1976 of a new Kodak material, from its Chalon-sur-Saône factories, brought fresh argument in favour of the positive/positive process. The fine qualities which we have found the paper to have, lead us to give the results of our experiments together with a processing formulary.

Development procedure

Ektachrome 14RC is a reversal colour material; the dyes necessary for the formation of the image are obtained chromogenically, in a similar way to those resulting from colour reversal film processing.

After exposure the paper is given a first, black-and-white development stage, which produces a negative silver image in the three layers. After re-exposure to light or reversal, the subsequent chromogenic development stage forms a positive colour image, without dye being produced in the silver negative areas of the print. Silver formed with the dye is removed together with the silver forming the negative image, by simultaneous oxidation, rehalogenisation and fixation, taking place in a bleach/fix bath. A final wash concludes the process, which thus requires only three baths. Our tests indicate that it is superfluous to use a stabilising bath so long as the prints are fully washed to eliminate completely any chemical products remaining in the emulsion.

14RC is a resin-coated material and so may be processed rapidly at a high temperature. This economises wash water, an advantage not to be overlooked in an age sensitive to ecological problems. The bleach/fix is non-toxic and so too minimises problems. In photofinishing houses there is, anyway, almost complete recycling: the silver is recovered and the solutions re-oxidised.

Processing method

The development of photographic material is a reaction subject to the laws of physical chemistry and, especially, chemical thermodynamics. Hence the process is one depending on a number of parameters, with temperature by no means the least important. Readers will be fully aware that an increase in temperature speeds up chemical reactions. In black and white or colour development, the temperature coefficient is usually between 2·2 and 2·6, or a mean of 2·4. In other words, a 10° rise in temperature multiplies the speed for development by this factor or divides the development time by the same amount. For a long time colour material manufacturers imposed very strict standard temperatures, without recommending any variations. Today, the real progress which has been achieved in coating and processing techniques, has made it possible to work within a temperature range of around 10°C, and this allows adaptation of the process to individual conditions of apparatus, ambient and water temperatures, or to increase output. An increase in working temperature speeds up the development process and also increases the productivity of finishing houses. However, it is fully understood that temperature must be maintained as closely as possible during processing and this is a fundamental condition for consistent print quality.

This time-temperature diagram gives the relationship between time of immersion and temperature for the three baths and the final wash. Curve 1 refers to the first, black-and-white, development, 2 to the colour developer, 3—identical to 2—to the bleach-fix, and 4 to the final wash. The corrected times may be considered valid over the range 28-38°C.

As a general rule, Ektachrome 14RC may be processed between 28 and 38°C. In amateur usage, unless a proper temperature control system is available with thermostat-controlled water bath, we recommend the 28-32°C range, which it is easiest to maintain. Dish development is possible, but it is better to work using one-shot baths in a processing drum, for example, a Durst, Jobo, Paterson, Unicolor or similar. Besides, it is more pleasant to work in ambient light than in complete darkness and, anyway, the reproducibility of results is improved, since fresh solution is used each time.

The scheme given below applies to both dish and drum development.

Temperature:	30°C		34°C		38°C	
	min	sec	min	sec	min	sec
1 *Pre-soak	1	—	—	50	—	40
2 B & W development	3	—	2	5	1	30
3 Wash min 4 changes	3	—	2	45	2	30
4 Re-expose	100W at 40cm, minimum 10sec on face of paper only during last minute of wash					
5 Colour development	3	30	3	15	3	—
6 Rinse 1-2 changes	1	—	—	50	—	40
7 Bleach/fix	3	30	3	15	3	—
8 **Final wash	3	30	3	15	3	—

*Follow the tank or drum manufacturers' recommendations.
**Minimum of 6 changes in a drum, but preferably made in running water in a tank, washbowl, or other container.

The time/temperature graph gives indications for immersion in the baths, for the adopted or necessary working temperature within a 28-38°C range.

Dish processing
Agitation: a slow, steady rocking motion. When finished, drain the print for 5-15sec, according to format, as it is taken out of each bath.

Temperature maintenance: this is critical in the first developer: ±0·3°C. Use either a water bath, or a dish warmer, equipped with thermostat control.
Safelighting: none. Absolute darkness is essential during first development and the first two minutes of the following wash. The subsequent steps may be carried out in normal lighting.
Re-exposure to light: to be made during the last 30sec of the wash following black and white development. Only expose the emulsion side of the print to the light.

Drum processing
Working with a drum, re-exposure is carried out by taking the print briefly out of the drum. This should be kept filled with water at the indicated temperature, so that work may continue afterwards without delay.

A stop bath
Is not absolutely necessary. However, it is possible to use one between first development and the wash before re-exposure, composed of 2% acetic acid for 30sec.

Drying
After having taken the prints from the final wash in the dish or container, they should be wiped or sponged on both sides to remove most of the water, and then hung freely in the air, or in a drying cabinet; this latter appears, however, clumsy and unnecessary. In passing it may be noted that a hairdryer works perfectly well and is quite cheap. Care must be taken not to char prints by holding them too close to the outlet!

Capacity
In a drum, allow 45-50ml of black and white or colour developer for each 20×25cm sheet (500cm²). A second sheet may be treated in the same quantity of bleach/fix. In our own practice, we prefer to use double quantities of the baths, using the developers twice and the bleach/fix four times. A litre of black and white or colour developer can be used to process 1-1·1m² of paper and the bleach/fix has twice that capacity. These figures include at least a 20% safety margin.

Working in a dish, when it will be necessary to use a relatively large amount of solution, one litre of black and white or colour developer should easily process 12-15 20×25cm sheets. The bleach/fix capacity is 2-2·5 times more. It is a good idea to work out the volume needed for the number of prints to be processed at a time, since part-used solutions do not keep.

Keeping qualities of unused solutions:
Black and white developer: 2-3 months
Colour developer, without CD-4: 3 months
Colour developer made up: 2-4 weeks
Bleach/fix made up: 1-2 months
A and B not mixed: 3-4 months

The keeping qualities of part-used bottles are reduced by 30-50%, according to the storage conditions—darkness, well-stoppered bottles and temperature 18-20°C—and exhaustion.

Formulae
Black and white developer (pH: 10·1-10·2)

Phenidone	0·5g
(*or* metol: 2·0g)	
Sodium sulphite (anhydrous)	40·0g
Hydroquinone	6·0g
Sodium carbonate (anhydrous)	40·0g
Potassium bromide	1·4g
Sodium thiocyanate 20% solution	7·0ml
Potassium iodide 0·1% solution	6·0ml
Sodium hydroxide 40% solution	
as required to adjust pH	0·5-2ml
Water to make	1000·0ml

Colour developer (pH: 10·1-10·2)

Benzyl alcohol 50%	40·0ml
Hydroxylamine sulphate	3·0g
Sodium sulphite (anhydrous)	2·5g
Sodium carbonate (anhydrous)	30·0g
Potassium bromide	1·0g
6-nitro-benzimidazole nitrate 0·2% soln	10·0ml
Sodium hydroxide 40%	
as required to adjust pH	2·5-3ml
Before use add: CD-4 (Kodak)	4·0g
Water to make	1000·0ml

A 25% CD-4 solution may be conveniently used, taking 16ml per litre:

CD-4	25·0g
Potassium metabisulphate (crystalline)	2·0g
Water to make	100·0ml
	(keeps 2-3 months)

It is best to mix in the 50% benzyl alcohol first by stirring into 700ml of water before adding the solid chemicals. The 50% solution is made up:

Benzyl alcohol	250·0ml
Diethylene glycol	250·0ml
Total	500·0ml

The print base whiteness may be improved by adding 5-10ml/l of a liquid optical brightener, such as Sandoz Leucophore SHR, to this solution.

Bleach/fix (pH: 7·0-7·2)

Solution A:	
EDTA acid	6·0g
EDTA NaFe or NH₄Fe (Merck)	60·0g
	(see note below)
Potassium iodide	2·0g
Ammonia 33%	
as required to adjust pH	12-14ml
Water to make	500·0ml
Solution B:	
Ammonium thiosulphate (crystalline)	120·0g
Potassium metabisulphite (crystalline)	5·0g
Water to make	500·0ml

In use take 1 part A with 1 part B. The pH of this bath when ready to use should be between 6·5 and 6·8. Any adjustment necessary can be made with ammonia or 20% acetic acid.

The ferric-ammonium salt of EDTA is much more easily soluble than Sequestrene NaFe, but the latter may be substituted and costs rather less.

Conclusions and general notes

With the alternative formulae given we have obtained excellent colour prints, comparable with those from the makers' own solutions.

Ektachrome 14RC Improved has better thermal stability than its predecessor. It may be kept for 1-2 months in an ambient temperature of 18-25°C without its characteristics being noticeably changed. Nevertheless, it is advisable, as far as possible, to keep it at a lower temperature, around 10°C, or even in a deep freeze, −18°C to −22°C, which gives it a life expectancy of up to a year. Do not forget that the main enemy of photographic material is damp. On taking the boxes from the deep freeze or refrigerator, let them temper for 2-4hr before opening, so as to avoid the formation of condensation.

Exposure latitude has been improved compared with the earlier paper and a 6-12sec bracket gave acceptable prints, when the true exposure was 8sec.

However, 4sec gave marked under-exposure. These tests were carried out with a low contrast transparency.

14RC Improved has greatly increased speed, considerably higher than that of Cibachrome—a fact which can sometimes be inconvenient, especially for small and medium-size prints. For instance we found it necessary to work with the following exposure conditions when enlarging an Ektachrome 35mm transparency on to a 20×25cm paper: using a Chromega B enlarger with dichroic head and a 48mm Angenieux lens, a 6sec exposure at f/11 with 20Y 20M filtration was required, compared with 14sec at f/5.6 with 50Y 10C filtration for Cibachrome.

The colour balance is very satisfactory, approaching that of Cibachrome. Visual contrast seems to us slightly lower than on the earlier RC 14. As regards definition, image sharpness, although entirely acceptable, is not as good as Cibachrome.

In short, our view is that the Ektachrome 14RC Improved paper provides a first-class material for positive/positive printing, easy to handle, simple to process, whose rendition will satisfy many amateur enthusiasts looking for a material with a good quality to price balance.

REFERENCES

The majority of the formulations given in the colour processing sections derive from independent investigations by the late Ernest Ch. Gehret and were originally published in *The British Journal of Photography*. The author continued to bring these up to date as the materials evolved until his death in April 1981. Subsequent revision has been carried out by George Ashton.

The principal references including those of obsolete processes no longer included in *The British Journal of Photography Annual* are:

Reversal colour processing
Agfachrome 50S/50L, *2 February 1974*
Ektachrome E3, *25 April 1969*
GAF 64, 100, 200, 500, T/190, *11 March 1966*
Orwochrom UT18 and UT21, *28 February 1966*
Peruchrome C18, *9 September 1960*
Ektachrome E-6, *28 August and 4 September 1981*

Colour negative films
Kodacolor X, Ektacolor Professional, *13 February 1959 and 15 July 1960*
Kodacolor II, *12 July 1974*

Colour print papers
Ektacolor 37RC, *11 January and 18 June 1974*

Colour reversal papers
Cibachrome Print, *26 December 1975*
Ektachrome 14RC Improved, *15 April 1977*.

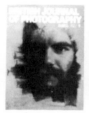